FRAMING
THE
SOUTH

FRAMING

THE

SOUTH

*Hollywood, Television, and Race
during the Civil Rights Struggle*

Allison
Graham

The Johns Hopkins University Press
Baltimore and London

For Amanda Graham, who shared the delights and affronts of a
southern baby boom upbringing and who made so much of this
work possible

The Johns Hopkins University Press
2715 North Charles Street
Baltimore, Maryland 21218-4363
www.press.jhu.edu

Library of Congress Cataloging-in-Publication Data

Graham, Allison.
 Framing the South : Hollywood, television, and race during the
Civil Rights struggle / Allison Graham.
 p. cm.
Includes bibliographical references and index.
 ISBN 0-8018-6615-4
 1. Southern States—in motion pictures. 2. Racism in motion
pictures. 3. Afro-Americans in motion pictures. 4. Mountain whites
(Southern States) in motion pictures. I. Title.
PN1995.9.S66 G73 2001
791.43'6275—dc21

00-011533

A catalog record for this book is available from the British Library.

CONTENTS

ILLUSTRATIONS

ACKNOWLEDGMENTS

This work grew from research begun over a decade ago for a documentary film on the Memphis Sanitation Workers' Strike of 1968 and the assassination of Martin Luther King Jr. The people who lived through those days, and who spent many hours helping me to understand the history of this region and the evolution of the civil rights movement, have been thanked elsewhere, but I remain indebted to them for setting me on a path that has proven to be constantly fascinating and unfailingly meaningful.

A subsequent research project I began, which focused on the unique history of Hoxie, Arkansas, convinced me that any recounting of postwar civil rights history was incomplete without a consideration of the complicated role of the national media and popular culture in shaping, reflecting, and creating particular and often contradictory attitudes toward race. I am extremely grateful to Andy Griffith, Roy Reed, Richard Stolley, and Bill McAphee, who graciously allowed me to interview them at length as I struggled to make sense of several decades of media history. A number of people who participated in the events of 1955–56 in Hoxie provided invaluable information to me over the past four years: Howard Vance, Fayth Hill-Washington, Rosemary Hill, Bill Penix, Jim Johnson, Herbert Brewer, Harry Ponder, and Helen Weir. Will Counts's stunning work from the 1950s helped me to understand the role of photojournalism during that era more clearly, and I thank him for allowing me to reprint one of his photographs here.

I particularly appreciate the kindness of friends and colleagues who read portions of this work or who encouraged me throughout the project: Will Brantley, David Chappell, Barbara Ching, Ken Goings, An-

gela Hague, Elizabeth Higginbotham, Sharon Monteith, Susan Scheckel, Barbara Ellen Smith, and Brian Ward. David Appleby, as usual, helped me in innumerable ways, both as a fellow investigator of the Hoxie story and as a thoughtful colleague. Moira Logan was a wonderfully supportive administrator, and department chairs John Bakke and Larry Frey generously provided essential research materials. A number of graduate assistants helped me plow through decades of film arcana: Danny Linton and Tuba Gokcek unearthed tomes of material, and Mary T. Easter was a dream assistant, taking it upon herself to track down obscure and always interesting archival leads. All of these contributions helped me prepare early drafts of several chapters for publication. Some material from the Introduction appears in "Remapping Dogpatch: Northern Media on the Southern Circuit," in the *Arkansas Historical Quarterly* 56, no. 3 (autumn 1997); a portion of Chapter One, entitled "The Loveliest and the Purest of God's Creatures: *The Three Faces of Eve* and the Crisis of Southern Womanhood," will appear in Daniel Bernardi, ed., *Classic Whiteness* (Minneapolis: University of Minnesota Press, forthcoming); and a very early version of Chapter Five will appear in Brian Ward, ed., *Media, Culture, and the Modern African American Freedom Struggle* (Gainesville: University Press of Florida, forthcoming).

My friend and northern colleague Luciana Bohne, always ready for any venture into her adopted homeland's strange history, jumped at the chance to drive the backroads of Mississippi with me in search of haunted terrain—something no sane southerner would agree to in mid-August. Our wanderings through the crossroads at Money, the Neshoba County Courthouse, Medgar Evers's last neighborhood, and the thickets along the Tallahatchie River created a connection to this region's history for me that is still mysteriously vivid and profoundly moving, and I thank Lucy for the experience.

Several archivists and librarians went out of their way to make my work easier and more productive. I cannot imagine more knowledgeable and courteous professionals than Bobs Tusa and David Richards at the University of Southern Mississippi's McCain Archives. Cassandra McCraw in the Special Collections at the University of Arkansas in Fayetteville was wonderfully helpful. For ten years now, Ed Frank has been patient, kind, and immensely generous to me as I've worked in the Special Collections at the University of Memphis McWherter (formerly Brister) Library. In the final stages of manuscript preparation, I

felt fortunate to work with the gracious and knowledgeable Susannah Benedetti at the Wisconsin Center for Film and Theater Research.

I would not have been able to devote full attention over the years to this project or to make necessary research trips had I not been awarded research grants from the Arkansas Humanities Council, the National Endowment for the Humanities, and the University of Memphis, as well as faculty development leave from the College of Communication and Fine Arts at the University of Memphis.

I am particularly indebted to Robert Brugger at the Johns Hopkins University Press for his unflagging support of this project, his remarkable patience, and his uncommonly sound advice and good taste. I thank Melody Herr for her consistently courteous and professional help during the preparation of this manuscript and Celestia Ward for her elegant copyediting.

Finally, I would like to thank James West for reintroducing me to the surreal pleasures of Brother Dave Gardner, helping me navigate through mountains of Sovereignty Commission documents at the McCain Archives, and bearing with grace and humor the home screenings of countless, sometimes awful, films from a bygone era. For not sticking it out through all thirty-one Elvis films, he is forgiven.

FRAMING
THE
SOUTH

Long before I knew that *Tobacco Road* was a work of
fiction, it existed for me as a scrap of fictional geography,
vague but real, and I shuddered to imagine its inhabitants.

LEWIS NORDAN

INTRODUCTION

Remapping Dogpatch

In 1987, NBC correspondent John Chancellor looked
back on his days as a young reporter covering the first big stories of the
civil rights beat. Remembering "the wonderful impact of technology
and . . . northern reporters on the sleepy southern towns into which we
all came," he noted that "we were able to show these people *themselves*
on television. They'd never seen themselves. They didn't know their
necks were red. They didn't know they were overweight. The blacks
didn't know what *they* looked like."[1] These images provoked "a pro-
found reaction in both the black and white communities," he claimed,
"because they'd never seen that, because we never see ourselves."[2]

This view of on-the-spot news coverage as a tool of social self-
awareness has long been dear to the medium's apologists. Claiming lit-
tle indebtedness to either print journalism or staged newsreel tech-
niques, television reporters in the 1950s came to see themselves as
pioneers of a wholly new way of seeing the world. As if television had
sprung full blown from postwar technology as a giant mirroring de-
vice, its midwives sat ready to monitor the shock waves produced by its
unprecedented glimpses of reality. If Chancellor's assessment is correct,
those first flickering transmissions from Little Rock must have sparked
a traumatic shift in consciousness for people south of the Mason-
Dixon Line. To see oneself, to become aware of oneself as an *image:*
such was the legacy of television in the region, according to its early
practitioners.

I doubt that many southerners of either race would concur. By 1957,
many white southerners knew their necks were red, and most black
southerners knew they were voiceless images in a tale of blood and

I

vengeance. They'd read it all before, and not just in regional fiction. For several years print journalists on the civil rights beat had been cutting a swath through territory previously occupied by novelists, their imagery at times barely distinguishable from that of aspiring gothic writers. And southerners had seen it all before, too, on a much larger and more vivid canvas than Chancellor's hazy black-and-white screen. They'd seen it at the movies.

At what point literary and cinematic conventions merged to shape the newly emerging southern race story is arguable. Perhaps it was during the coverage of the 1925 Scopes trial, when H. L. Mencken entertained the nation with descriptions of the "morons" and "halfwits" who populated "the Coca-Cola belt." His characters would have to wait until 1955, though, to be fleshed out on stage in Jerome Lawrence's and Robert E. Lee's *Inherit the Wind,* and until 1960 to make it to the movie screen in the film adaptation. Perhaps it was in the late-Depression-era collaborations of Margaret Bourke-White and Erskine Caldwell, of James Agee and Walker Evans, that the visual and verbal contours of "the southern" assumed predictable patterns. In *You Have Seen Their Faces,* Bourke-White claimed that she and Caldwell would watch sharecroppers for up to an hour "before their faces or gestures gave us what we were trying to express." "Photographs caught on the fly may serve as a record but they allow no chance for careful composition," she explained. Standing as distinguished examples of "photo-realism," her haggard faces and oppressive landscapes, "imprisoned on a sheet of film,"[3] would be replicated countless times by generations of documentary and fiction filmmakers intent on capturing "the look" of the South.

And by print journalists as well. By the mid-1960s the conventions were so firmly in place that Dan Wakefield, who had reported on the 1955 Emmett Till murder trial for the *Nation,* recalled Sumner, Mississippi, as "an eerie place. . . . The air is heavy, dusty, and hot, and even the silence has a thickness about it—like a kind of taut skin—that is suddenly broken with a shock by the crack and fizz of a Coke being opened." Surveying the "red-necks with faces shaggy from lack of a shave" sitting outside the courthouse, a fellow journalist had pronounced, "Faulkner is just a reporter." Wakefield, too, came to agree that "the Yoknapatawpha chronicler" had a documentarist's eye, for "nearly all his characters seemed to be there in one guise or another."[4] Mississippi-born Lewis Nordan would later parody Wakefield's prose

PRODUCT OF IMAGINATION

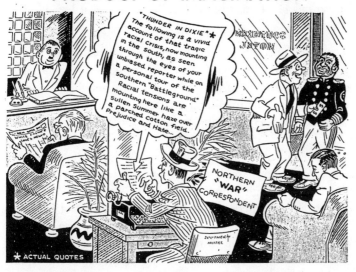

FIGURE 1. The South as journalistic cliché: a political cartoon from the newsletter of the Citizens' Councils of America (Jackson, Mississippi), April 1956. From the McCain Library and Archives, University of Southern Mississippi.

in his 1993 novel *Wolf Whistle,* a magical retelling of the Till case. After his "reporters from *Look* and the *New York Times*" crowd into the fictional town of Arrow Catcher, they immediately begin their inventory of living clichés. "Amazing," "Humid," "Do you believe this?" they repeat, concluding that "Faulkner was only a reporter." "That's the way they wrote about Arrow Catcher, Mississippi," the narrator remarks. "It was pure-dee poetry."[5]

During the 1950s, southerners across the political spectrum were quick to satirize the growing lexicon of southern clichés (fig. 1). Mississippi writer Elizabeth Spencer captured the ironic effect of the fictionalization of the region on native southerners in her 1956 novel *The Voice at the Back Door.* When Sheriff Duncan Harper mentions the possibility of a lynching occurring in his Delta town, attorney Kerney Woolbright reminds him, "It's the wrong time of year."

> "These things are supposed to happen in the middle of September after it hasn't rained for forty weeks, after all the cattle have died of thirst and their stench rolling from the country and there's so much dust the sun looks bloody all day long. Isn't that right?"

"I don't know," said Duncan. "I never saw a lynching."

"I never did either," said Kerney. "All I know is what I read in William Faulkner."[6]

The confusion of southern fact and fiction is such an inherent part of American media history that its survival in "objective" journalism should hardly have been surprising in the 1950s. After all, the nation's first "big" movie, and the medium's first fully realized technical masterpiece, was an impenetrable tangle of historical revision and mythic confabulation. D. W. Griffith had called many scenes in *The Birth of a Nation* "historical facsimiles," and President Wilson, himself a historian, had been quick to claim that the egregiously biased 1915 film "was like writing history in lightning."[7]

Forty years and hundreds of films later, "the South" had become a celluloid institution: "mammies, mobs, mockingbirds, and miscegenation,"[8] as one critic put it, all to the accompaniment of harmonicas, lone guitars, and a cappella gospel tunes. The region had been mapped by a century of fabulists, and Hollywood had been only too willing to claim squatters' rights within its moss-draped borders.

The encroachment of television into this imaginary locale created a particularly odd dissonance in the mid-1950s. In 1956, Rod Serling had been forced by U. S. Steel to change his teleplay based on the Emmett Till case to a drama about "an unnamed foreigner"[9] in New England, leading screenwriter Paddy Chayevsky to say, in 1958, "You can't write the Little Rock thing because they . . . can't sell the aluminum paper down South."[10] "They," however, were having no trouble selling "the Little Rock thing" in the hours before prime time. During September 1957, graphic news footage from Central High School provided the nightly lead-in to unintentionally ironic programming: a half-hour of musical entertainment presided over by the cool, sophisticated Nat King Cole, for example, or an hour of Civil War adventure on *The Gray Ghost*. The latter series, in fact, which premiered in September 1957, proved so troublesome to national advertisers that CBS initially had offered it only in syndication and then, fearing a backlash from northern viewers over the weekly spectacle of Confederate heroism, canceled the series altogether. But by December of that year, NBC had canceled *The Nat King Cole Show* because of national sponsors' fear of a *southern* backlash.

As the television screen became the battleground of a new civil war,

the issue of "permissible" (i.e., bankable) southern and racial imagery obsessed Madison Avenue. The solution should have been predictable. With the politically loaded Deep South now off bounds, the region came to be represented by a character well known to movie and radio audiences: the harmless hillbilly. Hailing from the predominantly white hills and mountains (thereby placating the feared southern markets, which could rest assured that race would never enter the narratives), the lovable yokel was almost completely "innocent": unschooled, naive, and practically asexual. Not only was the potential violence of the white southerner neutralized in this formula, but it was also transformed into a character flaw palatable to the equally feared northern markets: rural ignorance. Rod Serling's Tennessee-bred Mountain McClintock, in the critically-acclaimed 1956 teledrama *Requiem for a Heavyweight,* was perhaps the most pitiable hillbilly of the decade; those with more marketable talents, like Andy Griffith and Tennessee Ernie Ford, demonstrated remarkable adaptability during the 1950s, crossing media lines with ease. Although the rock-hillbilly-blues hybrid of Elvis Presley was an uncomfortable reminder to many of an explosive passion simmering in the ranks of the white southern working class, by the time Hollywood got through with him he was Ernie Ford's kissin' cousin—brash but peaceable, ignorant but trainable.

Despite the patronizing tone of much "hillbilly humor," its cultural function, as the 1959 musical *Li'l Abner* unintentionally revealed, was far from comic. The plot of the film (adapted from the 1956 play) revolves around the federal government's decision to move atomic testing from Nevada to the Appalachian town of Dogpatch. Claiming that it is an ideal place to "blow off the face of the earth," Congress declares Dogpatch "the most unnecessary place in the U.S.A." In response, the town offers its miraculous "Yokumberry" tonic as proof of its social worth. The tonic fails to save the town, but the locals' opinion of their value to the nation is more accurate than they know. For Dogpatch was not simply "necessary" to the nation; it was essential. As the benighted haunt of hicks, rednecks, and crackers, the "dumping ground" of white toxic waste, it stood on the quarantined outskirts of civility and taste, at the dead end of Tobacco Road. Those who "shuddered" at the thought of its inhabitants found solace in their own racial respectability.

Taking pages from both Dogpatch creator Al Capp and Erskine Caldwell, *Life* and *Time* magazines featured their own brand of "yokelization" in 1957. During the international uproar that followed Orval

Faubus's decision to call out the National Guard to prevent nine black students from entering Little Rock's Central High School, *Life* sent its Chicago bureau chief to Greasy Creek, Arkansas, to report on "the scenes and friends of the governor's early days." The reporter found a "remote and still virgin country" where "a rutted dirt road" led him to a shack "surrounded by yelping hounds," a deserted schoolhouse, and a Faubus relative who remembered young Orval as a "smart boy" and a "good worker": "When he hoed corn it was hoed. He didn't leave a weed," the relative was quoted as saying.[11] *Time*'s cover story on Faubus, which appeared the same week as *Life*'s profile, offered a clearer portrait of the defiant governor. Faubus, it noted, was a "slightly sophisticated hill-billy" born in "the night fog" to the "howl of timber wolves." Having spent "a lifetime clawing his way up so that he would not be looked down on," the "mountain Populist" now sat in the governor's mansion, belching "gustily" at his guest with "milk dribbling down his chin."[12] "Congratulations!" wrote one reader the next week. "Your story on Governor Faubus of Arkansas couldn't have been better if Al Capp had done it."[13] The story generated immense resentment among Arkansans and other southerners, many of whom were opposed to Faubus's politics. But the reaction was tame compared to that which had followed an earlier incursion of the national media into the state.

In the summer of 1955, one year after the Supreme Court's *Brown v. Board of Education* decision overturning the doctrine of separate but equal schooling and a full two years before the integration of Little Rock's Central High, the small farming town of Hoxie, Arkansas, quietly desegregated its public schools. Even though the school board's unanimous decision that integration was "morally right in the sight of God" had led some white townspeople to talk of a school boycott, twenty-six black students enrolled in the formerly all-white elementary school without incident on July 11, the starting date for summer term in cotton country. So smoothly were relations between the children proceeding that *Life* sent a photographer to Hoxie. His documentation of southern racial harmony hit the country's newsstands on July 25.

The effect of the article on the town was immediate. Handbills from a number of white supremacist organizations began to appear in the local mail and on the front seats of cars. A mass meeting was called at City Hall, where angry townspeople waved the *Life* article about and made speeches calling for a school boycott. Despite picket lines at the school, increased calls for violent resistance to integration, a local peti-

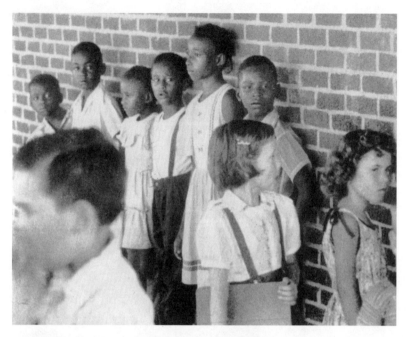

FIGURE 2. Apprehensive students on the first day of school integration in Hoxie, Arkansas, 11 July 1955. *Life,* 25 July 1955.

tion demanding the resignation of the school board, and the refusal of Governor Faubus to become involved, the board members would not rescind their decision and refused to resign. By the opening of the fall term on October 31, the board had obtained an injunction against the segregationist agitators—a move that was later upheld in a landmark federal appeals case, *Brewer v. Hoxie School Board*—and classes resumed on an integrated basis.

"It seems fairly certain," wrote Cabell Phillips in the September 25, 1955, *New York Times Magazine,* "that the [*Life*] magazine story not only triggered the latent discontent in Hoxie but also stirred up the white-supremacy forces elsewhere as well."[14] In retrospect, the inflammatory elements of the *Life* article seem obvious to anyone acquainted with the rhetoric of the times. Ten photographs chronicle the first day of school: the children are initially apprehensive (fig. 2), but eventually get along. Despite Hoxie's "misgivings" about integration, the town "finds to nearly everybody's surprise that it works." White farmers sitting under the trees in overalls and straw hats find the situation "a shame" (fig. 3), but the children know better. "By the end of the day," we learn, they

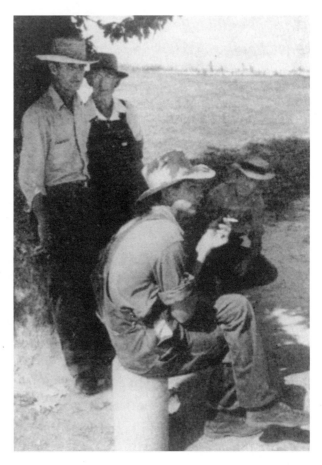

FIGURE 3. Hoxie farmers warily watch integration proceed at the elementary school, 11 July 1955. *Life,* 25 July 1955.

"were behaving as if they had gone to school together all their lives."[15] To illustrate the point, the story ends with a large photograph of a white girl walking arm in arm with two black classmates (fig. 4).

Life's editors should not have been surprised to get the following response from one reader in Virginia: "I never saw a more heart-rending picture than that of frightened, pathetic little Peggy being carried along by two larger and older Negro girls." The magazine's cool reassurance that "Peggy brought the Negro girls home with her and even wanted to go over to their house to play"[16] could hardly have tempered the reader's anxiety over "race-mixing." To suggest in the national press

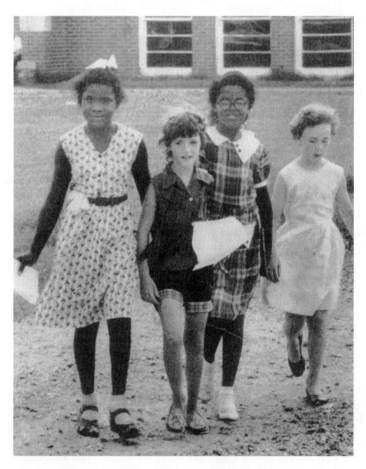

FIGURE 4. The end of the first integrated school day in Hoxie, 11 July 1955. *Life*, 25 July 1955.

that children know best must have been read by many southern whites both as proof that children were the real "targets" of integrationists and, worse, as a diminution of their own power, a rap on the knuckles of adults who, like the unnamed farmers, should have been in school themselves rather than sitting under the trees fretting in ignorance. South Carolina journalist William Workman, in fact, characterized this rhetorical pattern in 1960 as a provocation to southern whites. Discussing an NAACP pamphlet entitled *It Can Be Done,* which claimed that "desegregation tends to become a problem chiefly because of adults," he remarked, "That sort of reasoning pre-supposes that children know

better than their parents the sort of education they should have, and the sort of associations they should form in obtaining that education. The NAACP argument might as well ask . . . 'Why bother with parents?'"[17]

Clearly, judging by their response, white opponents of integration "got" the implications of the article. As Jonesboro attorney Bill Penix, who brought suit against the segregrationists for the school board, now says, "I don't think it correctly depicted what was happening. . . . I think it was thoughtless."[18] By depicting "die-hard opponents of de-segregation" as overall-clad, "disapproving" farmers, *Life* appeared intent on replicating pejorative stereotypes of the South. Or so it seemed to Howard Vance, president of the Hoxie school board. "The South, ever since I can remember," he claims, "has been looked down on. . . . *Life* was determined to show the bad side of the people down here. . . . And we wasn't that kind of community. We were just good, hard-working people, that's all."[19] The local opponents of integration found the article close to public mockery, too—but for different reasons. In their resolution protesting the school board's action, they claimed that the "unfavorable publicity for Hoxie, Lawrence County and Arkansas" in the "National Press" had resulted in "embarrassment to its [*sic*] citizens traveling in other sections of the state and country."[20]

Certainly, the *Life* article did not "cause" the Hoxie crisis, any more than *Time* later "caused" white support for Orval Faubus, but its provocative effect on many opponents of integration foreshadowed future responses to perceived misrepresentations in the national press. A few months after covering the Little Rock crisis, John Chancellor wrote that "most of the rioters were laborers . . . in overalls." But as Pete Daniel has pointed out, "few in the crowd fit the rural redneck mold. . . . It was, at its core, a respectable-looking working-class crowd." Moreover, he notes, "at the height of the crisis, 250 reporters mingled with the crowd." Ironically overlooking the possible effects of their own presence on events, the reporters played a crucial role in defining the social dimensions of the escalating southern drama. "Dissociating the mob from Little Rock and depicting it as rural and racist," Daniel says, "distanced the crisis . . . from the city's silently moderate whites. The mob members were portrayed as white trash from somewhere down the road."[21] Dick Sanders, a northern television journalist working in Jackson, Mississippi, during the 1950s, suggested in 1987 that "after Little Rock, there was a great deal said about how the TV coverage of Little Rock opened the eyes of the United States to the plight of the

Negro. What it did in Mississippi to a large extent was galvanize the white opposition."²² If this was so, what exactly was the galvanizing agent? The unwelcome first sight of their own "red necks," as John Chancellor argued? To believe this, we would have to believe that segregationists were united in their self-loathing, bonded in their contempt for what they all saw in the "mirror" of the television screen: vulgar pariahs stigmatized by the media. I would venture to say that this is what Chancellor saw. Whether "these people," as he called them, saw "themselves" is another matter.

:: The complexity of white reaction to school desegregation is a dimension of postwar American history which has yet to be fully explored. Standing in the way of exploration have often been conventional notions about the nature of southern culture. The overshadowing of the Hoxie story by later events in Little Rock, Birmingham, and other well-known civil rights battlegrounds demonstrates the degree to which such notions have informed popular understandings of that era. Hoxie, in fact, is emblematic of much that has been ignored in America's racial history. Rather than the simplified saga of reactionary southern whites battling the progressive forces of northern whites and southern blacks, the postwar southern drama was propelled not only by the conflicting interests of federal, state, and local politicians but also by a complicated interplay of racial and regional identities. Hoxie school board members (fig. 5), for example, all rural white southerners, insisted upon local adherence to national law (which in itself contradicted state-mandated school segregation). Never backing down from their "morally right decision," they refused to join forces with fellow white southerners, many of whom were far better educated leaders from urban areas. To the board members, the most dangerous outsiders were not northern "conspirators" but homegrown segregationist agitators. In fictionalized retellings of integration standoffs of the 1950s and 1960s, however, ambiguity and irony have tended to dissolve into stereotype, if not caricature, with black and white dichotomized into monolithic camps and men like those on the Hoxie school board becoming templates for the iconic southern racist.

As a southerner myself, one who came of age in the 1950s and 1960s, I am often struck by the persistence of such stereotypes not just in national representations of the South but in southerners' perceptions of their own history. A sizeable number of people who have seen

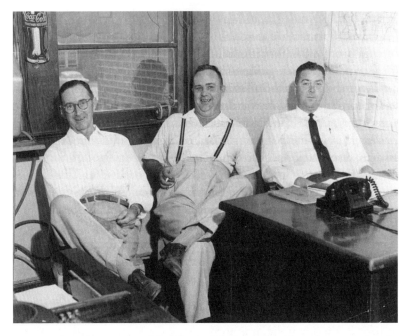

FIGURE 5. Several members of the Hoxie, Arkansas, school board meet during the town's integration crisis (Howard Vance is in the middle), 1955. From Special Collections, McWherter Library, University of Memphis.

the documentary film I produced in 1993 with colleagues David Appleby and Steve Ross (*At the River I Stand*,[23] a study of the 1968 Memphis sanitation workers' strike and the assassination of Martin Luther King Jr.) have been taken aback by its unconventional characters. How, they ask, could Memphis mayor Henry Loeb, a handsome, Princeton-educated, Jewish southerner, have been a standard bearer for the region's racist hierarchy? How could the genteel, well-spoken white members of the City Council have persisted so long in their blindly reactionary agenda? Left unspoken in such questions is a powerful assumption about American—not just southern—race and class. Where in this familiar regional tale of regressive social policy and racial oppression is the familiar villain of such stories, the Klan-inspired vigilante, the backwoods thug? Where, in other words, is the redneck? Without his presence, the postwar southern story appears shapeless, incomplete. And this is understandable. Lacking a narrative framework for dramatizing *institutional* racism, American movies have traditionally formulated our national racial crisis as a series of random

encounters with evil incarnate, ghostly adventure yarns unfolding on a morally inflected landscape of ruined shacks, murky rivers, and darkened swamps. Emerging from the shadows to enact his ghastly rituals, the redneck can be counted on to perform his time-honored, generic duty: roar the hatred that his betters will only whisper, and then die at their hands in a near-mythic purgation of the race.

The centrality of the "cracker" to our understanding of American racism cannot, I believe, be overestimated. More than simply a scapegoat, he has functioned in popular culture as a signifier of racial ambiguity, with his class-bound vulgarity consistently representative of contaminated whiteness. As the personification of sullied purity, he is racial debris, white trash. Ironically, it is he himself, the defender of Anglo-Saxon immaculateness, who is the "mongrel" so feared by segregationists: a stain on the race, a moral half-breed. By both accepting responsibility for racism (admitting white culpability, in other words) and denying it (depicting criminality as an inherent characteristic of class rather than race), popular reconfigurations of the civil rights era imagine the twentieth-century South as an arena of white—not black—heroism. More importantly, they offer the spectacle of racial redemption, for with the expulsion of the lawless redneck from southern society, the moral purity of whiteness itself is affirmed.

Hollywood's role in the refinement and perpetuation of this story since the early 1950s is the subject of this book. The film industry produced a number of films in 1949 which looked at contemporary racism (*Pinky, Lost Boundaries, Home of the Brave, Intruder in the Dust*), but by the middle of the next decade it was veering sharply from a direct confrontation with the emerging national crisis. Although *Pinky* and *Intruder in the Dust* strongly indicted poor rural whites for their racism, both films maintained a focus upon the politically charged relationship between southern blacks and privileged whites (Ralph Ellison, in fact, claimed that the latter production was "the only film that could be shown in Harlem without arousing unintended laughter").[24] After the *Brown* decision, however, Hollywood displaced its relatively daring interest in what Lillian Smith called "the edgy blackness and whiteness of things"[25] onto more blunted terrain, producing historically distant adventures, melodramatic romances, and hillbilly comedies. In post-*Brown* Hollywood, blackness all but disappeared from the screen as *intra*racial confrontation assumed interracial connotations, and white battled white for cultural supremacy.

By 1957, a highly connotative strategy emerged for cinematically alluding to the nation's escalating racial tensions. Central to this strategy was the figure of the southern criminal, the fugitive redneck, who would, in film after film, either bend to civilized law or suffer swift punishment. A far cry from the noble agrarian lauded by the Vanderbilt "Fugitives" in the 1920s, this man of the country took his stand with shotgun and noose in hand. A cousin to the newly infamous "juvenile delinquent," he was made to atone for his social sins through a formulaic program of reeducation. Like the "JD" terrorizing Hollywood's blackboard jungles, the reformed cracker would stand as an emblem of American inclusiveness, a testament to white progress.

Astonishingly, when American filmmakers finally dared to depict the racially divided contemporary South in the 1960s, they simply dusted off the well-worn narrative strategy of the 1950s. The inclusion of principal black performers like Sidney Poitier barely affected the updated films' politically "relevant" perspective on racism. Social class, in the form of the uneducated rural white man, continued to be the culprit, reflecting a now fashionable attitude among Hollywood liberals in light of white working-class support of the Vietnam War. The refusal to indict social and political institutions for racial injustice, in fact, would become an immutable characteristic of a new genre, the civil rights film, born from the marriage of *To Kill a Mockingbird* and *In the Heat of the Night.* The commercial success of later films like *Mississippi Burning, Ghosts of Mississippi,* and the series of John Grisham adaptations of the 1990s attests to the durability of the old southern mythography. However, the astounding popularity of a narrative and iconographic system that developed more than forty years earlier precisely for the *evasion* of contemporary political realities suggests that our national understanding of race and social class has changed little since 1954.

When the most popular film of 1994 retold postwar history through the befuddled homilies of an Alabama idiot, the nation did more than merely embrace the movie's eponymous hero; it celebrated a time-honored tradition in our collective myth-making. To Forrest Gump, the events surrounding his life just didn't "make no sense," but to his adoring audience, the confused simpleton who wandered through electronically altered news footage was, according to director Robert Zemeckis, the thread that held "the tapestry of American history" together.[26] Not privy to our fascinated glimpse of his red neck on the

television screens of the 1950s and 1960s, Forrest Gump reminds us once again of the "wonderful impact of technology" on "sleepy southern" folks. Standing dazed and confused at century's end, he is America's *fin-de-siècle* yokel. In Forrest Gump, the Hollywood South finally found its Homer. The rise, punishment, and redemption of the white racist is his tale.

:: Far too often, the movies are cited by academicians in many fields as mere "reflections" of social trends rather than as active participants in the political arena. The interplay of culture, industry, and conflicting ideological impulses at work in the production of a film—not to mention the divergent ways in which individuals interpret mainstream narratives—can easily frustrate any monolithic reading of its "intentions" and "effects." Having said this, I nevertheless attempt to distinguish several patterns of representation in American films that I believe had profound impact on at least one segment of the population, namely the generation of socially conscious white Americans who came of age in the 1950s, 1960s, and early 1970s. That the patterns were usually read as politically progressive throughout this group's young adulthood (when, in other words, they—we—consumed movies voraciously) only served to reinforce much of the generation's unconscious racism, sexism, and, certainly, classism. Looking back over the tremendous outpouring of Hollywood morality tales produced during the civil rights era, I wouldn't say that I see the patterns more clearly now. I respond differently to them, though, viewing them as almost transparent—but just as aesthetically compelling—purveyors of attitudes that are still alive and well on our political landscape.

The redemption of white America was not a new tale in the 1950s. Its embodiment throughout the coming decades in the punished and reformed figure of the southern racist seemed to take on a new urgency during the era, however, a sense through its relentless repetition of national compulsion. I begin my study of the tale in the years immediately following the Supreme Court's *Brown v. Board of Education of Topeka* decision. As southern segregationists mounted their resistance to federally mandated school integration, they invoked an old but powerful theme: "mongrelization," the pollution of the white race which would inevitably result from the state-sanctioned "mixing" of white and black children. The purity of the white woman became the focus of this theme, the foundation upon which the rhetorical struc-

ture of segregation rested. But "purity" was clearly a problematic notion, especially for its staunchest defenders. For quite some time, southern writers had been suggesting that whiteness itself was a cultural delusion, a fatal condition of the soul, an emblem, we might say, of a "bled-out" society. If that was so, however, segregationists were not the only ones who responded to the thought with something approaching hysteria. All of white America held an investment in the soundness and viability of its image, an investment fostered and nurtured by six decades of Hollywood fiction. In the aftermath of *Brown,* the southern white woman became a pivotal figure not just in the propaganda strategies of segregationists but in the narrative strategies of the movies themselves. For all of the apparent liberalism of the major studios' message movies, one of their most insistent projects throughout the 1950s and 1960s was the rescue and resuscitation of a threatened race. With public education now contested territory in a racial war, the *re*education of America's most wayward whites—poor southerners—became crucial to the reclamation of the South and, more importantly, to the redemption of white America itself.

Chapters One through Four examine specific aspects of the cinematic redemption of whiteness in the decade following the *Brown* decision. Chapter One looks at the pervasive theme of white decay in literature and film and focuses upon the ambiguous image of the southern white woman in Hollywood films of the era. It culminates in a detailed discussion of *The Three Faces of Eve* (1957) as a socially and politically complicated expression of white hysteria. In Chapter Two I extend these concerns into a consideration of particular film genres of the era—notably, teen movies, romances, and science fiction—which demonstrated a preoccupation with racial boundaries. I closely examine another 1957 film, *Sayonara,* both as a resonant example of gender and racial anxiety in the highly popular message movies of the day and as a pointed "lesson" in the necessity for southern reeducation. Chapter Three takes this lesson as its starting point and explores the roots and dimensions of the theme of reeducation, focusing upon the ways in which white southern criminality mirrored and yet differed from the national "wave" of delinquency which absorbed the press and popular media in the 1950s. The question of the southern male's ability and willingness to be reeducated informed political, social, and artistic discourse throughout the 1950s and early 1960s, with the hillbilly figure exploited as an object lesson in regional and class limitations. The chap-

ter concludes with an analysis of this exploitation in yet another film from 1957, *A Face in the Crowd.* I begin Chapter Four with a consideration of the different political functions of the hillbilly and the redneck in 1950s America by surveying the film career of Elvis Presley. The theme of the punishment, reeducation, and redemption of the poor white southerner, which took ironic shape in Presley's movies, found its clearest expression in a number of the era's westerns and continued to form the narrative spine of most southern films into the early 1960s.

The fusion of the rhetoric of western independence and southern resistance created a politically ambiguous rebel figure in these films who would be rediscovered and widely embraced by audiences in the late 1980s. Chapter Five examines the resurrection of this figure in the newly respectable southern lawman, a hero whose generic contract requires a showdown with America's late-century savage, the cracker from hell. The irrationally violent redneck is the indispensable convention of Hollywood's white redemption tales, the character whose essential, class-bound criminality is offered up, movie after movie, as proof of the inherent goodness of all other whites. Because the focus of this book is on what I see as the formative texts of the postwar white redemption story, I have not provided extensive critiques of films produced after 1970. Instead, I build my analyses in the first four chapters toward a final, broad examination of the ways in which the narrative conventions of the 1950s and early 1960s continued to inform cinematic treatments of region and race over the next four decades. During the era that saw the rise of massive resistance to desegregation and the triumphs of the modern civil rights movement, the movies refined their sociopolitical lexicon, creating an iconography that was at once racially ambiguous and socially unequivocal. In the final chapter I look at the endurance of that iconography and ponder its power to rewrite and even—literally—erase history altogether.

ONE

"THE PUREST OF GOD'S CREATURES"

White Women, Blood Pollution,
and Southern Sexuality

The inviolable white woman took center stage in the post-war southern drama. A rebuke to the masculinized women of American industrialism, she had long been an emblem of the femininity that bloomed unbidden in agrarian simplicity. To the defenders of racial segregation in the 1950s, she symbolized a threatened and embattled way of life, a way of life that, ironically, had existed primarily as legend for over one hundred years. Invoking a fantasy to defend a fantasy, segregationists rallied around their favorite icon when, in May of 1954, the Supreme Court issued its school desegregation decision in *Brown v. Board of Education.* Judge Tom Brady of Greenwood, Mississippi, sounded the clarion two months later in *Black Monday,* a tract that became the manifesto of the emerging White Citizens' Councils. The "peaceful and harmonious relationship" between blacks and whites in the South, he claimed, "has been possible because of the inviolability of Southern womanhood."[1] And who, exactly, was a southern woman? "The loveliest and the purest of God's creatures, the nearest thing to an angelic being that treads this terrestrial ball is a well-bred, cultured Southern white woman or her blue-eyed, golden-haired little girl."[2] "The Southerner," wrote African American sociologist Calvin Hernton in 1965, "had to find or create a symbol, an *idea* of grace and purity, that would loom large in a civilization shot through with shame, bigotry, and the inhuman treatment of . . . six million black people. Sacred white womanhood emerged in the South as an immaculate mythology to glorify an otherwise indecent society."[3]

Despite her fragility, the golden-haired girl of plantation mythology proved to be a durable symbol of segregationist fervor. In the midst

of deliberations on the *Brown* case, President Eisenhower told Chief Justice Earl Warren that the opponents of integration "are not bad people. All they are concerned about is to see that their sweet little girls are not required to sit in schools alongside some big black bucks."[4] Four months after the *Brown* decision, at the beginning of the nation's school year, the mythology's iconography received a shot of adrenaline with the first telecast of the Miss America pageant. Throughout the decade and well into the 1960s, Americans watched a succession of southern white women win the crown (five alone between 1957 and 1964); contestants from Mississippi, in fact, won consecutive titles in 1959 and 1960, and the University of Mississippi became famous as a "hothouse for nurturing beauty."[5]

One might wonder, though, if all white women in the region would have recognized themselves among those included in the magic circle of protected womanhood. "I was born trash in a land where the people all believe themselves natural aristocrats," writes South Carolina novelist Dorothy Allison. "The women of my family? We are the ones in all those photos taken at mining disasters, floods, fires. We are the ones in the background . . . ugly and old and exhausted."[6] Peering out from the Depression-era photographs of Walker Evans, Margaret Bourke-White, and Dorothea Lange, such faces became the stuff of alternative legend: the sunken, tattered residents of Dogpatch. Ridiculed by decades of cartoonists and filmmakers, pitied by liberal-minded defenders of the New Deal and the War on Poverty, the stereotypical hillbilly or redneck woman reminded Americans that another South existed adjacent to the crumbling mansions.

Despite their uncontested whiteness, the women of the Other South failed to make an appearance in postwar segregationist rhetoric, even though their male relatives insisted on their inclusion. After Roy Bryant and J. W. Milam murdered Emmett Till in 1955, they claimed they were merely defending the honor of Bryant's wife. A fourteen-year-old northern black boy's whistle or wink at a working-class white woman provided a convenient excuse for white Mississippians to assert their "sovereignty" to the nation, but as soon as Milam and Bryant were acquitted by an all-white jury, their former supporters turned their backs on the men, refusing to rent land to the embarrassing "peckerwoods."[7] For most segregationists, the iconic southern white woman bore little resemblance to the actual women who were apparently so threatened by the specter of miscegenation. It was the belle, not the peasant, who

was emblazoned on the banner southerners waved to decry their victimization at the hands of federal "race-mixers." Achieving her allure through juxtaposition to her "trailer-trash" sister, she embodied the ennobled and endangered racial purity of an entire region.

Movies, Fiction, and the Whiteness unto Death

By the mid-1950s, white Americans' love affair with the plantation myth had undergone several revisions, but the infatuation was as strong as ever. Under the spell of Tennessee Williams, Hollywood modernized its antebellum sets and filmgoers were treated to the new spectacle of southern decay. The mansions, juleps, and magnolias remained, but the residents of the screen South now began to enact the psychological crises of a dwindling subculture. Repression, hysteria, and sexual dysfunction were the new southern stories, as hothouse whites raged against the dying of a caste. "I understand that time erases whiteness altogether," a Georgia white woman says in Barbara Kingsolver's *The Poisonwood Bible* as she marvels at her half-African children, "four boys who are the colors of silt, loam, dust, and clay, an infinite palette for children of their own."[8] But it was precisely this prospect of racial obliteration, so liberating to a character who had come of age in the late 1950s, that fueled the manic obsessions of her compatriots. Imagining themselves the last specimens of unadulterated whiteness, southern neurotics boasted of bloodlines while displaying all signs of pathological inbreeding. Although the popular image of the incestuous hillbilly never extended to the regionally inbred members of Delta society, by the 1950s a significant number of movies began to point in that direction. Countering that implication, however, was a palpable national nostalgia for antebellum plantation days, a recognition in itself that the dream of racial purity, while doomed, exerted a powerful pull on the American imagination.

In Hollywood's formulations of the 1950s and 1960s, decadent whiteness was gaudily made up, its death throes enacted in near-camp performances that would earn Oscars for many actors. Throughout the early years of the postwar civil rights movement, in fact, "southern decay" movies proved immensely popular. But their studied remoteness from contemporary social reality only served to betray a deep-seated racial panic. At the center of the scenario, of course, was the southern white woman. Privileged (or once privileged), desirable (or once desirable), and impossibly frustrated, she testified again and again to the

need for racial rejuvenation. The Tennessee Williams adaptations of the 1950s provided the most flamboyant showcases for her sexual torment. Like Carol Cutrere in his *The Fugitive Kind* (1959), characters like Blanche DuBois (*A Streetcar Named Desire* [1951]), Baby Doll (*Baby Doll* [1956]), and Maggie Pollitt (*Cat on a Hot Tin Roof* [1958]) demanded "to be noticed, and seen, and heard, and felt." Ironically, Hollywood was telling the most virulent segregationists what they wanted to hear: it was the white woman who was most "at risk" in an integrated society. But it was also suggesting something unthinkable to racists: the white woman herself was the aggressor.

Sexual aggression in these films was rarely a simple matter of unleashed repression, though. Screenwriter Irving Ravetch, who, with his wife, Harriet Frank Jr., scripted a number of southern films of the era (among them *The Long, Hot Summer* [1958] and *The Sound and the Fury* [1959]), has said of the South that "it's full of memories, an indelible, brooding, phantom of a place."9 Within such a landscape, "healthy" sexuality becomes oxymoronic and the erotic is tainted by violence and dementia. In *The Fugitive Kind,* Carol Cutrere ends her roadhouse rounds with an attempted seduction in a cemetery; Blanche DuBois, haunted by her husband's suicide, finds refuge in her "many intimacies with strangers"; Ruby Gentry (in the 1952 film of the same name) ends her amorous quest with a bloody shootout in a Carolina swamp, while her Bible-thumping brother hurls curses through the mist; nymphomaniacal Marylee Hadley (in *Written on the Wind,* 1956) feverishly mambos during her father's death; and deranged plantation belle Susanna Drake (in *Raintree County* [1957]) drowns herself while clutching her favorite doll. "A man should not only marry his heart," Susanna's father-in-law warns his son at the beginning of the last film. "He should marry his region," an admonition that other Yankee suitors in the movies should probably have heeded.

The midcentury correlation of southern whiteness with morbidity was not unique to mainstream film. Southern authors had led the way, drawing upon vivid metaphors of decline and decay to depict the region's social order. Faulkner's Snopeses and Erskine Caldwell's Lesters come first to mind, but Carson McCullers, Flannery O'Connor, Harper Lee, and James Dickey all described a racial degeneration that bordered on the horrific. McCullers, in particular, who claimed that she needed to return to the South "periodically to renew [her] sense of horror,"10 peopled her stories with characters whose whiteness, when not

cadaverous, was evocative of madness. In *The Ballad of the Sad Cafe,* Miss Amelia has "a face like the terrible dim faces known in dreams—sexless and white, with two gray crossed eyes which are turned inward so sharply that they seem to be exchanging with each other one long and secret gaze of grief,"[11] and a memory of her ex-husband's siblings as "little whitehaired ghosts" (218). The men who gather at her store look "very much alike—all wearing blue overalls, most of them with whitish hair, all pale of face" (209), and the hunchback she takes in carries a photograph of "two pale, withered-up little children," whose "faces were tiny white blurs" (201). A drunk soldier who tries to attack Frankie in *The Member of the Wedding* has "light blue eyes, set close together" that appear to "have been washed with milk."[12] Frankie's dead uncle has eyes "like blue jelly" (320), and she senses John Henry as a "ghost-gray" (391) presence after his death.

The racial implications of her use of color did not escape McCullers. In her first work, *The Heart Is a Lonely Hunter,* members of a black family picture God as a white man "with a white beard and blue eyes" and an angel as "a little white girl . . . with yellow hair and a white robe."[13] One member of the family, Dr. Copeland, is enraged by his family's tendency to envision heaven as a white sanctuary, yet his father persists in the notion that Jesus will take pity on "all us sad colored peoples" and transform them into celestial beings "white as cotton" (124). Contrasted to this myth is the unglamorous reality of main character Mick's "damp, whitish hair" (14) and the dismal image of a peripheral character named Patterson, a man who holds out "a dead-white, boneless hand with dirty fingernails" (54).

In Flannery O'Connor's work, whiteness sometimes appeared otherworldly. A rural boy and his grandfather await a train at dawn in "The Artificial Nigger," "as if they were awaiting an apparition."[14] The apparition materializes when they board: the boy looks out a darkened window and sees "a pale ghost-like face scowling at him beneath the brim of a pale ghost-like hat"; his grandfather looks out the same window and sees "a different ghost, pale but grinning, under a black hat" (214). In "The Enduring Chill," the failed writer Asbury Fox returns from New York to his despised home in the South to, he hopes, die. Mysteriously but not fatally ill, he wastes away in his mother's white-columned house, shocking his family and even himself with a face that is "pale broken," "white wooden," and "pale and drawn and ravaged."[15]

Stripped of McCullers's and O'Connor's comic and even monstrous

irony, white ghostliness reappears in Harper Lee's 1960 novel *To Kill a Mockingbird* as a nostalgic evocation of the Old South. "The haunted childhood belongs to every southerner of my age,"[16] Lillian Smith wrote in 1949, and Lee's story suggests a similar conviction. Poor country child Walter Cunningham "looked as if he had been raised on fish food; his eyes . . . were red-rimmed and watery. There was no color in his face except at the tip of his nose, which was mostly pink."[17] And Mr. Radley had eyes "so colorless they did not reflect light" (11). Yet the moribund nature of southern whiteness for Lee was more a function of its historical disposition—its *remembered* quality—than of its social and psychological plight. The ghastly Boo Radley is the spirit of the Confederate Gray Ghost himself, a spectral "gentleman" (278) who emerges from his haunted house to rescue Scout and Jem from the murderous redneck Bob Ewell. The "good" whiteness of Boo, however, is fading fast, nearly insubstantial; when remembered twenty years later by Scout, Boo is a ghostly visitor on Halloween, a wraith with "sickly white hands . . . so white they stood out garishly against the dull cream wall," a face "as white as his hands," gray eyes "so colorless I thought he was blind," and "dead and thin" hair (270).

The phantoms who rise from the Georgia woods to violate James Dickey's urban canoeists in his 1970 novel *Deliverance* are just as evocative of the past as Boo Radley, only here it is the rural past, the world of Bob Ewell rather than of Confederate gallantry, a world that is to be flooded by a soon-to-be-completed dam. "Nobody worth a damn could ever come from such a place,"[18] thinks Ed, the narrator, as he looks at a village along the river. To be sure, the two ghouls who materialize at river's edge are as ghastly as Carson McCullers's corpses or Harper Lee's Halloween specter, but they are stripped of all pathos, their repellent whiteness now the sign of ingrown virulence. As members of an exhausted, anemic race, they are generations removed from the comically benign albino captured from a Georgia swamp in Erskine Caldwell's *God's Little Acre* (1933), who is thought by the Walden family to "possess unearthly powers to divine gold."[19] "It's the whiteness of him. His blood is white, the wax in his ears is white!" Pluto Swint (played by Buddy Hackett) marvels in the 1958 film adaptation. The albino's lust for Darling Jill comes as a surprise to Ty Ty Walden, who until then "had not for a moment considered [him] a human being."[20] By 1970, the Georgia albino had devolved into the monstrous Sodomite of Dickey's *Deliverance*, with "big white eyes and a half-white stubble that

grew in whorls on his cheeks." His partner, who almost succeeds in
forcing Ed to perform fellatio on him, is a toothless ogre who peers "as
though out of a cave or some dim simple place far back in his yellow-
tinged eyeballs" (95).

Although the backwoods couplings of the mutants are depicted by
Dickey as the violent acts of a genetically depleted, inbred group, they
are nevertheless mirrored in the narrator's insistent homoeroticism. Ed's
fascination with the naked body of Lewis ("I had never seen such a male
body in my life" [90]), his pleasure in riding in syncopated motion
behind his friend Drew on the canoe ("I plowed a little harder to turn
us exactly with the current. Drew glanced back. . . . His face-side had
a big grin" [66]), and his determination to shoot the toothless man
"from behind" (149) become, in the logic of the narrative, manifesta-
tions of the urban men's ultimate emasculation at the hands of Nature.
The river, which is feminized by the men as a force to be mastered, an
engulfing current "so vital and uncaring around my genitals" (67), Ed
says, becomes the master by novel's end. Bobby's rape at river's edge is
unspeakable, an "unthinkably ridiculous and humiliating" (104) sub-
ject; Drew is killed, washed downstream; Lewis breaks his leg; and Ed
wounds himself with his arrow. "It was in me. *In* me. The flesh around
the metal moved pitifully, like a mouth, when I moved the shaft" (167),
he says, and when he falls from a cliff into the river, his own spectacu-
lar sodomization is completed: "I felt the current thread through me,
first through my head from one ear and out the other and then com-
plicatedly through my body, up my rectum and out my mouth and
also in at the side where I was hurt" (177). The hillbilly rapist killed by
Lewis's arrow becomes an emblem of the men's ultimate impotence,
their own insignificance within the technology-driven New South, rep-
resented by the powerful new dam. "Every now and then I looked into
the canoe and saw the body riding there," Ed admits, "slumped back
with its hand over its face and its feet crossed, a caricature of the south-
ern small-town bum too lazy to do anything but sleep" (115). For Dickey,
the stereotypical bumpkin has shed his aura of harmless ignorance; he
has now become death itself. And death is stalking and haunting the
"new" white South with a vengeance.

Mongrels, Belles, and the Dying of the Light

The correlation of whiteness with death, of course, is not specific to
modern southern narratives. As film scholar Richard Dyer has pointed

out, such an association has characterized much of Western iconography. "Whiteness as an ideal can never be attained," he writes, "not only because white skin can never be hue white, but because ideally white is absence: to be really, absolutely white is to be nothing."[21] Yet, as he also acknowledges, the "nothingness" of southern whiteness is uniquely contradictory, for "even in as wholeheartedly white supremacist a text as *Birth of a Nation* (1915), there is a suspicion that the South is not truly white enough to found the white nation of the film's title. . . . In short, the South seems to be the myth that both most consciously asserts whiteness and most devastatingly undermines it, whereas the West takes the project of whiteness for granted and achieved."[22]

Throughout the postwar era, this double-sided myth was painstakingly exposed in the stage and screen work of Tennessee Williams. Although Williams was largely responsible for a resurgence of popular interest in an exoticized South of finely tuned eccentricities, he nevertheless refused to muffle or ignore the insistent death rattle of white southern masculinity. In *Cat on a Hot Tin Roof* (1955), for example, Big Daddy Pollitt and his son Brick epitomize the decline of white physical privilege: nouveau-riche plantation patriarch Big Daddy is dying of intestinal cancer, while the alcoholic and crippled Brick, grieving over the death of his (ambiguously) close friend, fends off the sexual advances of his wife Maggie. The "lie" of Maggie's pregnancy which looms over the play masks other sexual lies that could only be hinted at in the 1958 film adaptation. As David Savran has observed, what is striking about the white masculine power represented by Big Daddy's estate is "less its conspicuously patrilineal nature than the homosexuality that stands at its imputed origin and so determinedly 'haunts' its development." Not only did Big Daddy inherit the plantation from "a pair of old bachelors," but "he has also inadvertently passed along the possibility of arousing homosexual desire to his younger son."[23]

The complicated treatment of homosexuality in Williams's work owes much to the boundaries of dramatic license and popular taste at the time, and yet the connotations of doom and degeneration which cling to the ambiguous sexuality of his characters from the late 1940s through the early 1960s are countered by a paradoxical sense of the naturalness of their "deviance." Conventional male sexuality often emerges as a culturally and even politically destructive force. Stanley Kowalski in *A Streetcar Named Desire* (published in 1947, filmed in 1951) is the most famous of Williams's "brutes," but more politically powerful white

men combine physical viciousness with blatant racism. Jabe Torrance in *Orpheus Descending* (1957) and its film version, *The Fugitive Kind,* is another dying bully, a man who is responsible for the vigilante-led mob who killed his father-in-law (for "selling liquor to Negroes"). Cuck-olded while he lies on his deathbed, he rouses himself to destroy his tormented wife and her young lover, Val Xavier, an itinerant blues player who has been perceived by men of the town as a sexual threat to their women. Gulf Coast politician Boss Finley in *Sweet Bird of Youth* (1959), a man no doubt responsible for the castration of a black man for "prowl-ing," preaches to crowds of "the threat of desegregation to white wom-en's chastity" and sends his son to castrate yet another man, main char-acter Chance Wayne, for the "blood pollution" of his daughter.[24] When not brutal, however, the sexual obsessiveness of white men can be com-ically pitiable, as it is with *Baby Doll*'s Archie Lee Meighan, a once pros-perous Mississippi farmer whose virgin bride enforces and mocks his impotence from the shadows of his once-fine home. As his black field hands look on in obvious delight, Archie Lee flails in sexual frustration, a "bled out" specimen, in director Elia Kazan's words, of the archaic masculinity of a "washed-out white" world.[25]

Elsewhere on the mainstream screen, well-to-do young white men were demonstrating a similar lack of sexual prowess. In *The Long, Hot Summer,* Delta heir Jody Varner is a disappointment to his vulgar father, Will, who sets out to find a "stud" to sire grandsons with daughter Clara to ease the shame of Jody's childless marriage. When Will cruelly dashes his son's hope of ever filling his "big footprint," Jody collapses in despair and his wife and sister both rush to comfort him. Meanwhile, Clara's well-bred suitor, Alan, is passionless, almost sexless. "There were all sorts of feminine wiles I was gonna try out on you," Clara tells him. "'Course, I don't guess it would have done me any good. Your mama has a long head start on me and I don't think anybody's gonna overtake her." In *Home From the Hill* (1960, scripted by Irving Ravetch and Harriet Frank Jr.), Texas patriarch Rafe Honecutt's only legitimate son, Theron, appears sissified to his father and is the butt of male humor. Showing him how a "man" conducts himself, Rafe immerses Theron in the gun-and-liquor culture of the region and presents the boy with a choice: "You can be a man or a mama's boy."

Unlike the feckless sons of privilege, the working-class man with attitude welcomed the chance to catch the frustrated white woman on the rebound. Often a fugitive from the law, the southern rogue was in

many respects like the much-debated urban delinquent who had stepped into the national spotlight in the 1950s: disdainful of authority, sexually available, quick to take offense. His casual appearance in emotionally overwrought towns and plantations, however, did more than simply disturb the hormonal status quo. As a character consistently figured as *metaphorically* "black," the southern delinquent hurled an implicit insult at notions of racial purity. The sexuality of Stanley Kowalski (Marlon Brando) in *A Streetcar Named Desire,* Ben Quick (Paul Newman) in *The Long, Hot Summer,* Val Xavier (Marlon Brando again) in *The Fugitive Kind,* John Jackson (Tony Curtis) in *The Defiant Ones,* and certainly the early film characters of Elvis Presley (especially those in *King Creole* and *Jailhouse Rock*) was to varying degrees racially inflected, a function of the characters' marginal social legitimacy and poverty. The 1962 film version of *Sweet Bird of Youth* draws a clear parallel between white working-class drifters and victimized black men when Boss Finley's son tells Chance Wayne to leave town "by nightfall," a warning typically delivered to black men. When he was not an outlaw (or a man with "common" impulses, like Kowalski), the character usually retained his visual and thematic darkness. The dark-complected Silva Vacarro in *Baby Doll,* for example, who complemented his ethnic darkness with a black wardrobe, replicated the black field hands' contempt for pale-skinned Archie Lee by openly enticing the chaste, blonde, teasing Baby Doll (fig. 6).

Poor white women, like the frustrated rural mother in *The Defiant Ones* (1958) and Mayella Ewell in *To Kill a Mockingbird* (1962), suffered little loss of status for their "dark" desires—the former character longs for the white-trash (and racially compromised) convict John Jackson, the latter for black man Tom Robinson. To some degree, widowed Serafina Delle Rose in Tennessee Williams's *The Rose Tattoo* (published in 1950, filmed in 1955) was similarly situated. A transplanted Sicilian living on the Gulf Coast, she is doubly sidelined from white respectability by her ethnic darkness and her poverty. Her romance with an equally poor Sicilian only reinforces her status: "The Wops are at it again," a neighbor complains. "Had a truckdriver in the house all night!" In *The Fugitive Kind,* the adulterous Lady Torrance (played by Anna Magnani, who also played Serafina) has been "demoted" before the play opens, jilted in her youth by the wealthy David Cutrere as an improper match.

Often, the white woman's vulgarity was depicted as a function of her racial ambiguity. In *Beyond the Forest* (1949), for example, Bette Davis

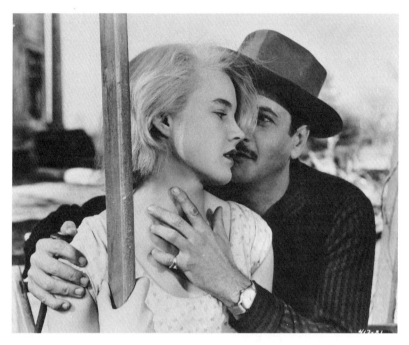

FIGURE 6. Ethnic darkness encroaching upon the "bled-out" whiteness of the Old South: Eli Wallach and Carroll Baker in *Baby Doll* (Warner Brothers, 1956). Wisconsin Center for Film and Theater Research.

is a lustful, amoral housewife and the visual twin of her indolent "Indian" housekeeper. In *Duel in the Sun* (1946), half-Mexican Pearl Chavez (Jennifer Jones) is taken in by a powerful Texas family whose racial expectations are made explicit in the film's casting: Lillian Gish, the Confederate angel of *The Birth of a Nation,* plays the family matriarch; Butterfly McQueen (the buffoonish slave Prissy in *Gone With the Wind*), plays the family servant. The adoptive mother's hope that young Pearl will grow up true to her white "half" are dashed by the adult Pearl's illicit encounters with the black-costumed, crude Lewt McCandles (Gregory Peck). "I guess I'm just trash, like my ma," the ruined "half-breed" cries, "trash, trash, trash!" Ultimately true to her dark heritage, she dresses in black for a showdown in the desert, killing the dusky Lewt before being gunned down by him.

Ruby Gentry (1952), however, took the step of identifying the class-bound darkness of the "marked" woman as a specifically southern trait. In a film narrated by "the new Yankee doctor" in a North Carolina

coastal town ("an outsider," he calls himself), Jennifer Jones once again portrayed a "half-breed," but here her physical darkness was entirely a function of her working-class origins. The doctor introduces Ruby as a "strange, gaunt woman" skippering her own fishing boat, an older woman seeming to suffer "in atonement for all the tragic consequences of her willful acts." In a flashback, we see the young Ruby first as the doctor saw her: a shapely black silhouette against the doorway of her father's North Carolina hunting lodge. Identified with nature and violence from the beginning, "wild" Ruby sets out to seduce and marry the wealthy Boake Tackman (Charlton Heston), only to be rejected for a blond debutante. Although as a child Ruby was sent to live with the wealthy Gentry family, she is shadowed by her social origins. "She's from the wrong side of the tracks," Jim Gentry (Karl Malden) tells the new doctor. "In this day and age?" the Yankee asks. "You're forgetting where you are," Gentry responds. When the widowed Jim proposes marriage to Ruby, he tells her that he and she are similar, that his late wife's social class was far above his. "As far as this town is concerned, we're mongrels," he says.

Throughout the film, Ruby's "mongrelization" is suggested as more than a social condition, however. "I'm ashamed we have the same name," her brother tells her, and, in fact, her black hair and dark skin starkly contrast with her judgmental brother's fairness. It is he who unrelentingly stalks Ruby with biblical curses, promising that her pursuit of Boake Tackman is "invitin' damnation," and that "the wicked shall be judged for the sins of the flesh." "Ruby doesn't belong," Jim Gentry tells the doctor, and in fact she is a pariah to rich and poor whites alike. A social parvenu whose marriage to Jim fails to change her status and a shameless slattern who openly flirts with Boake, Ruby flounders in cultural and racial limbo until she takes her revenge upon the "the foul-mouthed, whiskey-soaked Carolina gentlemen" who have treated her like "trash." Calling in promissory notes after Jim's death, she closes local industries. Flooding Boake's land with salt water, she effectively destroys his dream of restoring his family's old plantation. The land reverts to swampland, the primordial ground that spawned the despised and doomed Ruby (fig. 7). Finally killing her brother after he shoots Boake, she ends her days alone on the sea. In her social isolation, she exemplifies the fate of Donald Bogle's tragic mulatto, a woman whose "life could have been productive and happy had she not been a 'victim of divided racial inheritance.'"[26]

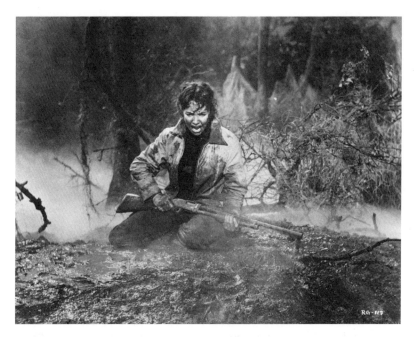

FIGURE 7. The white-trash woman as cultural mulatto: Jennifer Jones in *Ruby Gentry* (Twentieth Century Fox, 1952). Wisconsin Center for Film and Theater Research.

For white women of higher social classes, miscegenation was primarily a metaphorical phenomenon, a fall from class purity. "I pulled you down from those columns," Stanley reminds Stella in *A Streetcar Named Desire,* but some women resisted the temptation to flee the plantation pillars for the world of the "lower orders." Wealthy Clara Varner brings outcast Ben Quick into her world in *The Long, Hot Summer,* embracing the buttoned-up, redeemed drifter from inside her white-columned estate at film's end. Ex-Virginian Leslie Jordan (Elizabeth Taylor) in *Giant* (1956) grows progressively darker skinned as she empathizes with the Mexican workers on her Texas ranch, but she never relinquishes her place in the big house, never descends to an affair with white-trash Jett Rink (James Dean), a man who marks his entrance into oilman wealth by blackening his face with newly discovered crude. Quentin Compson (Joanne Woodward) in *The Sound and the Fury,* a delinquent girl already compromised by the scandal of her birth and her family's declining respectability, nearly leaves town with a traveling carnival worker, only to return to the dilapidated mansion a chastened and mature representative of a rejuvenated family. "I won't go shim-

mying down trees and I won't run away at night and I won't even tell lies because I've decided that's not dignified," she promises her uncle Jason, who tells her that she is the "first Compson in fifty years who's gotten up off her knees."

Southern women who did not follow the examples of Clara, Leslie, and Quentin, however, would be exiled to the margins of social—and psychological—propriety. When upright minister's daughter Alma Winemiller in *Summer and Smoke* (published in 1947, filmed in 1962) finally gives free rein to her sexual impulses, the object of her desire, John Buchanan, spurns her advances. Humiliated and drugged by the "infinitely merciful" pills John gives her, she picks up a traveling sales-man in the park in the last scene. Carol Cutrere, town tart and denizen of lowlife juke joints in *The Fugitive Kind*, so embarrasses her wealthy family that they offer her an indefinite stay in Italy to rid the county of her presence; she acknowledges her degraded status by telling Lady Tor-rance, the already disgraced Sicilian adulteress, "You and I are sisters." In *Suddenly, Last Summer* (1959), Catherine Holly's knowledge of the life and death of her gay cousin Sebastian, as well as her own status as a privileged woman who "came out" sexually at a young age, lead to her near-lobotomization at the request of her aunt.

Williams's most desperately and cruelly exiled female character, how-ever, is a woman whose racial purity is inseparable from moral and social ruin. Blanche DuBois's flight from the ruined Belle Reve in *A Streetcar Named Desire* mirrors her emotional flight from her own ruined state, much as the poverty-stricken, black-and-white world of *Streetcar* in many ways mocks Vivien Leigh's earlier, Technicolored fantasy in *Gone With the Wind*. The beautiful dream of the old estate has vaporized in the suicide of Blanche's homosexual husband, "the Grey boy," and with it the dream of her "lily-white" sensibility. "I like the darkness," she says, and in defiance of her name, strings up colored paper lanterns to ob-scure the return of her grey ghost. She herself is "fading," and will finally disappear in madness after her exposure to the "colored lights" of Stan-ley's violent sexuality.

If Blanche's decline suggests to some degree the demise of the myth of the old, white South, it is a process enacted within the context of a vibrant black culture. Describing the darkening neighborhood of the Kowalskis' appropriately named Elysian Fields address in scene one of *Streetcar*, Williams writes,

You can almost feel the warm breath of the brown river beyond the river warehouses with their faint redolences of bananas and coffee. A corresponding air is evoked by the music of Negro entertainers at a barroom around the corner. In this part of New Orleans you are practically always just around the corner, or a few doors down the street, from a tinny piano being played with the infatuated fluency of brown fingers. This "Blue Piano" expresses the spirit of the life which goes on here.[27]

The first characters seen in the play are two women, "one white and one colored," for, according to Williams, "New Orleans is a cosmopolitan city where there is a relatively warm and easy intermingling of races in the old part of town."[28]

That the final fragmentation of an already *unintegrated* personality would occur in such a setting indicates the degree to which race had become both psychologized and aestheticized in American fiction of the postwar era. Certainly, as Toni Morrison has observed, "A real or fabricated Africanist presence" in the national literature has traditionally been "crucial" to white Americans' sense of their own "Americaness," providing "a way of contemplating chaos and civilization, desire and fear, and a mechanism for testing the problems and blessings of freedom."[29] By the late 1940s, this presence, especially when visualized on the stage or the screen, was becoming less and less a "shadow" of the white self, a signifier of white "freedom" by its very *lack* of freedom, and increasingly a harbinger—a *fore*shadowing, we might say—of white diminishment. For Blanche's fading story unfolds not simply in the face of an encroaching darkness but *because* of it. The "new light" of poetry and music which she sees shining the way along the "dark march toward whatever it is we're approaching" is clearly not the music that plays throughout her drama. The "Blue Piano" played by "brown fingers" is the music of her undoing. If it seems the companion score to violence and sex, it is because, to Blanche, it is. The stereotypical nature of the association is implicitly Blanche's: to the flag bearer of white gentility in an "intermingled" region, the blues are surely a dirge.

Although to Blanche, she and the "ape-like" Stanley stand at opposite poles of cultural evolution, white gentility is hardly a matter of "breeding" here. "A woman's charm is fifty percent illusion," she says, and the feverish energy she devotes to creating her own persona depletes her emotional reserves. Singing of a "Barnum and Bailey world, just as phony as it can be," extolling the virtues of "magic" over "real-

ism," Blanche plays the only role whose lines she knows by heart, having been run out of home and job for playing "herself." But the southern belle act is so antiquated, so clichéd, that even she wearies of it. "I don't know how much longer I can turn the trick," she tells Stella. In truth it is not simply Blanche's age which undermines the role, nor the comical creakiness of her performance, but rather its fundamental deadliness. Life on the Belle Reve estate had been a nightmare of "sickness and dying," a "long parade to the graveyard" which Blanche alone had witnessed. "You didn't dream" death could be so gruesome, she tells Stella, "but I saw! *Saw! Saw!*" "The Grim Reaper," she says, "had put up his tent on our doorstep! . . . Belle Reve was his headquarters!" Despite efforts to the contrary, Blanche ultimately looks like an emissary from the Confederate underworld. In this she resembles Carol Cutrere in *Orpheus Descending,* who distorts her "odd, fugitive beauty," Williams writes, "to the point of fantasy," with "the face and lips powdered white and the eyes outlined and exaggerated with black pencil and the lids tinted blue."[30] Unlike the intentionally scandalous Carol, however, Blanche bedecks herself with a steadfast lack of irony. "Look at yourself," Stanley cruelly comments just before sexually assaulting her. "Take a look at yourself in that worn-out Mardi Gras outfit, rented for fifty cents from some ragpicker! And with the crazy crown on! What queen do you think you are?"

If Blanche DuBois's fate to some extent predicates the moral ruin of white purity, it also underscores the artificiality of whiteness itself. The frenetic construction of a racial "self" here is inherently an insane project, surely more insane even than the fabrication of an archaically gendered persona (the "belle"). In Williams's earlier work, *The Glass Menagerie,* Amanda Wingfield invests her energies in the creation of a similar persona with disastrous results, but Williams had not situated her effort within an overtly racialized context. In *Streetcar,* the mask of white gentility is stitched together from a trunkful of worn mementos and cheap baubles, pitiful remnants of social defeat which Stanley mistakenly identifies as invaluable plunder. The fervor with which he demystifies Blanche's "cover" and catalogs her "lies and conceits and tricks" is undoubtedly fueled by his escalating class rage. The "healthy Polack," as Blanche calls him, may protest that he is "one hundred percent American," but it is her implied entitlement—to land, education, and Stanley's own apartment—that reveals the class dynamics of "the greatest country on earth." Finding that this entitlement is supported by noth-

ing other than tradition, that the inherited estate is only a "bunch of old papers" and that the columns he pulled Stella from were already beginning to crumble, the cheated son of immigrants asserts power in the only way he knows. On the night of his son's birth, he assaults the emblem of his dispossession.

Stanley's rape of Blanche is the culmination of the play's painful unmasking of its heroine, the final violence perpetrated on an exhausted and humiliated body. But the progressive stripping away of inheritance, shelter, sanity—even, at the end, the small paper lantern that had veiled the "merciless glare" of unflattering lights—is, as Blanche herself realizes, in many ways the result of historical forces beyond her control, forces that she sees personified in a man who is as "common as dirt." What is left after the revolution is a nakedly exposed death's head, the mad ghost of Tara past (fig. 8). Leaving behind only "spilt talcum and old empty perfume bottles," Blanche exits the drama on the arm of her final gentleman caller, a psychiatrist, and deeds over to Stanley and Stella a world in which "the cries and noises of the jungle" are drowning out the soft melodies of plantation propriety.[31]

Appearing at the beginning of the modern civil rights era, *A Streetcar Named Desire* repositioned the South as a national theater space, an arena within which the social fictions undergirding the impending battle would be dramatized and exposed. One of those fictions was the inviolability of race, but the greatest of them was simply race itself. A significant number of films soon suggested that whiteness, like Blanche DuBois's charm, might be over 50 percent illusion.

Passing Performances

The notion of racial "passing" had long been of interest to Hollywood, but although films like *Pinky* and *Lost Boundaries,* both released in 1949, had explored the social implications of the phenomenon, films of the next decade, like *Show Boat* (originally produced on Broadway in 1927 and adapted to the screen in 1929, 1936, and 1951), *Island in the Sun* (1957), *Kings Go Forth* (1958), and *Imitation of Life* (originally produced in 1934 and remade in 1959), would employ racial passing as a melodramatic convention, a characteristic of the romantically "marked" life. What all of the films shared, however, was a thematic commitment to the emotional folly of racial masquerade. Even in *Lost Boundaries,* a film that ultimately attests to the tolerance of a white community that learns the "real" color of its doctor's family after twenty years, the son

FIGURE 8. The crumbling mask of white southern womanhood: Vivien Leigh as Blanche DuBois in *A Streetcar Named Desire* (Warner Brothers, 1951). Wisconsin Center for Film and Theater Research.

enacts the tragic mulatto's response after hearing the news. Fleeing his New Hampshire town for Harlem's nightlife, he is rescued from jail and further decline by an understanding black police officer.

Passing as white dooms other black characters in the genre to heartbreak and social exile, yet, oddly, it is not the passing itself which is depicted as demoralizing. It is the *unmasking* or "revelation" of one's "true" race that beckons a host of humiliations. In *Pinky*, the title character's white, northern fiancé does not end their engagement but proposes that the couple escape to Colorado, where "there'd be no Pinky Johnson" after the marriage. In *Show Boat*, the white husband of riverboat star Julie LaVerne stands beside her when she is run out of the troupe by Mississippi officials, but the story later finds her alone, alcoholic, and sexually dissolute in Chicago after her abandonment by "that man of mine." Similarly, Sarah Jane in the 1959 version of *Imitation of Life* collapses in shame and grief in a dark alley after her white boyfriend discovers her racial secret and promptly jilts her.

Kings Go Forth reconceived the discovery scene as a revelation of *white* deception: seemingly ardent fiancé Britt Harris (Tony Curtis) has only courted half-black Monique Blair (Natalie Wood) as a form of sexual experimentation—a "new kick," he tells the heartbroken Monique. Learning that her white suitor has merely feigned his passion for her, she throws herself in the ocean. She survives and, having learned her lesson, decides, like Pinky, to devote herself to the education of others. Here, it is French war orphans who are sheltered at her school, their disinheritance a mirror of her own. In yet another refiguration of racial discovery, the tragic mulatto of *Island in the Sun* turns out to be neither tragic nor mulatto. When Caribbean plantation heiress Jocelyn Fleury (Joan Collins) learns that her father is "one-sixteenth Negro," she decides to end her engagement to a man bound for the House of Lords. Offering him "romance" in place of a marriage that can never be, the despairing Jocelyn becomes pregnant, only to discover an even deeper secret: she is illegitimate. "There isn't a drop of African blood in your veins," her mother tells her. Nevertheless, the young woman who, in the words of her mother, has been "behaving like a peasant girl in the canefields," refuses to reveal her new racial identity to her fiancé. The devoted Lord Templeton marries Jocelyn, unaware of her "true" whiteness, and they promptly depart the island at film's end for a life of privilege in England—a conclusion that did little to dispel the notion that "real" whiteness ensured romantic success.

Like *A Streetcar Named Desire,* the racial passing genre built narrative tension around the disclosure of a woman's "dark" secret. Indeed, Blanche's story varies little from that of Pinky (who also returns to a southern home to confront the truth of her past), or those of Julie, Sarah Jane, or Monique (all of whom lose suitors when that truth is exposed). Ironically, though, Blanche's attempt to "pass" is undermined by the blatant transparency of her masquerade. The white poses of the other women are entirely successful, ruined only by the unearthing of background information. Blanche's persona, unlike theirs, is clearly a mask, and a badly applied one, an observation that begs a question central to the representation of race in such films: If passing is the white lie that dishonors a "true" black self, what color is the "self" of whites who also, in essence, pass?

Just such a question persistently plagued officials of the Mississippi State Sovereignty Commission, the public agency charged with resist-

ing federal "encroachment" upon southern states' rights. In 1963, the commission spent months investigating the racial status of two apparently white brothers who had been denied admittance to the white public school in Jasper County for their alleged "Negro blood." While the community claimed that the boys were one-eighth black and hence, under Mississippi law, considered "Negroes," the Sovereignty Commission, after compiling a detailed family tree stretching back to the 1850s, held that the boys were "between $\frac{1}{16}$ and $\frac{1}{32}$" black—legally white, in other words. The boys were effectively barred from public education, however, for if they "enrolled in a Negro school," the commission report noted, "Jasper County would have an integrated public school—the first integration of a public school in Mississippi history."[32] "When we close our files without progress we are afraid the news media will begin to publicize this case as two white boys who cannot go to school in Mississippi," Commission Director Erle Johnston Jr. wrote in a memorandum to the governor. "The School Board in Jasper County will not permit them to go to a white school. . . . They cannot and will not attend the Negro schools because they are white and because this will violate Mississippi law. They are eight and nine years old respectively and have never attended school one day."[33] In 1965, another investigation was launched at the request of two white parents who were concerned that their daughter might marry a "part Negro" boy. After examining the boy's brother for "any discoloration of the nails, which usually is present in Negroes or mixed breeds," the commission investigator could only conclude that the boy in question might be part Indian, but "wherever the darkness came from must have occurred a long time ago" since he and his family "had been accepted as white people" for many years.[34]

The power of the old segregationist adage that "a single drop" of black blood made one legally black extended beyond the rhetoric of southern politics; it was also the ghost in the machine for much postwar fiction. The national preoccupation with racial identity bled into stories of frontier romance and adventure (in which the Indian "halfbreed" took center stage) and contemporary exposés of anti-Semitism like *Gentleman's Agreement* (adapted to the screen in 1947), in which a Gentile journalist "passes" as Jewish in order to document prejudice firsthand. In 1960, white writer John Howard Griffin published the saga of his own passing as a black man in the Deep South in *Black Like Me*

(the movie adaptation was released in 1964). One novel, however, Ross Lockridge Jr.'s *Raintree County* (1948), openly questioned the concept of racial integrity by depicting it as a product of cultural hysteria.

The film version of *Raintree County* was released in 1957 to great media fanfare. A "Yankee version of the Civil War," MGM called it, and capitalized on its *Gone With the Wind* echoes by staging the premiere in Louisville. At the center of story was Louisiana belle Susanna Drake (Elizabeth Taylor), a Scarlett O'Hara–styled flirt who sets out to trap Indiana abolitionist John Shawnessy (Montgomery Clift) in marriage by feigning pregnancy. On their honeymoon in New Orleans, Susanna's mental instability becomes apparent, as she surrounds her bed with dolls and hints to John that "having Negro blood" can be a tragedy. "Just one little, teeny drop and a person's all Negro," she says. "Can't always tell, either." As it turns out, however, Susanna's "Negro blood" is entirely imaginary, a fantasy manufactured from her childhood wish for a black mother. "As long as I've known that child," a former family slave tells John, "there's been a war going on inside her." Like the Civil War it mirrors, Susanna's inner struggle for racial identity ends in calamity: she goes mad and finally commits suicide. If, as Donald Bogle has observed, the film strongly implied that "just the thought of black blood" could be psychologically devastating,[35] it also carried the implication to its logical conclusion that black blood, like white blood, might indeed be just a "thought."

Ralph Ellison pointed out in his 1949 review of *Pinky* that the lead character's belief that marrying a white man will "violate the race" obscures "the fact that her racial integrity, whatever that is, was violated before she was born." Regardless of this contradiction, "following the will of the white aristocrat who, before dying, advises her to 'be true to yourself,'" Pinky "opens a school for darker Negroes."[36] Like *Pinky* and other race-conscious films of the era, *Raintree County* depicted whiteness as a studied and disingenuous performance, but it went further in its critique by calling into question the notion of an underlying, racialized "self" which enacts the performance in the first place. Although American films consistently employed white actors to impersonate African (or Mexican or Asian) characters, the spectacle of a white actress (Elizabeth Taylor) pretending to be a white woman who believes herself to be black came perilously close to parodying the convention. One reviewer, in fact, called Taylor's performance "the greatest caricature of the season."[37]

Earlier in the decade, Ava Gardner had taken part in a similar masquerade when she recorded the album soundtrack for the 1951 remake of *Show Boat*. As the passing Julie LaVerne, Gardner had lip-synched the film's famous love songs, "Can't Help Lovin' That Man of Mine" and "Bill," for the screen. For a test record of the album, however, she used her own voice, imitating Lena Horne's phrasing. Yet MGM did not want to use Gardner for the album; "they took my record imitating Lena and put earphones on her so she could sing the songs copying me copying her." When the studio discovered it could not release the album displaying Gardner's name and image without including her actual voice on the soundtrack, MGM had Gardner use "earphones to try to record my voice over [Horne's] voice, which had been recorded over my voice imitating her."[38] However absurd the vocal "layering" of the album might have seemed, it only amplified the racial superscription of the film's previous version, in which professional singer Julie—a black character once again played by a white actress—after having taught white singer Magnolia how to sing like a "Negro," finds her career eclipsed by an impersonator. (The 1936 version had emphasized Magnolia's racial "indebtedness" in an early scene of her performing in blackface, a scene that would have been unthinkable in the 1951 version.) In an ironic flourish to an already impossibly ironic production history, Ava Gardner revealed in her autobiography that producer Dore Schary had wanted Dinah Shore—"of all people," Gardner wrote—to play the role of Julie in the 1951 version of *Show Boat*. Perhaps Schary's desire to cast the Jewish Nashville native had been rooted in a misbegotten sense of realism: Shore, after all, had been rumored for years to be a "secret Negro."

Despite the sincere social commentary of productions like *Raintree County* and *Show Boat*, their multilayered representation of race made evident what had been implicit all along in the passing genre: namely, the extent to which cinematic race was fundamentally a self-reflexive phenomenon, a register of performance style. If, as Blanche DuBois had shown, southern whiteness was a barely sustainable "act," its public disintegration could eventually expose the frayed seams and dulled ornaments of the "immaculate mythology" at its core. Like a demastered soundtrack of *Show Boat*, the chorus of borrowed and imitated voices might pour forth, transforming the white performer at center stage into a ghoulish ventriloquist, a fading mouthpiece for an "indecent society." With the "integrity" of the race itself at risk in Holly-

wood's escalating dissection of the southern white woman, Twentieth Century Fox produced a film that not only resuscitated but *replumbed* the ailing figure, sending back out onto the screen a newly sanitized patient, gutted of her festering secrets.

Reconstructing White Womanhood: The Three Faces of Eve

The Three Faces of Eve was released in 1957 to nearly unanimous critical and popular acclaim. Based on the 1957 book of the same name by psychiatrists Corbett Thigpen and Hervey Cleckley (which in turn was based on their 1954 article in the *Journal of Abnormal and Social Psychology* entitled "A Case of Multiple Personality"), the movie tells the story of the medical treatment of one "Eve White," a working-class Georgia housewife who, according to the narrator, "had one personality more than Mr. Jekyll," a personality named—what else—Eve Black. Praised for her "tour de force" performance, Joanne Woodward went on to win an Oscar for her portrayal of the tortured Eve.

Premiering in much-ballyhooed galas in Augusta, Georgia, in September 1957, with a newly minted Georgia-born star in the title role, the "true" story of a southern woman ravaged by her "black" and "white" selves was portentously timed. That month, Arkansas Governor Orval Faubus, reaping political capital from the growing regional outcry against the *Brown* decision, refused to support the integration of Little Rock's Central High School, a move that forced President Eisenhower to send in federal troops to protect the nine black children who had enrolled in the school. (Coincidentally, Joanne Woodward later played the role of teacher Elizabeth Huckaby in the 1981 television drama *Crisis at Central High*.) Although a number of southern school districts had voluntarily desegregated their schools following the Supreme Court's 1955 implementation decree and had even repelled segregationist attempts to rescind integration orders, Little Rock marked a dramatic turn in southern politics: the rise of massive resistance to integration. One year earlier, 101 southern senators and congressmen had issued the "Southern Manifesto," in which they pledged to fight the *Brown* decision by "any lawful means." In this emerging resistance movement, "states' rights" became the mantra of politicians, Citizens' Council leaders, and everyday segregationists.

Documented extensively by network news, the Little Rock crisis quickly developed into an international story. CBS reporter Robert Schakne asked white students to restage their protest chant ("Two—

four—six—eight—we don't wanna integrate") for his cameras, a move he regretted after Governor Faubus publicized the tactics of New York journalists. National audiences also saw mobs of white men and women jeer, push, and kick black students and black reporters. Meanwhile, the governor, depicted in news magazines like *Time* as a backwoods yokel straight from the *Li'l Abner* comic strip, sat in his mansion, a "victim" of northern incursion into a sovereign southern state. The "Second Reconstruction" had begun, and the new carpetbaggers—federal lawyers, officials of the NAACP, and the news media—were marauding across the region, appearing to segregationists to defame an entire way of life.

To segregationists, the federal interest in public schools held a deeper, more deliberate motive. Where better to begin the indoctrination of a nation into the "creed" of race-mixing? Integration of schools could lead to only one thing: intermarriage. Clearly a communist plot to weaken the country, miscegenation would spawn a "race of mongrels," they warned. In tract after tract, speech after speech, bitter-end segregationists preached the horrors of "mongrelization" and urged resistance to the federally ordered outrage. The ravaging of southern womanhood appeared imminent. Soon, the South would be shrouded in black—"Black," Judge Tom Brady wrote, "denoting darkness and terror. Black signifying the absence of light and wisdom. Black embodying grief, destruction and death."[39]

According to segregationists, integrationist propaganda was not the province of federal employees alone. The rest of the nation was also conspiring to push the message of racial mingling. The Mississippi State Sovereignty Commission, for example, claimed in its newsletters throughout the 1950s and 1960s that a "Paper Curtain" existed in America (fig. 9).[40] Like the Iron Curtain in Eastern Europe, the Paper Curtain was the creation of communist-inspired ideologues, an impenetrable wall of media lies extending along the north side of the Mason-Dixon Line. Hollywood, not surprisingly, was a member of the Paper Curtain conspiracy, filling its movies with subversive images of southern white degeneracy, black superiority, and even miscegenation.

For its part, Hollywood had long capitulated to southern white tastes, "segregating" African American performers in scenes that could easily be excised by southern censors (Lloyd Binford of Memphis being the most powerful of those censors, controlling the content of films shown within the city from 1928 to 1956). A number of films were still

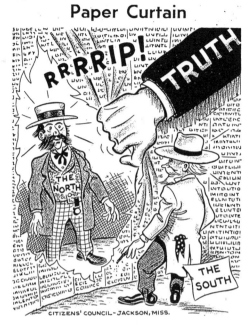

FIGURE 9. Segregationists' response to national "misrepresentations" of the South. The Citizens' Councils of America Newsletter (Jackson, Mississippi), July 1956. From the McCain Library and Archives, University of Southern Mississippi.

banned or severely re-edited in portions of the South in the 1950s, but, in general, the Production Code Administration fretted over the representation of black Americans and did remarkably little to rock conservative white southern attitudes. Repeatedly offered visions of a charmingly eccentric South, many white Americans no doubt wondered if racial relations could really be as tense as the escalating news reports suggested. Perhaps, as white southerners often claimed, race was a "complex" issue, best understood by those who had "grown up with" and "taken care of" black Americans.

By September 1957, though, the dissonance between nonfiction and fiction was clear to even a casual viewer of American media. How could producers of a Hollywood film like *The Three Faces of Eve* purport to paint a documentarylike portrait of a contemporary southerner without at least recognizing the social and psychological crisis of the region? In light of the film's historical context, the story of the battle between "Eve White" and "Eve Black" for the "mastery" (in the narrator's words)

of one woman's "character" seems an almost blatant indicator of the era's racial hysteria. The displacement of race onto the realm of gender, however, suggests that Hollywood practices and southern politics may have been closer in spirit than defenders of either would consciously acknowledge.

The "clean documentary clarity" of Nunnally Johnson's screenwriting and direction, so hailed by critics like Bosley Crowther,[41] marked the film's obsession with its own truthfulness. Johnson claimed, in fact, that his main difficulty in writing the script had been "trying to get some form that would convince somebody that this wasn't simply fiction."[42] The form that emerged was strikingly solemn. Black and white photography and ominous music announced the film's "serious" intent in the opening credit sequence, and the introduction and voice-over narration by "noted journalist and commentator" Alistair Cooke pushed the conventions of 1950s realism into the service of nonfiction documentation. Citing names, dates, and places, Cooke informs the viewer that the story to unfold is "true" and "needed no help from the imagination of a fiction writer." Through this framing narrative, Cooke establishes himself as the psychiatrists' surrogate voice, a voice that introduces each sequence in Eve's story and subsequently relinquishes narrative control to Lee J. Cobb's "Dr. Luther" (the character based on Dr. Thigpen).

Impossibly distanced from the original material, then, the character of Eve enacts her traumas before the "tripled" scrutiny and mediation of male professionals: physicians, journalist, actor. Not until 1977 did the "real" Eve, Chris Costner Sizemore, tell her own story, and it bore little resemblance to the film. Sizemore, for example, provides details of the twenty-two personalities she had manifested, a far cry from the three faces so neatly delineated in the film. But the patina of "public service" (as noted by the film reviewer of the *Saturday Review*)[43] clung to *The Three Faces of Eve,* polished not only by studio publicists but also by many in the medical profession: Twentieth Century Fox presented plaques to Drs. Thigpen and Cleckley "in recognition and appreciation of your service to the movie industry and the whole world," and the president of the Georgia Medical Association declared upon the film's release, "This movie is a milestone in the progress of medicine."[44]

Oddly, a similar film released by MGM that year attracted little critical attention and disappointing box office returns. Like *The Three Faces*

of Eve, the MGM film *Lizzie* told the story of a contemporary, light-haired white woman (played by Eleanor Parker) tormented by a "dark" second self. Both films were shot in black and white, both located psychological dysfunction in childhood trauma, and both focused on successful psychiatric intervention. *Lizzie's* failure to strike responsive chords among filmgoers, however, makes *Eve's* success all the more intriguing. Set in an anonymous, generically "American" town, *Lizzie* seems suspended in geographic limbo, much like a television show of the era (its flat lighting, in fact, lends it a "teledrama" look, in contrast to *Eve's* more conventionally cinematic high-contrast lighting). Although other differences exist between the films, the painstakingly detailed realism of Nunnally Johnson's film cannot be overlooked as a factor in its popularity. Ostensibly serving as documentation of the story's accuracy, such specificity grounded the film in a highly charged field of sociopolitical connotation and provided a powerful cultural subtext for the narrative.

As directed by Nunnally Johnson and played by Joanne Woodward, Eve White is (according to one of her doctors) a "dreary little woman from across the river," a put-upon, dutiful wife to her television repairman husband, whose ungrammatical commands and threats to "slap" or "kill" her meet with her own ungrammatical acquiescence (fig. 10). Eve White is, simply, a hick. Described by Corbett Thigpen in his professional manuscripts as "a colorless woman," Eve White is a member of a social class that is all but eradicated by the end of the book *and* the film. An embarrassment to 1950s progress, she seems mired in an agricultural past, a farm girl obedient to a working-class man who cannot begin to comprehend the words of her doctor ("Nothin' wrong with you but this multiplied thing," Ralph White says to Eve). After being confronted by the emergence of a new personality, Ralph asks his uncomprehending wife, "What kind of dope do you think I am?" His question is answered before long by his wife's "shadow self," Eve Black: "a jughead," "a creep," "a jerk," "a peapicker."

The transformation of "dreary" Eve White into "playgirl" Eve Black in Dr. Luther's office is signaled by well-worn cinematic conventions: jazzy clarinet music complemented by a bluesy guitar, cigarettes, unpinned hair, bare legs on display. Situated within the heavily shadowed office of Dr. Luther, however, these conventions signal the movie's adoption of a film noir mode, a visual style rarely, if ever, seen in "southern" narratives. Veering abruptly from the realist codes of its opening,

the film's *mise-en-scène*—like Eve herself—is transformed within the confines of the psychiatrist's office. Like a repressed urge, the new style emerges as a complement to Eve Black's desires, her aspirations to membership in a forbidden, "noir" world. From the moment Eve begins her psychological excavation, low-key lighting, along with noir's signature Venetian-blind shadows, dominates the *mise-en-scène*, usually to the accompaniment of a languid clarinet. The style may seem appropriate in Eve Black's scenes (her carousing in bars and motels, her attempted seductions in the sanitarium), but when Eve White's respectable lodgings appear as draped in shadows as a haunted house, the subtextual implications of the woman's crisis become harder to ignore. For Eve is hardly the only troubled soul in the film; her environment itself is shadowed by an unnameable fear.

Augusta, Georgia, may have seemed an unlikely setting for noir malaise, but the expressionist tropes so favored by German-influenced stylists had become charged vehicles for conveying myriad postwar anxieties, not the least of which was race. Dark alleys, basement nightclubs, dim hotel rooms (most of film noir's conventional locations) evolved within a fundamentally racialized milieu—namely, urban jazz. Although Hollywood had for decades appropriated black music as a marker of white illicitness, by the 1940s it found a complementary iconography in an underlit fantasy world of downtown dives. (In a film like Fritz Lang's *The Blue Gardenia* [1953], the connection is made obvious as Nat King Cole performs for unscrupulous white customers in the club of the same name.) In *The Three Faces of Eve*, however, jazz and blues compete with romanticism for "mastery" of the soundtrack. And just as noir lighting techniques encroach upon the initially established realist look of the film, so do Eve Black's clarinet and guitar continually upstage Eve White's mournful violins.

Eve Black's materialization within the heavily coded *mise-en-scène* and soundtrack of film noir places her squarely in the tradition of cinematic bad women. Yet it is in her "black" incarnation that Eve is most visibly white. As drab Eve White, she hides her hair beneath an unobtrusive hat. Later, as Jane, the "third face" of Eve, she pulls her hair into a stylish French twist, her propriety further enhanced by tasteful pearl earrings. Eve Black's hair, however, hangs loose. Bleached a gleaming blond, Joanne Woodward's naturally brown hair catches light as does nothing else in the frame and graphically emphasizes the inappropriateness of Eve's "black" persona. Although the image may appear to

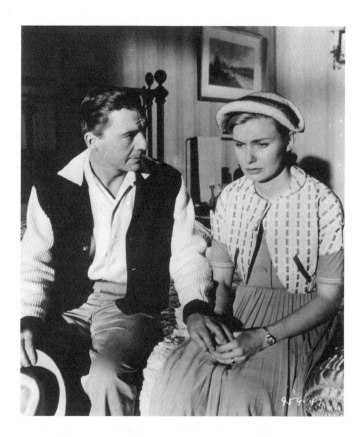

undermine the traditional white-pure, black-impure gender dichotomy, it ultimately reinforces it, for Eve Black's impersonation of a fallen woman is doomed from the start. The "badness" of the shining white woman is a facade, an incorrect personality that will be corrected by a recovered memory of *who she really is.* Her exaggerated whiteness, then, serves two rhetorical purposes. On the one hand, it displays the "scandal" of the sexualized white woman, a metaphorically blackened image which hints at miscegenation (fig. 11). On the other hand, it redeems whiteness by suggesting that gross sexuality is merely imitative, not essential.[45]

The biblical and archetypal overtones of Corbett Thigpen's names for his patient are, of course, obvious ("Eve Black," in reality, was "Chris Costner," Chris Sizemore's maiden name). But the film dialogue of Eve Black articulates a distinctly nonbiblical awareness of gender politics. "The thing is," she says, analyzing Eve White's relationship with Ralph,

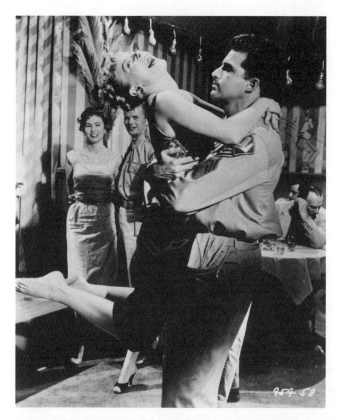

FIGURES 10 AND 11. Segregated personae: Joanne Woodward as fading rural housewife Eve White and noir siren Eve Black in *The Three Faces of Eve* (Twentieth Century Fox, 1957). Wisconsin Center for Film and Theater Research.

"she don't even really care anything *about* him. She just tells herself she does 'cause she thinks she ought to." Intervening in the unhappy marriage of the Whites, Eve Black tells the downtrodden housewife, "Leave the so-and-so. Take the kid . . . and beat it. What can *he* do about it?" She even threatens to "fix Ralph's wagon." How? "I'm gonna come out and *stay* out." After all, Eve White is in no position to fight back; according to Eve Black, "She's gettin' weaker and I'm gettin' stronger."

Eve Black's escalating threats to "stay out" indicate that rather than being a study of psychic "integration" (as several critics have claimed), the film is in fact a study of *dis*integration. The Black and White Eves do not "cohabit" peaceably or even coexist with mutual independence. In Thigpen and Cleckley's 1954 article on their patient, Thigpen noted,

"Perhaps we must assume in the multiple personalities at least a primordial functional unity." If such a unity once existed, though, it was most likely "in the stage of mere potentialities" and hence a purely theoretical construct. In the face of such a scenario, Thigpen asked, "what chance is there that an adequate integration might occur?"[46] Three years later in their book, the psychiatrists stated the case more graphically: If Eve Black were indeed "a hidden, unconscious, or subconscious side of the whole person," how could a "compromise" be struck? "Would appeasement lessen the rebellious drive or would it serve chiefly to incite it? Would Eve Black, encouraged and emboldened, merrily cry havoc and loose at once the dogs of total and relentless war?"[47]

In the film, the dogs are loosed, but the war between Eve's White and Black "selves" is essentially a rout; Eve White simply gives up in the face of Eve Black's unyielding aggression. Lacking the energy, intelligence, and will to fight, the "dreary little woman" suffers the taunts and pranks of her "black" self, finally declaring she is ready to die. Yet, curiously, her only sense of what's "wrong" with her comes about through medical intervention. It is Dr. Luther who tells her about her other self; it is he who makes her aware of her nightly masquerade in seedy bars as "Miss Black." This aspect of the film is consistent with Thigpen's account. "Though Mrs. White has learned that there is a Miss Black during the course of therapy," he wrote, "she does not have access to the latter's awareness. When Eve Black is 'out,' Eve White remains functionally in abeyance, quite oblivious of what the coinhabitant of her body does, and apparently unconscious." Eve Black, however, "preserves awareness while absent. Invisibly alert at some unmapped post of observation, she is able to follow the actions and the thoughts of her spiritually antithetical twin." So acute is Eve Black's knowledge of her "twin" that "when it suits her, she deliberately and skillfully acts so as to pass herself off as Eve White, imitating her habitual tone of voice, her gestures, and attitudes."[48]

The ability of the Black twin to "pass" as the White one pitches the film precariously close to the edge of Hollywood's gender and racial representational boundaries. In one scene, Eve Black attempts to seduce the hopelessly confused Ralph White. To the familiar clarinet whine on the soundtrack (which has by now become established as her "theme"), she drinks straight bourbon and prances about a motel room in a revealing dress. "Honey, there's a lot of things you ain't seen me do. That don't mean I don't do 'em," she tells him. Wanting assurance that the

temptress is "really" his wife, Ralph lunges at her. Were it not for the screen conventions of 1957, perhaps the scene would have ended with Ralph's "infidelity" to his wife—and more evidence of Eve Black's promiscuity. As it is, Eve Black remains a tease, jumping from the bed and scampering across the room.

Although Chris Costner (the "real" Eve Black) was in fact a tease, too, she nevertheless engaged in sex with Chris Sizemore's husband, Don, and had even, at some point before her "twin" married, lived with a violently abusive man (who, according to Sizemore's autobiography, was already married). The film erases this episode, but the script makes no secret of the Black twin's association with illegitimacy. Eve Black's open hostility to marriage and childbearing, as well as her preference for play over work, marks her, in Thigpen's and Cleckley's words, as "a travesty of woman," who would, "if unrestrained, forever carry disaster lightly in each hand."[49]

Two-thirds of the way into the film, then, we reach an untenable impasse. Dr. Luther's "search for one stable and complete woman," Alistair Cooke tells us, is stalled. Clearly, the rebellion of Eve Black is nearing victory; she is the center of the narrative, the illicit and "appealing" visual focus. Just as clearly, though, the rebellion of the shadow self is doomed. The cultural connotations of the dark twin, the merging of racial and gender oppression into one persona, virtually assure her timely demise. The dogs of war loosed by Eve Black may be raging offscreen, but onscreen they are humanely euthanized. Appealing to universal law to solve the narrative tangle, Alistair Cooke asks rhetorically, "What, in short, had nature in the first place intended this woman to be?"

The answer emerges in Dr. Luther's office: the "third face" of Eve. As the first two Eves were battling to the death, it seems, a new woman was forming in the recesses of their psyches—a tactful, poised woman whose memory bank is a complete tabula rasa. Who is she? "I don't know," she tells the doctors. What is her name? "I'm afraid I don't know that either," she replies, and promptly names herself Jane. Compared to this new woman, Eve White appears (in the words of Thigpen and Cleckley) "colorless and limited";[50] compared to Eve Black she is mature and sexually discreet. But Jane has another advantage over her fading sisters: she is decidedly middle-class. Miraculously "cured" of her boondocks accent and its attendant bad grammar, Jane now speaks the same "language" as Dr. Luther. "I hope she'll be the one to live," Eve

Black tells the doctor, realizing her end is near. It is Jane, Eve White agrees, who can be a proper mother for her child.

The class connotations of Jane's mid-American accent were surely not lost on the film's cast. Like many actresses before her (Ava Gardner being the most outspoken on this issue), Joanne Woodward had spent years getting rid of her southern accent only to imitate it later on screen. The recapitulation of her own career in the story of Eve did not escape her. "It was the easiest role I ever did," she told an interviewer in 1959. "Like me, Eve had the most unintegrated personality in the world."[51] Calling forth a lower-class version of her former voice, Woodward once again watched its erasure at the hands of professionals (in this case, the fictional Dr. Luther) and its replacement by an upscale "norm." A native of Columbus, Georgia, director and screenwriter Nunnally Johnson initially refused Woodward's offer to use a southern accent: "I had heard some of the phoney Southern accents in *Baby Doll* and I didn't want any part of that kind of acting." Woodward's "pot-likker talk," however, convinced him that she could do "the real thing." It was, he noted in a 1957 letter, "a great asset both to the character and to the picture."[52]

Although Johnson consulted constantly with Drs. Thigpen and Cleckley during the scripting and directing of the film and wanted his pivotal office scenes to be "exactly like [he'd] seen in the films that the doctors made," he apparently did not consider authenticity of accent "a great asset" to the doctors' character portrayals.[53] Corbett Thigpen's decidedly upper-class, low-country accent (which can be heard in his audiotaped readings from *The Three Faces of Eve*) was remarkably like that of Johnson (who himself can be heard in trailers for the film). Yet Lee J. Cobb played Dr. Luther as nonsouthern and Edwin Jerome did the same for Dr. Day (the psychiatrist based on Herman Cleckley), leaving Ralph White, Eve White, and Eve Black as the only indicated southern characters in a film set in Augusta, Georgia.

Not surprisingly, none of these characters survives the narrative. Eve White divorces Ralph halfway through the film, and both Eves "die" in Dr. Luther's office after Jane's emergence. Ironically, however, the original incarnation of this new character, who meets Dr. Luther's approval as a "complete" woman, was actually Chris Sizemore's imitation of her college-educated cousin Elen. "During Elen's visits to her cousin," Sizemore wrote in 1977, "when she had rambled on about her college life and the opening vistas of her own mind, she had been fill-

ing unborn Jane's storehouse of memories." Elen was the first to real-
ize that Jane "was faintly similar to roles Chris had played in their pre-
tend games as teen-agers, such as the famous actress, or the most beau-
tiful woman in the world. Suddenly, the hair tweaked on Elen's scalp.
It was like looking in a psychic mirror. It was her *own self* she was feel-
ing, was hearing. That was her own voice, her own speech, her exact
phrases, terminology!" Jane, "the dignified southern lady," the "com-
plete" woman, was, in fact, a complete construction.[54]

The psychic mirroring that forms the story of Eve, complicated as
it is, extends beyond the discourses of medicine and the recuperative
autobiography into the complementary practices of Hollywood repre-
sentation. Drs. Thigpen and Cleckley ended their 1954 analysis of Eve
by charging that "some, no doubt, will conclude that we have been
thoroughly hoodwinked by a skillful actress. . . . taken in by what is no
more than superficial hysterical tomfoolery." "It seems possible," they
continued, "that such an actress after assiduous study and long train-
ing might indeed master three such roles and play them in a way that
would defy detection." However, they warned, "in plays the actors are
given their lines, and their roles are limited to representations of vari-
ous characters only in circumscribed and familiar episodes of the por-
trayed person's life."[55] When we remember that Joanne Woodward's
much-lauded Method acting throughout the 1950s was aided by her
own psychoanalysis, the notion of "true" and "false" selves exposed by
careful probing—whether in therapy or in acting—evaporates. "I'm a
sponge and can be anything anybody wants me to be," Woodward said
at the time.[56]

The erasure and reconstruction of personality central to Hollywood
starmaking are often mirrored onscreen in stories of makeovers, blos-
somings, and transformations. In *The Three Faces of Eve,* however, the
torturous birth of a "complete" woman was also the birth of a star.
"A year ago all but unknown,"[57] *Life* wrote in 1958, Joanne Woodward
metamorphosed onscreen into a major celebrity, as *Time* put it, "easily
the twinklingest star that Hollywood has constellated this year."[58] As
struggling actress became established star, so too did the real Eve, a trou-
bled assortment of fragile personalities, become a "stable" feminine role
model. "Jane," the college girl constructed from Chris Sizemore's dim
perceptions of the ideal 1950s "coed," became "Jane," the key-lit New
Woman of 1950s progress. The coaxing (and coaching) of a middle-class

persona from the morass of white-trash alternatives occurred both on-screen and off, as Woodward rediscovered and discarded her "innate southern charm."[59]

Although many early psychic traumas had accounted for the fracturing of Sizemore's personality, in the film we see just one, and its recollection by Jane not only "kills" the Black and White Eves but also jump-starts Jane's memory. Tellingly, that event (young Eve being forced to kiss the face of her dead grandmother) is itself a marker of class. They "didn't mean any wrong by it," Jane tells Dr. Luther, explaining the backward superstitions of her family. "It's just the way people thought in those days." With this farewell to rural folkways, Jane experiences a rush of memories—*school* memories. Her education erupts, as lines from Shakespeare and teachers' names spill from her mouth and she tearfully exclaims, "I can remember! I can remember!" Possessing the education that Eve White and Eve Black lacked, miraculously "cured" of her southern accent, Jane can finally be launched into contemporary American life. Her farewell letter to the doctors, introduced by Cooke and read by Woodward in voice-over, and the film's brief final scene testify to her recovery. Long buried is the blues-in-the-night world of Eve Black; permanently installed is the brightly-lit world of 1950s domesticity. Reunited with her daughter and newly married to an understanding, middle-class man (who, unlike the poorly educated Ralph White, has no southern accent), Jane has taken her place in a reconstituted, modernized southern white family. As lush orchestration swells (no clarinets or guitars lurk in the closing score), the threesome drives off in the final shot between veils of Spanish moss lining the highway. "Here we all are—Bonnie, Earl, and me—going home together," Jane says.

With southern education the locus of postwar racial strife, national audiences responded sympathetically to the "true story" of a reeducated American Eve. Rejecting any notion of the successful integration of white and black, *The Three Faces of Eve* had reconstructed a new and improved whiteness from the ashes of the southern wasteland. By not only failing to question the "integrity" of whiteness but also insisting on its resurgence during a time of immense racial dislocation, the film adhered to a formula that would be repeated in subsequent Hollywood productions for decades. In the final analysis, such movies argued, social class presented the clearest threat not just to mental health and racial harmony but to white supremacy itself.

Eve White and Eve Black, the hillbilly and the social mulatto, were local "color"—humorous, pathetic, and ultimately dispensable. As obstacles to progressive representations of the South, they offered proof through their inevitable demise that the times were indeed changing. Poverty, ignorance, and ill-breeding, *The Three Faces of Eve* advised, were relics of an Erskine Caldwell past. By exoticizing the southern white woman, by marking her, or aspects of her, as distinctly anachronistic and self-destructive, the film could walk a tightrope between national sympathies. Displacing racism onto the conflicted figure of the working-class white woman, the picture appeared to examine and condemn an *inherently* class-bound social pathology, and yet, by consistently marking southernness as Other, it provided reassurance that whiteness itself was not an issue. Through its insistence on its own realism and documentary truth, *The Three Faces of Eve* stood as midwife to the birth of an icon of the New South—the educated, accentless, supremely genuine Everywoman of the 1950s. Racial boundaries might have been wavering offscreen, but onscreen Americans were reassured that whiteness was not just progressive. It was entirely natural.

TWO

SENTIMENTAL EDUCATIONS

Romance, Race, and White Redemption

The reeducation of the white woman was crucial to the reclamation of the South itself, for it was her racial purity that was most at stake in the political iconography of contemporary film. But, as Dorothy Allison has observed, "peasants" are always a problem in southern narratives. "Call us the lower orders, the great unwashed, the working class, the poor, proletariat, trash, lowlife and scum. . . . Make it pretty or sad, laughable or haunting. Dress it up with legend and aura and romance."[1] Liberal Hollywood preferred romance and would consistently disguise its reeducation fables as tales of sexual awakening. Ironically, though, cinema's rescue of the benighted backwoods female from the forces of cultural stagnation would betray the racism undergirding this iconography, for the movies left little doubt that a woman's "enlightenment" was, first and foremost, a literal phenomenon.

Eve White's successful struggle out of backwater darkness in *The Three Faces of Eve* would be duplicated by other desperate women trapped in an increasingly desolate South. In Elia Kazan's *Wild River* (1960), for example, young widow Carol Garth Baldwin (Lee Remick) eventually makes her way north from rural Tennessee with her new husband Chuck Glover (Montgomery Clift), a federal official who successfully fights off local opposition to a proposed Tennessee Valley Authority dam. Although set in the 1930s, the film dramatized a standoff between regional and national interests which had contemporary political resonance. Essentially an outside agitator from the North, Glover encounters a spectrum of white resistance to the New Deal's plans to modernize the Tennessee Valley, from employers afraid that black workers will flock to better-paying federal jobs to an old woman

(Carol's grandmother, Ella Garth, played by Jo Van Fleet) determined to stay on her farm despite Washington's order to clear the land for flooding. "For a minute I forgot where I was," he says caustically when he first arrives in town and is rebuked for suggesting that white and black men might work together on the construction of the dam. He is reminded again when a mob comes to attack him late in the film, yet warns them, "I came down here to do a job." Part of that job, he has told Ella, is salvational: "We're not taking away people's souls. Just the opposite. We're giving them a chance to *have* a soul!" He is, he thinks, bringing more than simply *electrical* power and light to the region.

Kazan has said that his film "was in sympathy with the old woman obstructing progress,"[2] and although Carol calls her immovable grandmother "a real romantic," Glover himself recognizes that the old woman is fighting for her "dignity" by holding on to land her family has owned since before the Civil War. Indeed, Ella represents a stratum of white resistance different from that of the lynch mob, one grounded in self-defined work. Kazan underscores her ethical superiority to the town racists (workers whose own social displacement may be a source of hostility to further change) by repeatedly revealing the black workers' respect for the old woman and by linking the demise of her proud sensibility with industrial progress. Within days of her forced removal, Ella dies. Workers torch her house, the last one standing, while the American flag waves in front of the flames.

Like *The Three Faces of Eve*, *Wild River* situates its story within a documentary framework, urging viewers to understand the historical importance of the work of men like Chuck Glover. Graphic archival footage at the beginning of the film shows the devastation the already impoverished area had suffered during repeated floodings of the Tennessee River; this footage conditions the audience to view Glover's mission as inherently benevolent. Carol in particular reaps the benefits of Glover's intercession. Her isolation in the ravaged region has fostered desperation; "I haven't talked to anyone for so long," she confesses to him when they meet, indicating Glover's primarily social function in the community. As a fictional story framed within a documentary chronicle of American history, moreover, Carol's rescue by the knight from the North not only replicates the larger rescue of the wasteland but also testifies to the national significance of regional "reclamation." Regardless of Kazan's decision to allow Montgomery Clift's noticeable lassitude and ineffectiveness (largely the result of a disfiguring car accident sev-

eral years earlier) to inform the character of Glover and thereby weaken the ethos of the government liberal, the ending of the film leaves little doubt about the ultimate rightness of his actions. Like the reconstituted family that drives toward the horizon at the end of *The Three Faces of Eve*, Chuck, Carol, and her children all leave Tennessee by plane at the end of the film. An aerial shot reveals a last glimpse of her former home, but Carol points ahead, to the majestic new dam, which is steadily erasing all traces of her rural past. The East Tennessee she is leaving will change; thanks to her husband and the federal government, it will be a place of jobs, better schools, and *light*.

The enlightenment of the South was the subtext of yet another showcase for serious actors of the era, *The Miracle Worker*. First produced as a teleplay in 1957, then as a Broadway play in 1959, and finally as a film in 1962, the story chronicled Helen Keller's childhood journey out of the "inferno" (in director Arthur Penn's words)[3] of blindness and deafness. Summoned at the end of the last century to the Civil War–obsessed Alabama household of the respectable Kellers, Boston teacher Annie Sullivan (Ann Bancroft) promptly initiates the seemingly hopeless reeducation of her new student, the near-feral Helen (Patty Duke). Sullivan is half-blind herself, and her own struggle out of disability and horrific poverty (seen in flashbacks) sets her morally apart from the elitist family and suggests that her strict pedagogy is at heart far more democratic than their careless, indulgent attitude toward the girl.

Introduced to the Kellers through Annie's eyes (i.e., from a *northern* perspective), the viewer cannot fail to see that Helen's impairment is as much cultural as physical, a manifestation, in some sense, of the family's arrested development. Annie first sees Helen fighting with a black child, and later, at her first meal in the large house, she disgustedly watches Helen wander through the dining room scavenging food from plates while the oblivious family debates the fall of Vicksburg and black servants silently witness the chaos. Determined to bring "law" to this microcosm of southern anarchy, Annie removes Helen from the family and, with the help of the black child, pitches a battle with the forces of indecency in a small cabin on the Keller property. Significantly, Helen's greatest progress occurs here—while away from "the big house"—in the care of a woman who is perceived by the family to be less than "white" ("a creature who works for you," Grandmother Keller calls her).

Helen's awakening to language brings about her civility, a "miracle" effected by the Boston teacher. (Significantly, the film ends with Annie spelling out "teacher" to her triumphant pupil.) Like the reconstructed Eve and the rescued Carol Baldwin, Helen finds herself mercifully reclaimed from the wasteland of southern ignorance and poised at film's end to encounter a world of enlightenment. (The real Helen Keller, in fact, would follow Annie Sullivan out of the South, north to Radcliffe College and ultimately to international fame.)

The convincingly represented social restoration of the southern white woman in films like *The Three Faces of Eve, Wild River,* and *The Miracle Worker* owed much to the rhetorical weight of realism. Embedded within the narrative conventions of autobiography and documentary storytelling and performed within the dramatic conventions of naturalism, the characters' transformations appeared historically grounded and socially probable. As such, they carried their own irrefutable, politically freighted logic: southern reeducation, it seemed, could occur only through outside intervention.

Moving off the River: Tammy Tyree and the Rewards of Enlightenment

The same narrative insistence upon the interdependence of southern improvement and social mobility would propel a popular romantic comedy heroine from her home in a literal backwater region to jet-set glamour on Rome's Via Veneto. The "Tammy" stories of Cid Ricketts Sumner were the basis of three films (*Tammy and the Bachelor* [1957], *Tammy Tell Me True* [1961], and *Tammy and the Doctor* [1963]) and one short-lived television series (*Tammy and the Millionaire* [1965–66]). Sumner, a native Mississippian who wrote from her adopted home in the Northeast, produced a number of novels after World War II which focused on racial identity in the Deep South. *Quality* (1946, adapted to the screen in 1949 as *Pinky*) and *But the Morning Will Come* (1948) explored the effects of "passing" on black characters, but in her series of "Tammy" novels Sumner attempted to create a southern white character whose unimpeachable goodness might mitigate the crimes of race chronicled in the other works. To do so convincingly, however, she employed a peculiar form of historical displacement: her redemptive figure existed *in* the contemporary South, but was not *of* the contemporary South. *Tammy Out of Time,* published in 1948, introduced the character of Tammy Tyree, an orphaned girl who lives in a small house-

boat on the Mississippi River with her moonshiner grandfather and a beloved goat. Tammy rescues plantation heir Pete Brent from a plane crash in the swamp and, after her grandfather is taken to jail, moves to the Brents' Natchez estate. The continual culture shocks that ensue provide the book's narrative tension, yet they are not produced from the simple confrontation of country and city, poverty and wealth. Tammy's sensibility, in fact, cannot be categorized as rural in any contemporary sense; it is simply *antiquated,* a vestigial white decency (Sumner suggests) that vastly "outclasses" that of the current Delta gentry. Her relationship to the region is preindustrial, almost spiritual, based on a sense that "time was large and wide as the sky, one part slipping into the next, unbroken as the flowing of water."[4]

Tammy knows that to the Brents she appears "shabby, alien, and unknowing, lowly," but she also realizes that "her way of thinking was too different. . . . Her life on the river had marked her and set a great gulf between her and these people" (116). The "gulf" opens widest at the mention of race, and threatens her growing love for Pete. She enjoys working on the plantation alongside a black family who, she thinks, are "the color of the river in high-water time, a pleasing color—if one did not look for it to be white" (112), and, when advised by black housekeeper Osia to respect the kind of manners that "goes back to slavery days," Tammy asks, "Do you reckon it will wear off in time?" (168). Pete reprimands Tammy for her racial naiveté, telling her bluntly, "You don't understand these things. . . . You've lived on the river all your life. . . . You don't know" (114). Sensing that his anger is "something from outside himself," she asks, "Why are you so afeard, Pete?" (115). As Osia observes in *Tammy Tell Me True,* "Miss Tammy, I declare, look like you come into this world with a fresh brain."[5]

Because of Sumner's investment in the notion of an almost primordial southern white virtue, however, Tammy's function as a cultural interrogator is limited. Dressed up by Mrs. Brent in an antebellum costume for the Natchez Pilgrimage, she enchants visitors to the plantation with her archaic dialect. A jaded New York houseguest confesses in *Tammy and the Bachelor* (the film adaptation of *Tammy Out of Time,* which starred Debbie Reynolds) that "seeing this place come to life for a few hours last night, watching Tammy like a ghost out of the past with all the warmth and charm of a more leisurely era made me realize something." What he realizes, of course, is the *absence* of "warmth and charm" in the urban North; that this southern charm is a complete fab-

rication, a tourist-driven fantasy, escapes comment. So, too, does the economic basis of the fantasy. In the film, Osia objects to wearing a "slavetime bandanna" for the Pilgrimage visitors because it "don't let no air in." In the book, she objects for emotional reasons, but her worries are cut short by Tammy, who advises her that "it might be good to look back once a year like this and see how far you come. Seems to me you come a long piece since slavery times." Osia, who moves "as if a drum-beat out of a distant time and place had set the rhythm of her step" (167), bows to the white girl's wisdom. "Yessum, I reckon I gets your drift," she admits (204).

Sumner's ambivalent perspective on race was mirrored in her atti-tude toward social class. Although she depicted Tammy's common sense and perceptiveness as remarkable, the three novels of the series essen-tially constitute an extended tale of reeducation. In *Tammy Out of Time,* Pete Brent's father, a professor, tells Tammy that her mind is "a blank." "He wants to write on it," she says, "only he doesn't know what, yet" (168). In *Tammy Tell Me True,* she admits to Osia that her brain is "too empty. There's lots I've got to learn" (20). Realizing that Pete Brent has broken his engagement to her most likely because of the disparity in their educations, Tammy enrolls in a local college. There she finds a new love, speech instructor Mr. Freeman, who understands that she is no run-of-the-mill country girl. "Many of your expressions . . . go back to the time of Chaucer" (149), he informs her. Pleased by his discovery, he tells his students about the historical wonder in their midst. "Miss Tyree's speech is of particular interest to the student of language," he points out in a class lecture, "because, due to the isolation of her early life and the manner of her upbringing, she has been quite out of touch with the modern world. Her vocabulary, therefore, has a flavor of the Elizabethan, as is true of some of the mountain folk of Kentucky and Tennessee" (174).

Like the reconstituted Eve, whose transformation is marked by her recollection of Shakespearean lines, Tammy finds that she too is a repos-itory of cultural information—the "missing link," as it were, to Shake-speare's England. With her social heritage no longer an issue, she sheds the remnants of her former life as "that shanty boat girl come off the river" (22). Dismissing the now repentant Pete, she observes that "I've et of the fruit of the tree of knowledge and now I can see you and me clear, not through a glass darkly" (253). Just as Eve's "knowledge" is re-warded with an appropriately civilized suitor, so is Tammy's newly dis-

covered heritage accompanied by refined romance. Having "freed" her from backwater ignorance, Mr. Freeman comes to her as a man "to put dependence on, and maybe more," and Tammy, seeing "a man growed" (254), accepts her teacher in "a kind of glory" (255). In the last novel of the series, *Tammy in Rome* (published in 1965), the progressively enlightened country girl even travels to Europe in her own version of the grand tour and mingles with Italian film directors; Hollywood would choose to relocate her to Los Angeles in *Tammy and the Doctor,* where a promising young intern would await her.

Despite the generic differences between Eve White's and Carol Baldwin's melodramas and Tammy's extended romantic comedy, they all built upon the bourgeois romance formula in which a young woman improves her social station by marrying "up." But unlike similarly structured romances of the time like *Sabrina* (1954), *The Best of Everything* (1959), or *Where the Boys Are* (1960), stories of southern "improvement" were profoundly embedded in contemporary politics. South of the Mason-Dixon Line, social mobility was a racially redemptive adventure, an often literal journey (as in *Wild River* and *The Miracle Worker*) out of benightedness. Like Eve, who unloaded the psychological residue of poverty, violence, and promiscuity onto her "dead" alter-egos to emerge a gleaming model of progress at film's end, southern characters who effectively shed the traces of cultural impairment were rewarded with romantic success, the purity of their whiteness restored in a symbolic union with the forces of enlightenment.

Exiled in Paradise: The White Southerner Abroad

Preferring displacement to direct confrontation, producers of Hollywood melodramas in the 1950s and early 1960s often transferred racially charged romance to politically "safe" locations. One subgenre, the "Oriental love story," was set in post–World War II Asia and centered on the relationship between a white American (usually male) and an Asian (usually female, and almost always Chinese or Japanese). *Love is a Many-Splendored Thing* (directed by Henry King, 1955) was arguably the most popular of such films, incorporating elements crucial to the subgenre's success: forbidden but magnetic love between two members of different races (here, a white American man and a Eurasian woman) and unquestioned sacrifice for that love, often followed by tragic loss, all photographed against the background of CinemaScopic, Technicolored panoramas of an "exotic" location (here, Hong Kong) and ac-

companied by an emotionally pitched popular song. *Japanese War Bride* (King Vidor, 1952), *The Teahouse of the August Moon* (Daniel Mann, 1956), *The King and I* (Walter Lang, 1956), *The World of Suzie Wong* (Richard Quine, 1960), *Bridge to the Sun* (Etienne Perier, 1961), and *A Girl Named Tamiko* (John Sturges, 1962) employed the formula to varying degrees (in *The King and I,* the white character is female and English, and the setting is nineteenth-century Siam), but all films found ample narrative space for exploring issues close to the surface of America's escalating racial crisis.

Bridge to the Sun, for example, tells the story of a white American woman's marriage to a Japanese diplomat during World War II. Based on the 1957 autobiographical book by Gwen Terasaki, the film announces its concerns in the image of two joined hands—one white and female, the other dark and male—which form the background of the opening credit sequence; because the film was shot in black and white, the Asian man's hand appears almost black in contrast to the startlingly white hand of the woman. Painting its main character as a naive but racially tolerant belle from Johnson City, Tennessee, *Bridge to the Sun* took the unusual step of denouncing a form of social injustice through the figure of a white southern woman. Played by Carroll Baker, moreover, who had become famous in 1956 as "Baby Doll" in the film of the same name, the character of Gwen Terasaki was particularly "layered" with decadent southern connotations, making her an ironic spokeswoman for cultural reform.

The culture under scrutiny here, however, is Japanese, not American. Gwen's rocky adjustment to Japanese patriarchal customs culminates in an impassioned outburst to her husband, Terry, about the superiority of American customs. When he condemns her "rude and humiliating" intrusion into a male-only discussion as probably "permissible in the state of Tennessee," she cries (in full geisha regalia), "Never mind the state of Tennessee! At least they treat women like human beings!" She's "sick," she says, of "the complicated rules that put honor and duty before simple human truth" and of a place "where women are treated like pieces of furniture and it's a quaint old custom for fathers to sell their baby daughters." The spectacle of a southern woman defending American social equality was clearly a deviation from the conventions of liberal Hollywood, but the fact that the South emerges as progressive only in contrast to a sixteenth-century patriarchy tempers its eccentricity. Further, although Terry learns much from his

brash American wife, it is she who undergoes the most intensive instruction, choosing dutifully to stay with him in Japan during the years of the war and to suffer prejudice and deprivation for her love.

At the end of the film, the terminally ill Terry sends his wife and their daughter back to Johnson City, where the child, he says, should enter school and "lose her prejudices." Gwen herself, who feels "so small" and knows "so little" at the beginning of the film, leaves Japan having "learned so much." A woman newly instructed in the violence of racism and misogyny, she will return to the South to fight new battles (most likely when her biracial daughter enters school in Johnson City and encounters the "hillbillies" she has exoticized in Japan). In contrast to the film's ending, the real Gwen Terasaki returned to Tennessee with a grown daughter, who promptly entered a local college. "How foolish had been our fears that she would not be accepted by her fellow students," Terasaki noted with relief in her autobiography.[6] The movie's alteration, however, reinforced the theme of reeducation, linking the southern mother with a child who must be reschooled in racial tolerance.

If *Bridge to the Sun* evaded direct confrontation with contemporary racism by portraying it primarily as a "foreign" problem (virulent anti-Japanese feelings among Americans are expressed only after the attack on Pearl Harbor), two romance films of the era, *South Pacific* (1958) and *Sayonara* (1957), both directed by Josh Logan and based on short works by James Michener, pursued more blatant civil rights agendas through the figure of the reeducated and reformed white southerner.

Navy nurse Nellie Forbush, *South Pacific*'s main character, is, in Michener's story, a country girl from Arkansas who "suffered no social distinctions" while stationed abroad because "white women were the exception and pretty white women rarities."[7] By the time Rodgers and Hammerstein adapted the story to Broadway, however, the "fugitive" (as she called herself) from Little Rock carried inescapable political connotations which heightened her already scripted racial prejudices. During the height of the federal-state standoff at Central High School, for example, *Time* reported that when a Long Island summer theater audience heard Nellie announce her hometown, they "stopped the performance with three minutes of furious boos and hisses."[8] Claiming to want to "meet different kinds of people" (unlike her mother, who "is so prejudiced—against *anyone* living outside Little Rock"), Nellie (played by Mitzi Gaynor in the film adaptation) finds that too much difference

elicits similar antipathies in her as well. In *South Pacific,* the southern white woman falls in love not with an Asian man but with a French plantation owner (Emile De Becque, played by Rossano Brazzi). Here, cultural insecurity ("He's a cultured Frenchman / I'm a little hick," she sings) is replaced by racial panic when Nellie encounters Emile's children, products of his relationship with "a Polynesian." After running away from the revelation in tears, she turns down his proposal of marriage, justifying her decision on the grounds that "this is something that's born in me. I can't help it." Michener makes a stronger point in his story: "Her entire Arkansas upbringing made it impossible for her to deny the teachings of her youth. Emile De Becque had lived with the nigger. He had nigger children."9

A subplot, however, revolving around the romance between Cable, a white lieutenant, and Liat, a Tonkinese girl, argues the movie's (and play's) liberalism. "You've got to be carefully taught" to hate, he tells Emile, explaining Nellie's racism (in the song of the same name). When Cable dies, and Nellie fears the same fate may await Emile, she recognizes the error of her "inborn" ways. Pledging to forego her prejudices, she cries, "I know what counts now. Just you. All those other things, the woman you had before? Her color? What piffle. What a pinhead I was!" Sufficiently repentant, Nellie is rewarded with a wealthy husband and begins her reign over an updated, multiracial plantation.

Nellie Forbush's conversion to a somewhat trivialized racial tolerance (one's color is mere "piffle") is made possible, narratively speaking, by Lt. Cable's death. As Gina Marchetti has pointed out, parallel love stories serve an explicitly ideological purpose in interracial romances. "The two couples," she notes, "provide the tragic 'punishment' for those who cross racial barriers as well as the liberal 'happy ending' for those who can be assimilated into the American mainstream."10 Although Nellie and Emile will stay in the South Pacific, their union evokes the Allied victory of World War II and, by extension, American entrenchment in Asia. Emile's spying mission, after all, makes possible the landing of 10,000 American troops on the island. The tragic punishment of Cable and Liat, however, also follows inevitably from the exaggerated sensuality of their relationship, which will presumably stay constant since Cable, like an American Gauguin, plans never to return to his home in Philadelphia. As Liat's mother, nicknamed Bloody Mary, promises Cable, his marriage to Liat will be constant play and lovemaking (the song "Happy Talk" and the underwater frolic scenes em-

phasize the couple's childlike but sexualized simplicity). As in *The Three Faces of Eve*, the threat of sybaritic pleasure is coded as "colored" (Logan's use of monochromatic filters in particular scenes garishly echoes the film's thematic interest in color), and it must be effectively dispatched to make way for the possibility of a chastened, mature, interracial family.

Tenuous Whiteness and the American Male

The national preoccupation with racial integrity placed the white man in a precarious and (to segregationists) humiliating position: bearer of the racial "seed," he stood guard over a progressively attenuated cultural bulwark. "What's coming?" Robert Penn Warren asked a Memphis taxi driver in 1956 when researching his book *Segregation.* "'Lots of dead niggers round here, that's what's coming,'" was the reply. "'But hell, it won't stop nothing. Fifty years from now everybody will be gray anyway, Jews and Germans and French and Chinese and niggers, and who'll give a damn?'"[11]

For a nation obsessed with the racial uncertainty of its population, white anxiety over the "graying" of America found its most hysterical metaphorical expression in the era's science fiction films and, perhaps, its most concrete expression in the story of Betty and Barney Hill, an interracial couple from New Hampshire who attracted national attention in 1961 with their claim of being abducted and sexually abused by extraterrestrials. The conjunction of burgeoning national interest in UFOs, cultural obsession with the possibility of nuclear annihilation, stepped-up investigations of domestic Communist conspiracies, and a fashionable preoccupation with the "anomie" of corporate and suburban life stimulated an onslaught of hugely popular and largely B-grade science fiction films, which all seemed to ask the same question: What, exactly, is a human being? More precisely, what is a (white) man? Is "modern man," asked films like *The Fly* (1958), simply a fiction, a flimsy "cover story" for the primitive beast within? Or is he merely a tenuous life form poised on the brink of extinction at the hands of either alien invaders (*Earth vs. Flying Saucers* [1956], *The Day the Earth Stood Still* [1951]), mutated earth monsters (*Them!* [1954], *The Creature From the Black Lagoon* [1954]), or fascistic scientists (*The Thing* [1951])? Most disturbing of the possibilities, might he be nobody at all? *Invasion of the Body Snatchers* (1956) blamed spores from outer space for the proliferation of pods that yielded replicas of humans, but it nevertheless

strongly suggested that whatever uniqueness resided within "normal" humans could be effortlessly erased through the simple act of sleeping. As *Body Snatchers'* blond, straight-arrow Dr. Miles Bennell slowly recognizes the encroachment of psychic erasure among his entire idyllic town, his panic escalates into hysteria by the film's end. Flailing in terror on a congested California highway, screaming "You're next!" to everyone—even to the audience (a sequence so disturbing that director Don Siegel was forced to add a reassuring closing scene), Miles was in several ways an emblem of postwar white manhood: tenuously functional, perilously distressed, and ultimately impotent in the face of social upheaval.[12]

What Paul Wells has cited as the genre's "systematic destabilization of movie-made masculinity"[13] was most clearly demonstrated in 1957 by Jack Arnold's *The Incredible Shrinking Man.* Based on Richard Matheson's 1956 novel, *The Shrinking Man,* the film tells the story of blond, happily married Scott Carey, a man who encounters a cloud of nuclear fallout on a romantic sailing trip. The radiation triggers a steady diminution of his body, to the point where he must live in a dollhouse and endure terrorizing raids by the family cat. "I felt puny and absurd," he tells us in voice-over narration, "a ludicrous midget. Easy enough to talk of soul and spirit and essential worth, but not when you're three feet tall." The smaller he becomes, the "more tyrannical, more monstrous" he grows in his domination of his patient wife: "I loathed myself, our home, the caricature my life with Lou had become" (fig. 12). He runs away to join a circus troupe, but when he realizes the inexorable progression of his mutation, he returns home to take up residence in the basement. There, in a tattered loincloth, he battles spiders with pieces of debris ("I still had my weapons. With these bits of metal, I was a man again. My brain was a man's brain, my intelligence still a man's intelligence"). Nearly washed down the drain when the water heater breaks, yelling for help with a pitiable voice unheard by his wife (who, thinking him dead, abandons the house), Carey finally climbs outside, where he stares at the stars and ponders his fate: "I was continuing to shrink. To become what? The infinitesimal? What was I?" As he comforts himself with the thought that "to God there is no zero," he feels his body "dwindling, melting, becoming nothing." The film ends with a shot of the cosmos, over which Carey pathetically asserts, "Yes, smaller than the smallest, I meant something, too!"

Just *what* this shrunken man, this "Homo reductus" (as Carey calls

FIGURE 12. The anxiety of the postwar white male: Scott Carey (Grant Williams) is reduced to "nothing" in *The Incredible Shrinking Man* (Universal Studios, 1957). Wisconsin Center for Film and Theater Research.

himself in the novel), means in the scheme of things might be answered differently depending on one's politics. On the one hand, the evaporation of the suburban Everyman is an indictment of the technological imperative, and the victimization of a progressive, "enlightened" man by the weapons of his own culture could be read as either ironically fitting or socially outrageous. On the other hand, the main character's most disturbing metamorphosis—into a bellicose tiny tot in a dollhouse lorded over by both a woman *and* a feline—suggests a barely disguised satirical impulse at work. In fact, early on, as Carey visits his doctor for increasingly depressing "measurements," the question of sexual "size" leering just beneath the surface threatens to pitch the film into full-blown parody. The novel, however, unambiguously spells out

the implication. When Carey informs his wife that "it's not just my height I'm losing. Every part of me seems to be shrinking. Proportionately," she answers, "*No*" (Matheson's emphasis).[14] Much of the book is concerned with the shrinking man's unrelieved sexual desires and his awareness of women's increasing enormity, and the novel submits him to far greater humiliations than simply a large wife and a predatory cat. Matheson's Carey is not only dominated by the women in his family but also shamed by a proposition from a homosexual. He manages to redeem a sense of power by slaying a black widow spider, a creature who "destroyed and ate the male, if she got the chance, after one mating act."[15]

In most movies, the instinctive behavior to which Carey descends in his basement would be redemptive, with the assertion of shrunken masculinity ensuring a miraculous reversal of his malady and the regaining of his proper place in the world. Not so here, where masculine power is merely an ineffectual raging, a (tiny) howl before eradication. All that mars the satirical effect of *The Incredible Shrinking Man* is its refusal to relinquish fully the power it has persistently held up to ridicule; the voice of Scott Carey, inaudible to characters within the film, dominates *our* soundtrack as he continues his narration until the end of the film. Invisible, lost, absurd, *Homo reductus* nevertheless has the final word. Here, almost literally, the American white man is revealed to be the ghost in the Hollywood machine. The movies might be unimaginable without him, but the world was not. Yet, as a more prestigious film from 1957 would demonstrate, his story was far from over. Ever resourceful, he would reclaim his mastery of an increasingly "gray" world and preserve the prerogatives of white manhood in the process.

Performance Anxiety and the Southern Male: Sayonara *(1957)*

White male anxiety was most blatantly displayed in low-budget science fiction films, but it informed nearly all American genres of the era. Romance films, especially those set during the Civil War or in Asia, presented unavoidable opportunities for the exploration of racialized sexual identity. *Band of Angels* (1957), for example, based on Robert Penn Warren's 1955 novel, tells the story of the conversion of a wealthy white southerner (albeit a transplanted one) from racial prejudice to tolerance. Having made his fortune in "the nigger business," Hamish Bond (Clark Gable) renounces his past when he falls in love with and then sets free his half-black mistress, Amantha Starr, during the Civil War.

"That drop of blood you've got in you would never stop despising me," he tells her, and his confession ultimately seals their union. Reprising the role of Rhett Butler here, Gable plays Bond as a sophisticated, blockade-running man of the world, more businessman than demagogue. "Don't get the idea that it was all white man's wickedness," he says of the slave trade, and in fact he emerges as far more benevolent than the African king who was his partner. In the film's climax, he tells his former cotton manager, the rebellious Rau-Ru (Sidney Poitier), that it was he, Bond, who had rescued the two-year-old Rau-Ru from a slave raid in Africa. "Fighting on the other side" that night to save the child, he ended up raising Rau-Ru as his son. Upon learning this, Rau-Ru in turn helps Bond escape the encroaching Union troops. "He felt he couldn't be free unless I was," Bond tells Amantha as both flee the South by sea, Rau-Ru waving goodbye on the shore.

Band of Angels offers an apologia for southern intolerance by insisting upon both African racism and northern hypocrisy. As the Yankees march closer to his plantation, Bond tells a black ex-mistress that, contrary to rumor, they will not be freeing slaves but merely relocating them to carpetbaggers' plantations. There, he warns, the Yankees will "use the whip." But the apologia is possible only because of Bond's redemption, a redemption, it should be noted, that he himself initiates. Significantly, however, the paternalistic and often kind Hamish Bond of Warren's novel had not emerged as an heroic figure. Hanged at the end of the war, the ex-slave trader's last words in the novel were curses to his betrayers. "All niggers," he uttered, looking at Amantha and Rau-Ru with "his lip curled." "Ass-deep in niggers."[16] Furthermore, Warren's Amantha turned down Bond's proposal of marriage, marrying instead a Union officer who had led a battalion of Negro infantrymen.

Rejecting Warren's complex vision of the South, Hollywood reformulated *Band of Angels* as a romance of southern redemption in which Bond's innate "class" triumphed in a display of racial tolerance unmatched by other white men in the film. It was Bond himself, not federal judges and Yankee soldiers, who forced the conversion, and Bond who found his self-willed enlightenment sexually rewarded.

This pattern of redemption was followed by a more popular—and more ambiguously resolved—film of 1957. Rather than ultimately affirm the self-confident white masculinity of Clark Gable's generation of stars, however, *Sayonara* took advantage of the angst-ridden acting style of a new generation to dramatize the era's escalating racial panic.

Mitigating this panic, in fact, was the primary narrative goal of the film, which centered on a martially outlawed romance between a southern Air Force major and a Japanese actress during the Korean War. As in *South Pacific,* the southerner's political conversion would be resolved by a tragic parallel relationship. But here, racism would be linked to gender dislocation in ways that complicated that very resolution. Marchetti has argued that the film ultimately affirms "white, male, American hegemony,"[17] but in fact the film's finale fails to provide a convincing "fix" for its preoccupation not just with the status of the American white man but also with an all too noticeable "performance anxiety" on the part of its leading character (Lloyd Gruver, played by Marlon Brando). Brando's own strangely concocted acting style—alternating between parody and naturalism—undermines the seriousness of a "hegemonic" reading of the film, for it incorporates to some extent a criticism of the masculine power it ostensibly upholds. Ironically, though, the *form* of Brando's parody ultimately works to reclaim the prerogatives of established power, for the butt of the joke is not the American white man but the *southern* white man, a rube in desperate need of schooling.

Released the same year as *The Three Faces of Eve, Sayonara* shared acting Oscars with Best Actress Joanne Woodward (Red Buttons and Myoshi Umeki won Best Supporting Actor and Actress), yet the man who had been uniformly heralded as the nation's best actor was ridiculed for his performance in the film. "Brando is supposed to be a Southerner," *Time* noted, "though his accent sounds as if it was strained through Stanislavsky's mustache."[18] *Newsweek* mocked his "Texas accent thick as crude oil,"[19] and the *New Yorker,* in an assessment more revealing of the reviewer than of the movie, claimed that the actor "mumbles along with a corn-pone-and-chitlin accent that seems absolutely legitimate, even to the generic drawback of occasionally—particularly when he is cracking jokes—making him sound like the end man in a minstrel show."[20] *The Nation's* Robert Hatch agreed with the "corn-pone" description; with a delivery "slumped to the point of novocaine," he said, Brando plays "an anomaly—a Southern military character capable of thinking out his own problems." Nevertheless, this particular southern half-brain "would scarcely attract Blanche DuBois."[21] That Brando's character could be read variously as Texan, hillbilly, and minstrel, and his accent as both "legitimate" and studiously affected, indicates the degree to which "southernness" itself was a purely cinematic

invention open to a number of conventional inflections. Yet the contradictory readings were no doubt influenced to some extent by the actor's own movie incarnations: Stanley Kowalski, rebel biker, waterfront laborer, comic Okinawanese (in his last role before appearing in *Sayonara*). The most touted Method actor of his day, Brando was consciously, intentionally playing *somebody*, but who was it?

He was certainly not the Lloyd Gruver created by James Michener in the short novel upon which the movie was based. That Lloyd Gruver was an Air Force brat whose mother had grown up and still lived in Lancaster, Pennsylvania. The only southern character in the novel, in fact, was the craven Lt. Col. Calhoun Craford, "a paunchy red-faced man who hated every human being in the world except certain Methodists from his corner of a hill county in Georgia."[22] The decision to play Gruver as southern was apparently Brando's. "He's made up this Southern accent for the part; I never would have thought of it, myself,"[23] director Josh Logan admitted during the production of *Sayonara*. According to Brando biographer Peter Manso, however, the star had "demanded" that his character be southern in his preproduction negotiations: "If anything, this would make the racial conflict all the stronger."[24] A native of Louisiana himself, Logan found no flaw in the corn-pone accent ("it's exactly right—it's perfection"[25]), yet his critical distance from Brando's interpretation may have been diminished by his own autobiographical reading of Gruver. In 1958, he told readers of *Look* magazine in a three-part series chronicling his prewar hospitalization for manic depression:

> With my illness came a churning up of submerged guilt feelings that had troubled me for years. I was raised in the Deep South, and I never comprehended my feelings about Negroes. I was reared by a Negro nurse, Amy Lane. She was my second mother, the queen who ruled the back areas of the house, those permissive places where I was happiest. . . . Then, one day, I was told she couldn't eat with me or ride in the same railroad car with me. This is a guilty agony that all decent Southerners carry inside of them.[26]

Sayonara was in some respects his expiation for that guilt. "Some of Marlon Brando's dialogue expressing racial attitudes in *Sayonara*," Logan wrote, "was born in the darkness of the night" during his hospital stay.[27] Lloyd Gruver, in effect, would give voice to the racial guilt of "all decent Southerners."

Brando, however, claimed that his portrayal of Gruver was partially motivated by contempt for the entire film project. As he told Truman Capote in an extensive profile in the *New Yorker* a month before the film's release, "Oh, *Sayonara*, I love it! This wondrous hearts-and-flowers nonsense that was supposed to be a serious picture about Japan. So what difference does it make? I'm just doing it for the money anyway." According to Brando, Logan had encouraged him to rewrite the script as he saw fit ("write it your own way," he had supposedly said) and then ignored the results. "I give up," the actor told Capote, reliving the shoot.[28]

> I'm going to walk through the part, and that's that. Sometimes I think nobody knows the difference anyway. For the first few days on the set, I tried to act. But then I made an experiment. In this scene, I tried to do everything wrong I could think of. Grimaced and rolled my eyes, put in all kinds of gestures and expressions that had no relation to the part I'm supposed to be playing. What did Logan say? He just said, "It's wonderful! Print it!"[29]

Regardless of the story's veracity, it at least offers a possible explanation for a performance that turns parodic at dramatically crucial moments. It also might explain the motivation for Brando's blatant sabotaging of Logan's conception of Gruver as an upper-class, "decent" southerner—as an idealized extension, in other words, of the director himself. Scripted as a West Point-trained, well-bred Virginian, Gruver instead emerges on screen as a gum-chewing quasibumpkin—a *privileged* version, in fact, of Andy Griffith's Will Stockdale in *No Time for Sergeants*—given to using a fair amount of "ain'ts" and an exaggerated accent ("But ah *do* luv ya, baby, ah *do!*" he pleads with his sophisticated fiancée). He may be the son of a four-star general, but he sounds like a country boy, with his yen for "St. Louis goo-lash and a little Memphis greens." Brando's decision to "southernize" a character who confronts and reforms his own racism undoubtedly owed much to his avowed liberalism and to a sincere desire to make a politically relevant "statement." His decision to play the character alternately as a comic stereotype and as a sensitive man in crisis, however, confused the statement. On the one hand, it suggested that American racism might itself be a consciously adopted mask, a defensive persona, while on the other hand it reinforced the far less interesting notion of an "essential" southern provincialism: you can, in other words, take the boy out of the hills,

but you can't take the hills out of the boy. By not playing Gruver as either a northerner or an upper-class Virginian, Brando ensured that his character would be received as a regional joke, not as the *national* joke he (perhaps) intended.

The negative reviews given to Brando for his dramatic excess served not only to deflect critical praise onto his costar Red Buttons (who resuscitated his failing popularity with a comparatively serious acting turn as Airman Kelly) but also, inadvertently, to illuminate a central subtext of *Sayonara*. Brando's portrayal may have been, in the words of one reviewer, "not entirely consistent,"[30] but it was nevertheless *thematically* consistent with the film's overt fascination with performance and theatricality. For *Sayonara* flirts with the notion that race and gender might be constructed facades; the recognition of this possibility, in fact, triggers the emotional crisis of hard-core white southerner Lloyd Gruver.

The opening sequence of the film establishes Gruver as a war hero of uncertain professional and emotional solidity. Having returned from another successful bombing mission (and validating his nickname, "Ace," by downing his ninth MIG), he sits morosely in the cockpit until the congratulatory ground crew help him out. In the next scene, an Army doctor informs him that he's "through flying—for awhile, anyway." General Webster, father of Gruver's fiancée Eileen, has "prearranged" for Gruver to be transferred to a desk job in Japan ("Why shouldn't a three-star general look out for a four-star general's son?" the doctor asks).

In the final scene of the sequence, Gruver receives his transfer orders from Airman Kelly and, as requested by a commanding officer in the preceding scene, tries to persuade Kelly not to proceed with his plans to marry a Japanese woman. "Maybe you've forgotten what an American girl looks like," he says as he shows Kelly a photograph of Eileen. Kelly in turn produces a picture of his fiancée, Katsumi, and defends his intention to defy the Army strictures against American-Japanese marriage, even to the point of renouncing his citizenship. "You stupid, ignorant slob. I mean, you go ahead and marry this slant-eyed runt if you want to," Gruver angrily retaliates. Kelly has the final word, however. He may be crazy, but he's "*love*-crazy"; Gruver, he implies, might not understand the power of sexual passion. Maybe, Kelly wonders, "you don't feel as strong about your girl as I do mine." Gruver has no reply and fidgets uneasily.

Declared physically depleted by a doctor ("Don't get *pale,* Gruver!" he jokes), his sexual potency questioned by a subordinate, Gruver finds he must submit to a further indignity. Unbeknownst to him, his and Eileen's fathers have colluded to force the couple together. (Like many aviator movies, notably Howard Hawks's *Only Angels Have Wings* [1939], *Sayonara* initially poses the ultimate threat to a flyer's autonomy as a domesticating woman who "grounds," or "clips the wings," of the fearless pilot.) But it is Gruver himself who reveals the source of the most dangerous threat to his sense of masculinity: his own growing pacifism. "There was a guy with a face in one of those planes today," he says. "There was a guy with a face in all the other seven you shot down," Kelly reminds him. "Yeah," Gruver agrees. "That's exactly what I've been thinking about."

Five years after the end of the Korean War, *Sayonara* could risk an antiwar sentiment, but, within the context of the film's entire opening sequence, the comment provides psychological motivation both for Gruver's increasingly apparent discomfort with military uniformity and for his equally uncomfortable recognition of the racial Other. The situation comes to a head when, on his first night in Japan, Eileen takes him to a Kabuki production. At once repelled and fascinated by the notion of men playing women's roles, Gruver is struck in particular by the ability of the lead actor, Nakamura (a character who does not exist in Michener's story), to alter the genders and ages of his characters so rapidly. Eileen reads from the program that Kabuki actors ("male actresses") are "trained since childhood to have the grace of a woman and yet the power of a man." "Oh my word," Gruver groans. When Nakamura subsequently appears in male warrior costume, Eileen asks, "Man enough now for you, Lloyd?" The actor meets Gruver after the show and remarks that perhaps the American was not particularly taken with his first exposure to Kabuki. Gruver replies, rudely, that the performance could have used "a Marilyn Monroe here and there." This scene, in which Eileen's infatuation with the Japanese actor and embarrassment over Gruver's provincialism are obvious, provides the reasoning for Eileen's subsequent rejection of Gruver's marriage proposal. Announcing that she will never be like his mother ("walled-up" and "tucked away"), Eileen makes clear her desire for a life beyond military regularity and, most importantly, for a sexual passion she sees no evidence of in Gruver. "I'm not a type; I'm me," she tells him, to which he can only answer, "I look at you and I don't understand you. I don't

know what's goin' on in your brain. I think sometimes I don't even know who you are, or what you're all about." Like the enemy pilots whose "faces" have begun to imprint themselves on his conscience, Eileen is emerging as a distinctive and unpredictable personality, a woman who finds a female impersonator more sexually exciting than a uniformed war hero.

Set free by his fiancée, Gruver begins steadily to loosen his ties to the American community. Having served as best man at Kelly's wedding, he is called on the carpet by General Webster and his wife not just for failing to hold his men to the military's racial code but also for avoiding contact with Eileen. As played by Brando, Gruver interprets the dressing-down as an attack on his masculinity. Sitting awkwardly in a chair, he places a cushion over his groin before protesting that the parents' demands place him "in a position of incompetence . . . when it comes to doin' anything" to help his men. Further, he complains that he's "embarrassed by [his] whole situation here." He was a pilot in Korea with "an unfinished job," but suddenly he was "pulled off that job and sent over here and plunked down at a desk. . . . all so's [he] can be with Eileen."

An emasculated puppet with, as he says, "nothing to do," Gruver turns for advice to fellow officer Mike Bailey (James Garner), a man who has flagrantly defied military injunctions against "fraternizing with indigenous personnel" by bringing Japanese women to the officers' club. Gruver admits that he had never wanted to go to West Point and had wanted instead to be an actor. "I had an idea about a whole different way of life," he says. Nevertheless, he followed his father's wishes, and now, pressured by several sets of parents to marry as soon as possible and "buck for stars," he voices his fear of getting "swallowed up by all that." No sooner has he confessed his repressed desire to be an actor than his salvation appears—in the form of an actress. Mirroring Eileen's fascination with Nakamura, Gruver's adulation of Hana-ogi, star of an all-women's performance group, underscores the exhaustion of American sexual standards and opens up a field of gender play that the film can only signify but not fully explore (fig. 13).

Like Nakamura, Hana-ogi plays an array of roles on stage, easily slipping from female to male personae. As Gruver (in effect) stalks the actress on her daily walks to and from the theater, she appears in male costumes, inflaming his interest even more. Their affair is consum-

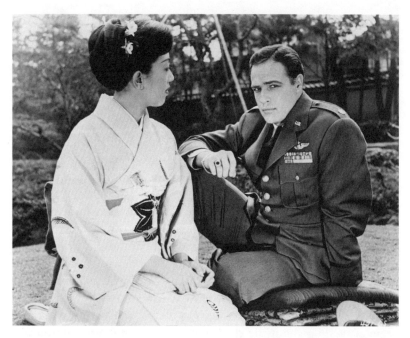

FIGURE 13. The white southern male in cultural crisis: Lloyd Gruver (Marlon Brando) is reeducated in *Sayonara* (Warner Brothers, 1957). Wisconsin Center for Film and Theater Research.

mated in the "off-limits" home of Kelly and Katsumi, where the contrast between the couples none too subtly reveals the familiar socioeconomic warning of the romance genre. As a low-ranking airman, Kelly the "peasant" (as he calls himself in the film's first sequence) has married within his station (his wife is described by Gruver in Michener's book as "repugnant," and Kelly himself says she is "fat and dumpy" and has had "to work like a slave"[96]). His marriage becomes a model of conventional gender roles, with Katsumi happily cooking meals and scrubbing her husband's back. The violence implicit in the arrangement surfaces only once in the film, when Kelly throws Katsumi to the floor and threatens to "kill" her for considering cut-rate Westernizing eyelid surgery. (In the book he gives her "a terrific belt" [103], "a solid wallop on the bottom" [90], and threatens to "break her arm off at the wrist" [90]. "Honest to God, Ace," he says, "it's easier to train a dog" [103].) A misfit in America, Kelly claims his only home is the house he shares with his wife. Ordered by the racist Lt. Col. Craford to return alone to

America, Kelly chooses suicide for both himself and Katsumi (in the film, it appears to be his idea, inspired by a double suicide performed by a puppet troupe).

Although the film romanticizes the working-class couple's conventionality, it also condemns their inflexibility. Unable and unwilling to change, Kelly is the American in retreat from modernity, much like Craford. His outrage over Katsumi's interest in Westernizing her appearance is, in the context of the narrative, not so much an expression of his racial liberalism as an indication of his intolerance of change: he would "kill" his wife before allowing an alteration of her image. (In Michener's story, however, Katsumi does in fact go through with the eye operation. She looks "horrible" afterward, according to Gruver, but Kelly tactfully accepts her decision.) The film attempts to convert the scene into a metaphorically liberal "lesson" about the mutilating effects of racism, but what emerges instead is a demonstration of the white American's power. Poor, orphaned, and repeatedly in trouble with the law in his home country, small Joe Kelly is a king in Osaka. Yet it is white southerner Gruver who adapts to the cultural, sexual, and racial changes swirling about the cloistered American military community. His difference from Kelly, in fact, is emphasized when Hana-ogi confesses her past as a prostitute to Gruver. While he quietly absorbs this blow to his idealized notion of her, Kelly, in the next room, rampages against his wife's proposed self-mutilation.

Kelly's suicide is ultimately shown to be rash, even "grotesque," in the words of General Webster. No sooner does he die than the federal government proposes a law to allow Japanese women to enter the United States with their husbands. The film casts the government as an agent of social change and the military (like the South itself at the time) as a fortress of reaction. Kelly's sacrifice, then, is double-edged: a liberal indictment of institutional racism *and* of those who have lost faith in the system. Narratively, Kelly represents a political impasse, one the film insists will soon be history. His orientation to the past, to a romanticized notion of domestic hierarchy, must be demonstrated as archaic if Gruver's *re*orientation is to be seen as progressive. For the instructive purposes of the film, Kelly *cannot* change; that prerogative belongs to the conscience-ridden southerner. It is he who delivers the final speech in the film to Hana-ogi about the rightness of their union: "We've been wastin' two good lives tryin' to do the right thing . . . the right thing for my father, the right thing for the military . . . the right thing for the

Great White Race." Their children, he proclaims, will be "half yellow, half white, half you, half me." Unlike the ending of Michener's story, in which Hana-ogi leaves Gruver and he returns to America with Eileen, Logan's cinematic resolution unites the lovers in a public declaration of their engagement before watching them leave for the now welcoming shores of America.

Gina Marchetti has justifiably called *Sayonara* "a profoundly conservative film" in its "reaffirmation of male—and by implication, American—domination of the racially, ethnically, and sexually other."[31] This reaffirmation, however, is largely cosmetic, a barely convincing generic adjustment to the film's gender and racial dislocations. Although these dislocations exist in the original material, Logan's evasive adaptation may be the more unsettling of the two versions, for it appears to resolve narrative complications under the banner of universal "love," yet undermines that resolve with a self-reflexive insistence upon the performative, ambiguous nature of romantic relationships.

In Michener's novel, Gruver, who is the narrator, voices anxiety about the power and privileges of the United States. "I didn't like anything I'd seen happening in Japan since General MacArthur left and I didn't want to be a part of it," he says. "After all, who did win the war, anyway?" (72). As it turns out, this anxiety is a displacement of a far more personal disruption: the growing assertiveness of American women. Initially repelled by "chunky" and "clodden" Japanese women (22, 65), Gruver finds himself increasingly critical of the "tough, bitter" women of his homeland, women who cannot "take a wounded man and make him whole" (138, 120). Mike Bailey's pointed question to him, "Are you afraid of American women?" (118), is left unanswered as the book details the ways in which Japanese women "make their men feel important" (52). Most of the narrative, in fact, is devoted to Gruver's attempt to understand his lack of passion for his fiancée. "She had what *Life* magazine once called the well-scrubbed look and was absolutely adorable with the fresh bright charm that only American girls ever seem to have" (60), he concedes, yet later he states, "I almost cried aloud with pain to think that something had happened in American life to drive men like Mike Bailey and me away from such delectable girls" (138).

Hana-ogi, however, is not presented as more conventionally feminine. The first time she appears to Gruver she stands above him in male clothing, reprimanding him for consorting with a fellow actress. This "intruder" with a "strong face" is, as Gruver discovers, a star male im-

personator in the all-female Takarazuka shows, adept at playing "a Spanish bullfighter, a Venetian gondolier, a Broadway playboy and a Japanese samurai." "She was always the man and she always looked devastatingly feminine" (96), he marvels. The erotic pull of Hana-ogi's androgyny becomes particularly ironic when Gruver discovers her most famous role: Lieutenant Pinkerton in a parody of *Madame Butterfly* entitled *Swing Butterfly:*

> The girl in the slacks who had reprimanded us in the restaurant played this part and her Lieutenant Pinkerton was blatantly ridiculous. He was arrogant, ignorant and ill-mannered. Yet at the same time the actress herself seemed more essentially feminine than any of the other girls on stage and it was this that made her version of Pinkerton so devastating. She was all Japanese women making fun of all American men. (93–94)

At first, Gruver is insulted by the performance ("I couldn't tolerate people making cheap fun of men in uniform" [94]), but by the end of the novel he is flattered: "She had studied with intimate care my mannerisms and now reproduced them in burlesque form. When she lit a cigarette she mimicked me, when she propositioned Madame Butterfly she was me trying to kiss her on the Bitchi-bashi. This time I, more than anyone else in the audience, enjoyed her burlesque of Americans" (231).

The *performance* of American manhood, then, is read by Gruver as an affirmation of the persona threatened by the women of his homeland. His delight in the recognition of his own behavior as painstakingly constructed, however, is most likely a consequence of the performer's identity, for one might wonder how he would enjoy a similar burlesque performed by the "tough, brittle" women at the army base. Beginning as parody, Hana-ogi's mimicry evolves (or, perhaps, devolves) into a testament to her devotion, her work little different in effect than that of Katsumi, who, Gruver observes with approval, "had obviously studied her man and had worked out every item of the day's work so that the end result would be a happy husband and a peaceful home" (165).

The homoerotic dynamics that undergird Gruver's obsession with the "mannish" (120) Hana-ogi remain unexplored by Michener and are finally subsumed within the novel's larger interest in the disillusionment of the postwar male. Like Joe Kelly, the American veteran of the 1940s and 1950s will return to his home "sore and defeated" (119), but,

unlike Kelly, he will find no gracious wife waiting to scrub his back. As Gruver laments, "My mother in thirty years of married life had never once, so far as I knew, done for my father the simple healing act that Katsumi Kelly had done for her man" (120).

The film, however, finds the postwar woman just as disillusioned. Eileen's infatuation with Nakamura—a subplot completely absent from the novel—suggests her own frustration with the rigid codes of middle-class sexuality. The Kabuki actor's ability to perform femininity is as compelling to her as Hana-ogi's performative masculinity is to Gruver. The film's fetishistic interest in Nakamura's body (revealed in shots of him undressing during costume changes and applying makeup while kneeling half-clothed before his mirror) validates Eileen's attraction, offering him to the audience as an elegant, polymorphous spectacle. (Hana-ogi's body, meanwhile, is of little visual interest to the film; the modesty of Japanese women, in fact, is positively contrasted to the physical display of American women in the first sequence, when Kelly's love for the kimono-swathed Katsumi is presented as more passionate than Gruver's love for the bathing suit-clad Eileen.) Nakamura declares a cryptic interest in Eileen, saying that "beauty is not confined to any one race" and then claiming that he is "not *necessarily* making love" to her. She agrees to see him with the slightly veiled remark, "I need to know more, much more, about everything." What she "learns," though, is only hinted at, for after Gruver tells Eileen that he will marry Hana-ogi, she runs to Nakamura, telling her mother, "There's only one person I'd like to talk to at the moment, and oddly enough, he's Japanese." Neither character is seen again in the film.

Regardless of whether Eileen turns to Nakamura on the rebound, the amount of screen time devoted to their developing relationship suggests the narrative centrality of the Americans' encounter with gender and racial ambiguity. This is most oddly underscored in the first Kabuki sequence of the film, in which shots of Gruver's discomfort with "male actresses" are intercut with shots of Nakamura's backstage costume changes and application of white Kabuki makeup. Like a reverse image of a minstrel performer, the cross-dressed Asian in whiteface materializes onstage before the uniformed American, his whiteness an obvious mask, his presence a challenge to the solidity and import of that uniform. It is here that Logan's and Brando's decision to recast Michener's discomfited American as a white southerner most clearly demonstrates their enlistment in liberal Hollywood's political project. By exploring

the fragility of the white southerner's facade, though—by, in effect, suggesting that the psycho-social problems of white Americans are most dramatically exhibited by the white southerner—the film employs the familiar class-bound logic of other reeducation films. Demoting Lloyd Gruver to the *behavioral* status of quasicracker, Brando and Logan set about breaking down and rebuilding the character's manhood through a system of punishment and reward: his potency is imperiled when he is a racist, but it is rejuvenated when he learns racial tolerance. Through his own moral conversion, he redeems the inherent goodness of the race and provides an object lesson for the recalcitrant. Like Hamish Bond in *Band of Angels,* Gruver does exactly the right thing for "the Great White Race." Southern white men of a different class would make the leap (when and if they did) at the point of a gun, their innate lack of "class" guaranteeing that yet another civil war would erupt over conflicting notions of white purity.

THREE

NATURAL ACTS

*Hillbillies, Delinquents, and the
Disappearing Psyche*

Unlike his privileged cousins in movies like *Sayonara* and
Band of Angels, the working-class southern white man would not be so
easily tamed. As education erupted into a regional flashpoint after 1954,
he became an increasingly problematic figure in American popular cul-
ture. News photographers, especially television cameramen, seemed
fascinated by his intractability, galvanized by the spectacle of his un-
guarded rage (fig. 14). The "lean-hipped men," Robert Penn Warren
wrote in 1956, with "weathered faces and hard, withdrawn eyes, usually
pale eyes"[1] were the new southern guerrillas, their "awful, hollow-eyed
look" (in the words of *Life* correspondent Dick Stolley)[2] a monolithic
mask of resistance.

The opponents of federally mandated school integration were, in
one sense, simply adding their voices to a rising national chorus chant-
ing its demands to teachers and legislators. With the rise of postwar
youth culture and the escalation of public interest in the power of ide-
ologues and advertisers to "brainwash" vulnerable members of a soci-
ety, the juvenile delinquent assumed center stage in a heated national
debate on the changing disposition and values of the American teen-
ager. Only in the South, however, did the different sides of the debate
converge in a rhetorically unified bulwark against the very *concept* of
public education in contemporary America.

Only in the South, moreover, was the "delinquent" often a social
activist rather than a disaffected dropout. As Pete Daniel has observed,
the young men across the nation who copied the sideburns, jeans, and
sexualized attitude of Marlon Brando, James Dean, and Elvis Presley
were the stereotypical rebels without a cause, chafing against the stric-

FIGURE 14. Southern delinquents: segregationists assault journalist Alex Wilson in Little Rock, September 1957. Photograph courtesy of Will Counts.

tures of their parents and schools. "The Central High School 'bad boys,'" however, and other gangs of vocal southern troublemakers "enforced their parents' segregationist ideology; they were rebels of a lost cause." Explaining the contradiction, Daniel notes that "popular culture had created sideburners' style and even musical preferences, but they rejected its message of cultural fusion. In their assault on the black students, they rebelled not against parents but against school staff and, in a larger sense, the federal government."[3]

While the poor southern white woman could find social enlightenment through romance with the proper outsider, her male counterpart seemed permanently mired in backwater ignorance. Unlike urban and suburban rebels across the nation, whose modern, angst-ridden alienation was glamorized and ultimately commodified by Hollywood, rural delinquents posed a more dangerous threat to the progressive ethos of postwar America. The movies might insist upon the southerner's reeducation, but obscured within liberal formulas for the reclamation of delinquent youths were politically sensitive questions about the educability of one segment of that population: Was the white south-

ern male beyond cultural rehabilitation? Was he, in fact, *incapable* of reeducation? If the answers were yes, the country faced a prospect more calamitous than communist infiltration. It faced a second civil war.

Identifying the Enemy

In retrospect, the countless inquiries during the 1950s into "threats" to the nation's young people seem unavoidably linked to racial anxieties. At the time, however, these threats appeared to spring unbidden from any number of cabals: urban gangs, record manufacturers, comic book publishers, "smut" peddlers, drug dealers, liberal college professors, Kremlin agents, extraterrestrials. In 1952, crime exposé writers Jack Lait and Lee Mortimer proposed an all-purpose theory of domestic decadence in their bestseller *U.S.A. Confidential:*

> Only of late has delinquency been tied to drugs. . . . It has been protected by Democrats and splinter parties, who get funds from drug dealers; and Socialists and Reds who find youthful resentment against constituted authority and morality encouraging. . . . No community, rich or poor, rural or congested is free from the plague of juvenile delinquency. . . . it is a fanatical drive tied up with religious and political overtones; a sort of secret society. Teen-agers speak their own mystic tongue. . . . Their cells are in juke-box joints . . . and hot record shops, especially the latter. Like a heathen religion, it is all tied up with tomtoms and hot jive and ritualistic orgies or erotic dancing, weed-smoking and mass mania, with African jungle background.[4]

This "strange brew," as Tom Englehardt has called it,[5] of crime, communism, atheism, drugs, sex, and "African" rhythms found its most willing imbibers (according to vigilant observers) among white teenagers. *Seduction of the Innocent,* Dr. Fredric Wertham's best-selling 1954 critique of comic books, lent scientific validity not only to the notion of "media effects" but to the national preoccupation with "brainwashing." Bolstered by Wertham's finding that comic books were "primers for crime,"[6] the U.S. Senate convened a Subcommittee to Investigate Juvenile Delinquency in 1954 and launched an attack upon the juvenile pulp literature industry. Wertham's role in a project that reinforced many Americans' belief that alien (i.e., communist) forces were behind this subversion of "innocent" youth is particularly ironic. As a liberal psychiatrist who had testified on behalf of the NAACP in the *Brown v. Board of Education* hearings, Wertham had long been committed

to addressing the debilitating psychological effects of racism on black Americans. In his 1951 study of Delaware children, for example, he noted that a white child had told investigators that her classmates wanted to tie up black children. "'The boys say that they [the Negro children] should work and we should play,' she said. 'I guess they got that from the comic books.'"7 Popularized notions concerning psychological manipulation, however, ensured that Wertham's concern with violence against black Americans would be misconstrued by many as a concern with violence against *white* Americans: the "seduction" of *their* innocence was the ultimate crime of the society's hidden persuaders.

Certainly, this interpretation—not Wertham's actual point—would account for the fervor with which communities in the Deep South embraced comic book censorship. In Memphis, for example, a city whose exposure to films and plays had been tightly restricted since 1928 by arch-segregationist Lloyd Binford, the mayor named a thirteen-member committee to judge "objectionable dime literature."8 Though the creation of a second tier of municipal censorship in an already efficiently policed city might appear to have been redundant, perhaps both the young age of the local comic book audience and the perceived urgency of the task seemed to warrant it. In fact, the mayor's action was spurred by a local newspaper campaign against comic books, which had been launched at the beginning of the 1954–55 school year—the first school term after the *Brown* decision. The threat of school integration, it seems, triggered broadly based anxieties about white children's vulnerability.

On the national level, the convening of the Senate subcommittee on juvenile delinquency was the most recent installment in a long-running series of congressional investigations. Estes Kefauver's televised hearings on organized crime, which won the Tennessee senator an Emmy in 1952 for "bringing the workings of our government into the homes of the American people,"9 had followed five years of anti-Communist investigations by HUAC and Joseph McCarthy. Such a rapid proliferation of "subversive" influences was no doubt responsible for the public's muddled perception of enemies in American society. To delinquency subcommittee chairman Robert Hendrickson, for example, the dissemination of crime comics aimed at the nation's youth necessitated a patriotic vigilance comparable to that of Hoover's FBI. "Not even the Communist conspiracy," he claimed, "could devise a more effective way to demoralize, disrupt, confuse and destroy our future cit-

izens than apathy on the part of adult Americans to the scourge known as juvenile delinquency."[10] Comic book publisher William Gaines, however, told the subcommittee that "the group most anxious to destroy comics are the Communists."[11]

In the South, the "strange brew" of American enemies was an intoxicating stimulant to those eager to expunge all traces of postwar change from their social landscape. Pete Daniel has noted that a typical Ku Klux Klan rally in 1958 featured a screening of *The Birth of a Nation* and attacks on alcohol and teenage sex—all to the accompaniment of "The Old Rugged Cross." "Religion, race, changing values, and juvenile delinquency all blended together in the minds of Klan members."[12] Like a funhouse mirror, southern segregationist rhetoric seemed to exaggerate the already distorted features of mainstream ideological fixations.

By 1959, such distortions were so conventionalized in the media that television writer Rod Serling caustically observed, "If you want to do a play about a man's Communist background as a youth, you have to make him instead a member of a wild teen-age group."[13] Hollywood had already proved his point in 1954, when the most prestigious film of the year aimed rhetorical attacks at a wide spectrum of social enemies. Skillfully exploiting postwar political confusion by blurring the line between the "self-appointed tyrants" of labor unions, Italian and Irish mobsters, and working-class juvenile delinquents, *On the Waterfront* managed to appeal to alarmists and apologists alike. Marlon Brando's Oscar-winning performance as conscience-ridden mob lackey Terry Malloy in the film followed by only six months his cult triumph as a marauding biker in *The Wild One,* and together the two roles would come to define the new American "rebel": white, working-class, and lawless but ultimately reformable.

White Rebels, Dark Causes

Although James Dean's suburban misfit in *Rebel without a Cause* (1955) seems an exception to the type, director Nicholas Ray's film was in many ways merely a CinemaScopic, mainstream version of the booming genre of teenage outlaw movies. Like *Blackboard Jungle* (1955), *I Was a Teenage Werewolf* (1957), and *High School Confidential* (1958)—among the most popular films of the genre—*Rebel* located a virulent strain of Lait's and Mortimer's delinquency "plague" in the nation's public schools, but, unlike its "grittier" companion films, it offered salvation to middle-

class youths in the form of enlightened law enforcement. Peter Biskind has pointed out that Dean's Jim Stark is "the most important target of social control" in the film. Guided through his crisis of rebellion by an understanding police officer, Jim internalizes the values of the state and, in turn, guides the reeducation of his entire family: "We know social control has succeeded," Biskind writes, "when patient becomes doctor, student becomes teacher, son becomes father, controlled becomes controller."[14]

For teenagers without Jim's country club parents, time-consuming education is replaced by swift physical force. For these working-class teenagers, the pull of the primitive is too strong and intellectual resistance and cultural allegiance far too weak. The signature high school film of the decade, *Blackboard Jungle*, made no attempt to disguise its class sympathies. The racially and ethnically mixed boys of North Manual High are destined to replace their fathers in blue-collar jobs, and their leader, "Irish Mick" Artie West (Vic Morrow), even envisions a jail term as a good way to avoid the draft. His black ally Miller (Sidney Poitier) listens to the counsel of dedicated teacher Rick Dadier (Glenn Ford) and goes the way of Jim Stark—in his case toward, we are to hope, the black middle class. West, however, stays a "hood" to the end, making the crucial mistake of attacking Miller ("You just keep your rotten mouth out of this, black boy") and cursing and threatening the teacher (fig. 15). Before hauling West and his last remaining buddy, Belazi, "downstairs," Dadier tells his class of newly reformed students that they are making "a big step forward." For these kids, there will be "no sliding back now."

This isn't the case for the teenaged antihero in *I Was a Teenage Werewolf*. For working-class Tony (Michael Landon), down and back are the only directions in his future. Tony's chronic aggressiveness endangers both his education and his social life; at the beginning of the film he beats up a fellow student on school grounds and is warned by a sympathetic policeman that his next fight will land him in jail. Trying to help the troubled boy, the officer recommends psychiatry as a way to "adjust." After Tony has frightened even himself with his sudden and inexplicable violence, he submits to hypnosis and drugs, the civic-minded psychiatrist's prescription for "human progress." Believing that "mankind is on the verge of destroying itself," Dr. Brandon (Whit Bissell) proclaims that "the only hope for the human race is to hurl it back into its primitive dawn, to start all over again." So, fueled by Cold War panic

FIGURE 15. The Hollywood delinquent: Artie West (Vic Morrow) confronts teacher Rick Dadier (Glenn Ford) in *Blackboard Jungle* (MGM Studios, 1955). Wisconsin Center for Film and Theater Research.

and scientific hubris, Dr. Brandon launches Tony on a trip, "a voyage of discovery" to uncover his "true self."

Yet this is hardly the kind of "trip" later extolled by the 1960s drug culture: Tony's "true self" turns out to be not simply a monster but an Old World demon, born of "peasants" and medieval "myths." "This is modern America, not the Carpathian Mountains," Dr. Brandon sneers at the police (who themselves have been informed of Tony's alter-ego by an observant "Old Country" janitor). The doctor expects his regression to lead Tony into "the primitive past" and that he himself will shape this raw material: "I'm going to transform him and unleash the savage instincts that lie hidden within," Dr. Brandon predicts. Unfortunately for him, those savage instincts are rooted far east of Freudian Vienna. The suspected malleability of the id is itself a myth here, and in its place is genetically hard-wired pathology, atavistic criminality: in short, "a thing." With biology like this, education is futile (a point made absurdly clear in the image of Tony-as-werewolf, with his drooling monster head protruding from a high school letter sweater). And

so, like West and Belazi in *Blackboard Jungle,* Tony is eliminated at film's end, shot down by police. Those who cannot be taught eventually learn the hard way.

While the most monstrous behavior in another movie, *High School Confidential,* is simply antisocial, the film nevertheless points to a similar provocateur: drugs. The Wheelers and Dealers gang is determined to "hook" all of the students on marijuana (one stalwart holdout is Michael Landon, newly reincarnated as a good boy, having apparently taken his lessons in *Werewolf* to heart). Here, however, the main pusher is an undercover agent, merely posing as a flamboyant delinquent to indict the mob—the real backers of teenage corruption, as it turns out. Within this scenario, the attitude of one English teacher that "there is no such thing as a bad boy or bad girl" is ultimately validated. Everyone here can be taught.

Not surprisingly, the moralizing conventions of teen outlaw films quickly became fodder for parody. In *The Delicate Delinquent* (1957), Jerry Lewis played half-wit Sidney Pythias, a gentle "apprentice janitor" mistakenly arrested with a street gang. Targeting both the liberal and conservative tendencies of the genre, the film lampooned the sociological pontificating of reformers as well as the disaffected stance of juvenile criminals. "I think you can handle kids without belting their brains out," the movie's crusading cop asserts, echoing *Rebel without a Cause*'s understanding police officer. "Am I nuts because I think that in that bunch of slobs out there, there may be one worth saving, just one? But that good one, if given a chance, can breathe, multiply. Now if that happens, every decent community benefits!" Predictably, Sidney blooms under the guidance of the progressive officer, becoming a policeman himself by film's end. His reformation, of course, is a joke, since he was never a delinquent to begin with. To complete the parody, the violent gang members who have tormented Sidney throughout the film gather in the last scene at his apartment for a counseling session, where they earnestly promise to try to change their ways.

Although cleverly mocked by *The Delicate Delinquent*, the liberal reformist attitudes of the teen outlaw films found their way into other genres of the era. In the social-problem drama *12 Angry Men* (1957), for example, a defendant whose fate is debated by a politically divided jury is visually coded as a Puerto Rican slum kid; Henry Fonda's impassioned plea to his fellow jurors to consider the demoralizing home environment of the defendant (a youth who has, Fonda assumes, "been

kicked around all of his life") wins an acquittal for the boy. In the romantic comedy *Teacher's Pet* (1958), a big-time reporter played by Clark Gable poses as a journalism student in Doris Day's class and wins her admiration with a story about a murder by a Puerto Rican "trigger-happy teenager." "People been throwing things in my face all my life. I guess I couldn't take it no more," Gable quotes the boy as saying. Excited by the "why" of the story, Day asks, "Was it because he's a member of a minority group, struggling to solve the complex problem of assimilation? Did society at large create the climate for this tragedy?" *Teacher's Pet* frames the issue of juvenile delinquency within the larger story of Gable's recognition of his own need for reeducation. As a defensive high school dropout who prizes experience over book learning, he comes to see the importance of formal education, even forcing his dropout errand boy to quit his job and return to school ("experience is the jockey, education is the horse," Gable tells him).

West Side Story, in its 1957 Broadway incarnation and 1961 movie adaptation, parodied to some degree what James Gilbert calls the "therapeutic model of explanation" for juvenile crime (most notably in the song "Gee, Officer Krupke"),[15] but it shared the conservative tendency of the teen outlaw genre to envision youth rebellion as inherently tragic. On the other side of the political spectrum, noir thrillers like Orson Welles's *Touch of Evil* (1958) depicted delinquents as one-dimensional Mexican thugs, leather-jacketed hoods who lurk in darkened alleys and hotels awaiting brightly lit American blondes like Janet Leigh.

As the recurring borrowed imagery in these extremely different genres demonstrates, the iconography of the teen outlaw film was steeped in the "strange brew" of the era's racial obsessions. Whether Puerto Rican, Mexican, or black, "darkness" signaled lawlessness, a condition in turn associated in the 1950s with the rise of rock 'n' roll. National media linked the music to juvenile delinquency, blaming it for riots, crime, and general immorality among teenagers. In the South, the sudden mainstream popularity of black-derived music hardly seemed unrelated to equally sudden federal orders to desegregate public schools. Was it merely a coincidence that Elvis Presley exploded on the regional scene less than two months after the *Brown* decision?[16] Across the South, the message was repeated by White Citizens' Councils: the new music that held white teenagers in thrall was "vulgar" and "savage." It was "jungle music," pure and simple. Segregationists could easily have saved *Teenage Werewolf*'s Dr. Brandon the trouble of regressing poor

Tony; in this new age, as Alabamian Klansman Asa Carter warned, through music alone "white boys and girls were turned to the level of the animal."[17]

The unexamined assumption of racially based attacks on rock 'n' roll—that innocent children were in fact savages in whiteface—fueled the urgency with which antirock forces argued their case. But this assumption also stoked the fantasies of many white teenagers. "Haven't you heard?" asks West in *Blackboard Jungle* as he smashes a teacher's valuable jazz records against the wall. "Music is soothing for the savage beasts." "The beast," of course, was loosed rather than soothed by rock 'n' roll; on that, critics and fans agreed. It is hard now to appreciate the fervor generated by Richard Brooks's choice of Bill Haley's "Rock Around the Clock" to accompany the opening and closing credit sequences of *Jungle,* but in several instances theater managers turned off the soundtrack when the song played, for fear of riots in the aisles. Memphis censor Lloyd Binford was forced to withdraw his ban on the film only after MGM threatened an injunction, and he was not alone in his condemnatory stance. The film was singled out by northern and southern politicians alike as an irresponsible display of a national problem. By 1958, though, the use of rock 'n' roll in the teen outlaw genre was so conventional that *High School Confidential* could open with Jerry Lee Lewis singing from the back of a truck without inciting theater owners' fears. Although the music was usually segregated in specific "performance scenes" (in a manner much like that of films of the thirties and forties, from which black performers were routinely excised by southern censors like Binford), the genre was able to integrate its racial preoccupations in other, sometimes peculiar, ways, which exposed a controlling racism at the heart of the seemingly liberated stories.

The most obvious integration "technique" was the inclusion in the cast of racial or ethnic minorities. If teen films were concerned with the reeducation of the troubled white male, his encounter—or flirtation—with social otherness was efficiently indicated by his association with black characters. Sal Mineo's Plato in *Rebel without a Cause* is not black, but his ethnic "darkness"—coupled with his strongly coded homoerotic attachment to Jim Stark—suggests his narrative function as the shadowed, sexualized alter ego of the central character (Jim's father even mistakes the dead Plato for his son at the end of the film). Further, Plato's parents have abandoned him, landing him in the sole care of his black housekeeper. As a free-floating cultural orphan in search of

"roots," Plato attaches himself to Jim and thereby ensures both Jim's resocialization and his own death, for once Jim sees the necessity of separating himself from his immature and lawless friend (and, by extension, his own former ways), Plato is brutally ejected from the film.

In *Blackboard Jungle,* Sidney Poitier's character, Miller, is called upon to perform two seemingly opposed narrative functions: to suggest on the one hand the proximity of white juvenile delinquents to black culture (and hence their "inherent" otherness and criminality) and, on the other hand (because this is a liberal film), the *deeper* criminality of the intractable working-class whites. Miller's conversion to establishment values (he will continue his education and give up gang life) allows the film to exploit the popular iconography of "coolness" to propose a new and improved postwar white man. Tough loser West, uneducable to the end, is sent "down" and out of the picture; tougher teacher Dadier ("Daddy-o," as the students call him), freshly scarred from an alley battle, bonds with Miller at the end of the film. Now street-smart and hip to "the score," Dadier looks on at his reformed friend in the final scene as Bill Haley serenades both the peaceful integration of North Manual High and the successful assimilation and coopting of black culture in mainstream film.

A subtler method of suggesting the encroachment of ethnic otherness into white teen culture was the adoption by certain characters of "hip" slang. In *High School Confidential,* for example, the ultracool leader of the "Wheelers and Dealers" marijuana gang (played by John Drew Barrymore) takes over an English class to improvise the tale of Christopher Columbus: "One day Chris was sittin' at the beach, goofin'. He dug that the world was round. And when this crazy idea stashed in his lid he swung over to the royal pad to cut up a few touches with a cool chick, Queen Isabella, who was a swinger." Oddly, in this suburban California high school, Barrymore's character is the only one with a distinctly southern accent. In terms of performance, of course, the accent lends itself to an easy dropping of *gs*—a requisite affectation of the jazz-inflected hip argot of the 1950s. Barrymore's "cool" dialect, like Brando's similarly incongruous southern accent five years earlier in *The Wild One* (in which he played an ultracool California biker), telegraphs a set of connotations that were, at the time, politically and socially charged. The adoption of racially ambiguous speech by disaffected whites in the 1950s was essentially an attempt to try out, or perform, a seemingly more liberated persona: the jazz man in whiteface, the hipster.

The White Negro

"The bohemian and the juvenile delinquent came face-to-face with the Negro, and the hipster was a fact in American life,"[18] Norman Mailer wrote in 1957. "The white Negro," according to Mailer, was an urban adventurer "who drifted out at night looking for action with a black man's code." This code, not surprisingly, evolved from "the art of the primitive" (341), which to Mailer was an existentialist stance appropriate for twentieth-century life: "The Negro," who "has been living on the margin between totalitarianism and democracy for two centuries," knows that "the only life-giving answer" is "to divorce oneself from society, to exist without roots, to set out on that uncharted journey into the rebellious imperatives of the self," to, ultimately, "encourage the psychopath in oneself" (339).

The racism implicit in Mailer's argument is hardly covert, yet, as a description of the ways in which white men—and men are indeed Mailer's subjects—read black culture, his essay is a handbook for achieving the very *de*socialization condemned by teen outlaw films. After all, "the psychopath is a rebel without a cause," he says, quoting psychiatrist Robert Linder, and this desocialization requires an absorption of "the existential synapses of the Negro" (341). Despite the boldness of this evolutionary leap from "antiquated nervous systems," however, Mailer's new racial hybrid sounds strangely familiar; and indeed he turns out to be the oldest of American icons: "a frontiersman," Mailer calls him, "in the Wild West of American night life" (339). Like James Fenimore Cooper's Hawkeye, the archetypal character Richard Slotkin has termed "the man who knows Indians,"[19] the refurbished contemporary white man has inside information in the new race wars. He is, in effect, the man who knows Negroes. If, as Michele Wallace has argued, Mailer was really insisting that "the major function of blacks was to produce a better white America, to humanize white men,"[20] his new urban man, although a character of the margins, was to play a central cultural role. Revivifying whiteness through an infusion of the black "lifeforce," Mailer's white Negro, in a reversal of evolutionary "progress," would lead the race *into* the jungle of spiritual fecundity.

Serving as a guide through the thicket of hip terminology, Mailer offers salvation to white men through sexualized *style*. But if marginality, criminality, and liberated sexuality are his sacraments, on one point both the apologist for hipness and its censors agree: white contact with

black culture *overwhelms* the intellect. Education falls helpless before the electric "lifemanship" of the Negro, which allows him to "communicate" and "swing with the rhythms of another." To become hip, one must abandon traditional ways of learning ("What makes Hip a special language is that it cannot really be taught" [348]; it is "a language most adolescents can understand instinctively" [343]; it is "a pictorial language" [348]).

Ironically, white America would come to agree that this instinctual new half-breed held the key to racial salvation. Instead of spawning a generation of liberated, black-souled whites, however, the white Negro would appear to mutate back into his distinctive original strains: the *de*educated bohemian (the white beatnik/hippie) and the *un*educated delinquent (the redneck). The latter would become a crucial player in the drama of white redemption during the civil rights era. Unlike Jack Kerouac's Dean Moriarty (who appeared the same year as Mailer's hipster), a man whose "'criminality' was not something that sulked and sneered" but "a wild yea-saying overburst of American joy," the rural delinquent would issue a resounding "No" to changes that had been "long prophesied, long a-coming."[21] Breaking laws in the name of white sanctity, the redneck would unknowingly condemn himself to racial limbo because of his inherent vulgarity, a vulgarity associated throughout the 1950s and early 1960s with black music and style. The working-class southern white man would bear responsibility for racism precisely because of his class-bound "blackness." In the process, whiteness itself would be absolved of criminality and the redneck, a cultural half-breed, would be ostracized from the very ranks of which he prided himself a member, sacrificed in an iconographic war of racial purification.

Educating the Redneck: The School of Hard Knocks

"The South," South Carolina journalist William Workman wrote in his 1960 book, *The Case for the South,* "has its share aplenty of individuals who think with their fists in the absence of anything else to think with."[22] The region's "po' white trash" (of which there are "more than enough") are "frequently anti-social" yet usually "kept in line." "When inflamed by liquor, by fleeting passion, or by occasional mob psychology," however, they threaten the carefully tended harmony of "decent" and "respectable" southerners through their "stupidity and viciousness." Using a rationale common among defenders of segregation, Workman blamed "Negro and Northern pressure" for the rise of

working-class lawlessness: "They think, or think they detect, an attitude more tolerant of their violence, at least insofar as that violence is directed against the forces which threaten the broad social order of Southern whites." Without external "agitation," in other words, the "low-down fellows" (139, 140) would stay in their place—precisely the logic used by segregationists to explain the rise in civil protest among black southerners ("We never have any trouble until some of our southern niggers go up North and the NAACP talks to them and they come back home,"[23] complained Sumner, Mississippi, County Sheriff Harold Strider in 1955).

The rhetorical linking of blacks and poor whites as easy targets of propaganda reveals an underlying assumption on the part of many southern whites about the role of public education in the region. The centuries-long denial of education to black southerners, of course, supported the logic of slavery and racial hierarchy, but the historically inadequate education afforded working-class whites extended the logic to encompass an entirely class-bound notion of educability. Just who could—and should—be educated, and what that education should comprise were matters of the highest concern, on the level of internal security. In 1958, Governor Orval Faubus was able to close all four Little Rock high schools for the school year; Virginia Governor J. Lindsay Almond followed suit, closing nine high schools that were under federal integration orders.

Such radical examples of resistance, however, were not rash improvisations. The preparation for educational shutdown had begun throughout the South years before. In 1952, South Carolina voters (undoubtedly, as in other southern states, predominantly white) approved a measure that *repealed* constitutionally guaranteed free public education; in 1954 (six months after the *Brown* decision), Georgia voters approved a constitutional amendment permitting the establishment of private segregated schools; seven months after the *Brown* decision, Mississippi voters approved a constitutional amendment empowering the state legislature to "abolish" public schools and to "dispose of school buildings, land and other school property"[24]; in 1956 Alabama voters approved a "freedom of choice" amendment to the constitution allowing state funds to be used for private schools; and in the same year, North Carolina voters approved a constitutional amendment allowing local school boards to close public schools.

Although several open-schools coalitions in Arkansas, Virginia, and

Georgia were able to halt school closures (after, it should be noted, often lengthy suspensions of classes), the massive abandonment of the region's educational system, coupled with vigilante attacks upon teachers, students, and school property (the bombing of the integrated Clinton, Tennessee, high school in 1958 being perhaps the most notorious example), indicates that upon one point segregationists and Supreme Court justices were in agreement: schools were the seedbeds of social change. The white southerner, William Workman wrote, agrees with the high court's claim that education "is a principal instrument in awakening the child to cultural values . . . and in helping him adjust normally to his environment" (238). What the white southerner fears, however, is alternative—hence unacceptable—interpretations of the words *culture* and *environment*: "He wants his children," Workman said, "to absorb the 'culture' and preserve the 'environment' which reflect the social traditions of white society in the South" (238–39). Rather than "surrender all hope of transmitting their own cultural heritage to their children" (302), then, white southerners would embrace "the sensible alternative": the dismantling of the entire public education system.

Those who would suffer most from this sensible alternative would be the poorest of both races, children whose parents could not afford tuition at hastily fashioned private schools. Even though the broadminded segregationist might agree that both groups stood to gain from exposure to the "heritage" of powerful whites, the price was too high. "It takes no hydraulic engineer," Workman argued, "to realize that the linking of two reservoirs of different levels necessarily means the lowering of one to bring about the raising of the other" (239). Thus it was decided that "po' white trash," their education sacrificed in the name of a heritage far removed from their own experience, would continue to "think with their fists." If education in the South was largely a social project, the ejection of poor whites from that project would be mirrored in the very antisocial behavior noted by William Workman, as white attacked black to claim mastery in the arena of the socially abandoned.

The Southern Delinquent and Internal Security

To the rest of the nation, debate concerning the role of schools in the socialization of youth grew more complicated after 4 October 1957. The urgency of combating delinquency and drugs waned in the wake of the USSR's successful launching of *Sputnik*. Upgraded science education became a national imperative, and schools were enlisted in the

Cold War. The news of civil chaos in Little Rock in conjunction with intellectual achievement in the Soviet Union created a jarring ideological paradox that autumn, for while the failure of American science seemed validated and even predicated by the visible failure of American education, the opponents of the educational system—those who might be, in *Time*'s words, giving "aid and comfort to Communism"[25]—were avowed patriots. To many Americans, and to the federal government, the rioting segregationists in Little Rock were simply outlaws, but to many other Americans, and especially many white southerners, the outlaws were law-abiding citizens—*state* law–abiding, that is. The legality of racial segregation in Arkansas, in the terminology of states' righters, nullified U.S. Justice Department desegregation orders. To be a law-abiding Arkansan, then, was to be a federal outlaw. "What Communism has been to the rest of the nation," Workman wrote, "so integration is to the South—something so undesirable, so foreign to the domestic way of life, so fraught with danger to present and future generations that it is fought on every front, including the educational" (245).

The shifting and mutable definitions of *foreign* and *domestic* values during the era often seem in retrospect impossibly tangled. To many Americans above the Mason-Dixon Line, the South itself was a foreign territory, riddled with subversive (i.e., antifederal) lawlessness. Calvin Trillin has said of his days as a civil rights reporter during the early 1960s, "Sometimes after working in Mississippi for a few days I'd drive to Memphis to write my copy and send it out. When I called my office, in Atlanta, I'd say, 'I've slipped over the border.'"[26] Complicating a perceived communist threat from both without and within the United States, then, was a right-wing threat.

The attempt by many white moderates below the Mason-Dixon to defend the region's integrity was consistently undermined by segregationist violence. To moderates, an "outside agitator" was not necessarily a Yankee or a communist; he could be a fellow southerner bent on disrupting integrated classes or, worse, harming anyone obeying federal law. In 1955, for example, townspeople in rural Hoxie, Arkansas, blamed a boycott of their newly desegregated schools on urban activists. "Outsiders from Little Rock caused all of the trouble here," elementary school teacher Helen Weir remembers, noting that the sudden influx of modernized, chrome-laden cars into Hoxie was a sure sign of the town's invasion by outside forces.[27] During the Central High School

crisis in Little Rock two years later, the local agitators who had traveled to Hoxie now seemed outnumbered by colleagues from across the Mid-South; as one resident told newsmen, "If I were back in the newspaper game . . . I would be interested in how many of these cars are not from our county at all."[28] On the other hand, organized resistance to the 1956 integration of Clinton High School in Tennessee was led by New Jersey native John Kasper, a graduate of Columbia University and former manager of a racially integrated bookstore in Greenwich Village. Kasper's alliance with regional segregationists ("strangers," teacher Margaret Anderson called them, "from Alabama, Georgia, Mississippi"[29]) pitted him squarely against many townspeople who organized their own home guard to battle the outside agitators.

Kasper's staunch anti-Communism, abetted by his adoration of Mussolini-sympathizer Ezra Pound, stood as an indication that for radical segregationists of the time, the lines between outsider and insider, foreign and domestic, were more unambiguously drawn than they were for either integrationists or moderates. To adamant segregationists—whether northern or southern—the national government itself was an invasive force, an agent of Communist-friendly race-mixing. If Soviet education appeared to be superior to American, then intellectualism itself was ideologically suspect—all the more reason to support the South's *socially* based educational system. To the nation at large, however, an educated northerner like John Kasper was an ideological anomaly; in the iconography of civil insurrection, the white southern delinquent, through his lawless resistance to federally defined education, would signify an urgent challenge to national security.

Satirizing the Red(necked) Menace

As it had for decades before the postwar era, the uneducability of the poor white southerner seemed a correlative of his inherent foreignness to mainstream American culture. As the growing ranks of popular nightclub and recording comedians discovered during the late 1950s and early 1960s, the combination proved to be commercially durable. "Our captain has a handicap to cope with, sad to tell," lamented Harvard math instructor-turned-satirist Tom Lehrer in a 1959 song about life in the U.S. Army. "He's from Georgia, and he doesn't speak the language very well."[30] By 1965, the alienation of the South from the rest of the nation provided the punch lines for spoofs of Lyndon Johnson's eagerness to send Marines "to the shores of Tripoli / But not to

Mississipoli"[31] and the global acquisition of nuclear weapons ("Lux-
embourg is next to go / And who knows, maybe Monaco? / We'll try to
stay serene and calm / When Alabama gets the Bomb"[32]). Lehrer's vision
of the South—"the land of the boll weevil, where the laws are medie-
val"[33]—was shared by other, more popular, comedians. Woody Allen
told tales of northern Jews trapped "down South" by Klan members
and forced to sell Israel bonds to escape, and Lenny Bruce claimed that
because "Mississippi is like the Amazon," the government should estab-
lish "Radio Free South."[34] Yet of all the comedians mining the politi-
cal absurdities of the region, Bruce alone questioned the source of the
humor, and pondered what seemed to be the essential ludicrousness of
the white southerner himself:

> I wonder . . . if we'll ever see the Southerner get any acceptance at all. I
> mean, it's the fault of the motion pictures, that have made the South-
> erner a shitkickuh, a dumb fuckhead. . . . But it's just his sound. That's
> why Lyndon Johnson is a fluke—because we've never had a president
> with a sound like that. Cause we know in our culture that "people
> who tawk lahk thayat"—they may be bright, articulate, wonderful peo-
> ple—but "people who tawk lahk thayat are shitkickuhs." As bright as
> any Southerner could be, if Albert Einstein "tawked lahk thayat, theah
> wouldn't be no bomb."[35]

Several southern comics of the time no doubt agreed with Bruce's
assessment, and adopted the "dumb hick" stereotype for ironic, often
satirical, purposes. Brother Dave Gardner, for example, a musician and
standup comedian from Jackson, Tennessee, achieved a measure of
national fame after successful appearances on *The Jack Paar Show* in the
late 1950s. His routines, many of which were recorded and sold respect-
ably, took the guise of backwoods revival preaching ("Dear Hearts," he
often began, interjecting shouts of "Hallelujah!" and "Glory!" through-
out). But his musings were far from rustic; a self-described "fanatic
without a cause,"[36] Brother Dave encouraged his listeners to revel in
the pleasures of drugs, sex, and beatlike "grooving" and "meditating"
on "the freedom pendulum of the essence of ideation."[37] "When we
leave the realm of dualities, that's when we commence to swing,"[38]
he intoned. William Lightfoot has noted that "several components of
Brother Dave's ideology . . . were consonant with the value orientations
of America's flower children,"[39] but one component in particular was
distinctly out of synch with the emerging counterculture. Brother Dave's

racism became blatant toward the end of the 1960s, when, as Lightfoot has pointed out, he grew increasingly defensive about the South. He was, he repeatedly proclaimed, "a southern cat who *loves* the South! I mean every section of it and everything in it." Moreover, he was "just sick and *tired* of making excuses for bein' white."[40]

That Brother Dave's incipient racism had resided rather comfortably (at least for many listeners) within an otherwise "transcendent" and "swinging" sensibility during the 1950s and early 1960s indicates one of the central dilemmas of white "liberation" in the era. Like the "instinctive" argot of Mailer's white Negro, Brother Dave's hip riffs were imitations of black style, jazz-based emulations of "primitive" communication. Yet, unlike Mailer's hero, Brother Dave often employed the style for precisely the *opposite* effects of those intended by Mailer. In high-pitched, exaggerated southern black accents, complete with hip vocabulary ("man," "flip," "bugged") and languorous delivery punctuated by rhythmically placed finger-snaps, Brother Dave tended to reinforce stereotypes of black superstition and ineptitude. In his retellings of opera plots or Shakespearean tragedies, however, his delivery complicated such inferences. This was most apparent in his rendition of *Julius Caesar,* in which Brother Dave's default voice of white deacon alternated with that of his resident black character and that of "Morolon Brando." Brando had played Julius Caesar in Joseph Mankiewicz's 1953 film adaptation, so Brother Dave here capitalized on Brando's hip persona, and his impersonation of the actor sounded like a parody of Brando's southern / black-inflected accent in *The Wild One:* "Mark Anthony say, 'Hey, Julius,' and Julius say, 'Huh?' He say, 'Hey, Julius, like what you want 'round you, man?'"[41]

The comedian's effortless blending of voices—southern white, southern "black," white Negro—does not indicate cultural proximity so much as cultural dominion, for the last two voices are *interpretations* or *imitations* on the part of the first. The easy accommodation of racist mimicry and hip posturing within the rural white man's performance style suggests that rather than operating as a beacon of liberating "*psycho-*pathology," as Mailer would have it, the hipster might have functioned as a repository of regressive *social* pathology. A figure whose "blackness" was itself a fiction, the white sociopath was embraced by liberals for his "primitiveness," but white southerners (like Brother Dave) perhaps saw more clearly—and even celebrated—the conservative political purposes he served. (Indeed, by the mid-1960s, segregationists would con-

sistently point to the alliance between "beatniks" and black activists as evidence of "mongrelization" in action.)

In his distorted retellings of well-known operas and plays (which featured his own helium-voiced versions of arias), Gardner exploited the perceived gap between High and Low cultures; Shakespeare it seems, was just *funny* when related by a southerner. "Hail, Brutus!" Cassius yells in Brother Dave's "Down Home Players" version of *Julius Caesar.* "Hail, yes!" Brutus replies. "Et tu, Brute?" Caesar asks. "No, man, I ain't et nothin'."[42] Yet Brother Dave's monologues on education were hardly the stuff of hillbilly anti-intellectualism: "That's why I love to work for school audiences, is because it's good—you know, colleges?—is because there's one thing that I've learned about higher learnin', and that's to get high and learn!"[43] Gardner's embrace of a drug-attained "spiritual-ity" and "oneness," coupled with his equally passionate embrace of ra-cism (to the point of entertaining a Klan Grand Dragon in his motel room),[44] marks his anomalous position among successful comedians of the era. Moreover, his ability to straddle both poles of contempo-rary social pathology—*de*educated hipsterism and *un*educated delin-quency—indicates the degree to which race undergirded such seem-ingly opposed modes of white rebellion.

Stanislavsky's Yokel: Andy Griffith and A Face in the Crowd *(1957)*

Most successful among southern comedians was North Carolinian Andy Griffith, a Chapel Hill graduate who, like Gardner, recorded nightclub retellings of Shakespeare and opera plots ("Hamlet," "Romeo and Juliet," "Andy and Cleopatra," "Opera Carmen") which became comedy hits in the mid-1950s. Posing as a country rube encountering "culture" for the first time (his first recording, "What It Was, Was Foot-ball" [1953], had situated his character as remote from even *popular* cul-ture), Griffith delighted national audiences with his naive simplifica-tions of classic works. "It's a pretty good show," he said of *Hamlet.* "And the moral of it is, though, I reckon, if you was to ever kill a fella and then marry his wife, I'd be extra careful not to tell my stepson."[45] Intro-ducing his version of *Carmen,* he told an audience, "Now I know that you all say that opera ain't nothin' but hollerin'. And it ain't. But, well, it's high-class hollerin'. But the real, real high-class singers have got these high roofs to their mouths. Some of 'em is two or three inches way back

up here—fact, some of 'em is so high they ain't hardly got to know where to hook their teeth on."[46]

Andy Griffith's canny manipulation of mainstream prejudices often eluded critics, who preferred to laud the performer's "natural" charm. Griffith himself remembers his first agent calling New York from North Carolina to gloat, "I've found a real Li'l Abner!" "I guess that did something to my mind," he says. "I didn't consider myself a Li'l Abner."[47] Nevertheless, he found himself repeatedly cast in Abneresque roles. Winning rave reviews for his television, stage, and film portrayals of hillbilly Will Stockdale in *No Time for Sergeants* and even stronger praise two years later in Elia Kazan's film *A Face in the Crowd* never fully dissipated the public perception of Griffith as an actor who merely "played himself."

During the immensely successful run of *The Andy Griffith Show* (1960–68), profiles of Griffith consistently alluded to his inherent lack of sophistication. A 1964 article in the *Saturday Evening Post,* for example, took pains to note that although "critics and public assume" that Griffith's portrayal of Sheriff Andy Taylor "is largely a self-projection," "closer inspection . . . reveals there is much more to Andy Griffith than meets the CBS eye."[48] Producer Danny Thomas may claim that Griffith "is just a normal hillbilly," the author warns, but the former country boy has been "reshaped by show business and Southern California": "He knows now what room service is. He has learned to yell '*Ole!*' with the bullfight crowd in Mexico. He enjoys concerts and opera and talks knowledgeably of music, from Mozart to Monk. He tips well. He can read a wine list. He has developed a taste for fettuccini and enchiladas, and he knows a little delicatessen where, he says, 'They fix the most dee-licious knishes'—which is a long way from grits." A later mention that Griffith had majored in *music* at the University of North Carolina is offered without irony, for, as the *Post* author notes, the salubrious cultural effects of California cannot eradicate the "strong residue of the backwoods Tarheel." In fact, it is Griffith's rusticity which dominates his appearance, despite the best efforts of Hollywood "reshapers": the actor has a "thickish forest of rust-brown hair," he is a "walking example of the rumpled look," he is "true to his mountain nature." He is, in short, "a contradictory picture": urban sophistication layered (but not grafted) upon rural artlessness.[49]

"I ain't no Shakespearean actor, that's for day-yum sure," *Coronet*

magazine quoted Griffith as saying in 1957. How, then, were critics to explain his masterful performance as country demagogue Lonesome Rhodes in *A Face in the Crowd* that year? Screenwriter Budd Schulberg claimed that his and Kazan's decision to cast Griffith had not been easy: "Griffith could give us the hillbilly stuff all right, but what about the power madness that dominates the whole second half of the picture? Andy seemed pretty one-dimensional with his quaint backwoods expressions and wide-eyed innocence. But we sensed another sort of talent underneath—an untapped strength, a wolf-in-sheep's clothing kind of thing." Indeed, it was Kazan—film and stage director of Brando, interpreter of Tennessee Williams, and acclaimed practitioner of the Method—who "wrung" a stellar performance from the hillbilly. "Just a hunch," the director called his casting, but, as critics were quick to point out, it was casting by "an authentic genius." Publicity for *A Face in the Crowd,* in fact, repeatedly emphasized Kazan's ability to "wrench" a terrifying performance from a man "who looks more like a pro football player than an actor."[50] For Griffith, however, the encounter with Kazanian Method acting proved nearly disastrous. "I *became* Lonesome Rhodes," Griffith told the *New York Times.* "It was something bigger than I was and it might have got to control me."[51] Kazan, it seems, had gone looking for "chinks" in Griffith's psychology, a technique typical of New York–based performance training of the era.

Deriving from the work of Konstantin Stanislavsky in the early twentieth century, the various branches of American Method acting, according to James Naremore, point to "a stylistic or ideological leaning within fifties culture"[52]—namely, the investment in expressionist-realist acting as a *sign* of psychological "reality." Teachers of Method acting (namely, Lee Strasberg, with whom Elia Kazan had worked early in his career) stressed "a quasi-Freudian 'inner work' fueled by an obsession with the 'self,'" with the teacher (or director) functioning as "analyst."[53] Kazan's own turn to psychoanalysis no doubt contributed to a reliance on ego-excavation with his actors. "Directing," he wrote in his notes for *A Streetcar Named Desire,* "finally consists of turning Psychology into Behavior."[54] But again, as Naremore rightly notes, the Method

> was never intended to refer to a performing technique in the strictest sense. It consisted of a series of quasi-theatrical exercises, often resembling psychological therapy, designed to "unblock" the actor and put

him or her in touch with sensations and emotions. Most of all, it tried to develop an "affective" or "emotional" memory. . . . Players . . . learned to manipulate buried sensory recollections and the Stanislavskian "as if," thus appearing more natural and spontaneous. Technically, they were not "living the part."[55]

In the hands of Elia Kazan, however, Andy Griffith "lived the part" of Lonesome Rhodes; according to the *New York Times,* he became "possessed."[56] Operating as pseudoanalyst, Kazan discovered that while growing up in Mount Airy, North Carolina, Griffith had been called white trash. Finding what appeared to be the key that would unlock "the wolf" under Griffith's congenial hillbilly surface, Kazan took to whispering "white trash" to his actor before crucial scenes. Not surprisingly, Griffith began to feel "left out" of conversations among the cast about "art or literature" and was "mocked" by them on the set for his "ignorance." The result of such tactics? According to the *Times,* "a fine psychotic day's work." His life off the set suffered dramatically, however, from the psychological ravages of work. "You play an egomaniac and paranoid all day and it's hard to turn it off by bedtime," Griffith confessed, talking about the state of his marriage during the Kazan shoot. "We went through a nightmare—a real, genuine nightmare, both of us."[57]

For Griffith, "manipulating" his "sensory recollections" was out of the question. "I can't just play-act a part; I have to *be* it."[58] The careful distancing of performance from self which is essential to the craft of Method acting was not, it appears, encouraged by Kazan; indeed, Griffith claimed to have no training in acting ("It's just the way I feel, is all").[59] Unlike fellow actors, whose immersion in roles was proof of their artistry and commitment, Griffith could only apologize for his emotional absorption during the making of *A Face in the Crowd.* About his rampage during the final sequence of the film, he said, "It was a terrible thing . . . [and] frightened me far enough so I'll never do it again."[60] Despite the critical acclaim for his performance, Griffith was quick to assure his audience that his descent into artistic madness had ended. The *Coronet* profile quoted "an associate of long standing" as saying that Griffith "talks and acts like your country cousin" because "it's his way of saying, 'Look, I'm not getting big-headed or carrying a torch for myself. I'm just a guy from Mount Airy, North Carolina, who got a lucky break. And that's the way I mean to stay.'" The encounter

with New York intensity, according to publicity after the film, had simply overwhelmed "the barefoot boy from out yonder."[61] His rural naturalness apparently precluded continued training in Method acting; resisting the notion—or even the possibility—of a self/persona split, Griffith could not aspire to the artistry of a Brando or Paul Newman. As a yokel, he could only *play* yokels.

As Griffith himself understood, his own professional dilemma mirrored that of his character in the film and was in some ways a self-fulfilling prophecy. Rising to the expectations of his director, he diligently worked to excavate and expose the emotional rawness that Schulberg and Kazan had gambled upon. The revelation of the "wolf in sheep's clothing" validated their artistic hunch and certified the "dimensionality" of their actor. To suggest, though, that Griffith's roiling crudity might itself have been a performance, an *enactment* of rage, runs counter not only to the received wisdom of Method training but also to the logic of the film itself. Despite its self-reflexive concern with performance, *A Face in the Crowd* is profoundly committed to the notion of psychological nakedness. The film seems to condemn the deceptiveness of "self-appointed tyrants" (Kazan's phrase from the opening crawl of *On the Waterfront*), but politics ultimately takes a back seat to the driving force of the narrative's evil: the unadorned will to power. The machinations of the film's effete industrialists, milquetoast politicians, and media-savvy admen pale beside Lonesome Rhodes's frenetic, intensely physical self-aggrandizement. Behind the smiling face of the southern hick—the face of "just plain folks" (Rhodes's recurring theme song)—lurks the "Demagogue in Denim" (the title within the film of a tell-all biography of the character). Fascism here has no politics; it is class run amok, the triumph of untutored aggression.

A Face in the Crowd flirts with the idea that folk culture—specifically, southern rural culture—may be nothing more than the romantic construction of progressive education and exploitative advertising. Lonesome Rhodes, after all, is "discovered" by Sarah Lawrence graduate Marcia Jeffries (played by Patricia Neal) in jail when she interviews inmates for her radio program, "A Face in the Crowd". Having been arrested on a drunk and disorderly charge on the Fourth of July, Rhodes agrees to sing for Marcia in exchange for his freedom. Excitedly telling her listeners that "back East . . . I learned that the real American music comes from the bottom up," she promptly dubs her star "Lonesome" and helps him land a featured spot on her uncle's radio station. Rhodes's

commonsense, homespun chatter is an immediate hit, and Marcia begins to realize not only the charismatic potential of her discovery but also his malevolent ambition as well. Leaving town in a blaze of glory to star in a Memphis television show (fig. 16), Rhodes, in an unguarded moment, mutters, "Boy, am I glad to shake that dump," providing the film's first jarring indication of the man's unrustic cynicism.

Despite the irony of these first sequences, though, the film falls victim early on to the same tendency to exoticize rural culture that Marcia Jeffries displays. The opening credits appear while a slowly whistled tune accompanied by a single guitar provides the musical introduction to the setting itself: the small-town South, its dusty courthouse square filled with white men in shirt sleeves, overalls, and straw hats playing checkers and chewing tobacco. The semidocumentary look of the film's initial black-and-white photography, however, connotes more than simple summertime languor. By 1957, as readers of news magazines and viewers of network news were increasingly aware, summer was the season of "trouble" in the South, and courthouse squares like those in Sumner, Mississippi, and Clinton, Tennessee, were becoming less places of fraternal mingling and more sites of confrontation, not only between local townspeople and the northern press but between formerly peaceful white neighbors. Kazan and Schulberg attempt an "insider's" perspective by making the journalist figure a well-ensconced member of the community, yet Marcia's exposure to northern education, coupled with her relative wealth, ensures a cultural distance from her northeastern Arkansas hometown and from the "bottom" stratum she will both explore and exploit. Like Mel Miller (played by Walter Matthau), the "Vanderbilt '44" graduate who studies and documents Rhodes's abusive rise to success, the film's sympathetic southerners are college-educated professionals, ardent anthropologists among the region's natives.

Kazan and Schulberg establish their liberalism in the second sequence of the film, when the town sheriff (conventionally overweight and sweating) tells a black inmate to perform for Marcia's microphone. "Just because I got black skin I ain't no minstrel man," the prisoner replies. It is left to Lonesome Rhodes to play the role, which he does with violent energy, to the delight of Marcia and her listeners. Later, Rhodes's introduction of a destitute black woman on his television debut in Memphis—a move that "takes guts," Mel exclaims—pushes his characterization into seemingly unstereotypical territory. In developing the notion of an unprejudiced redneck, however, Kazan is fol-

FIGURE 16. The hillbilly as demagogue: Andy Griffith as Lonesome Rhodes in *A Face in the Crowd* (Warner Brothers, 1957). Wisconsin Center for Film and Theater Research.

lowing a pattern laid down earlier by Robert Penn Warren in his fiction-alized treatment of Huey Long's career. In the film version of *All the King's Men* (1949), in fact, the populist-driven fascism of "red-faced and red-necked" Willie Stark,[62] like that of Lonesome Rhodes, seems par-ticularly menacing *because* of its relative freedom from southern racism. But while the regionalism of Stark's story is not a primary focus for director Robert Rossen, Rhodes's regionalism is crucial to Kazan's nar-rative.

Lonesome Rhodes had first appeared in 1954 in Schulberg's short story "Your Arkansas Traveller" as a cowboy singer who makes his name on a Wyoming radio station. "He's big and he's Western," Marcia, the story's narrator, says.[63] And although Rhodes is, as he is in the film, from Arkansas, he is not sketched as specifically southern but rather as "a big Western clown" (10). Marcia calls him a businessman in "the sheep's clothing of rural Americana" whose act appeals to people's "Amuricanism" (23, 11). He wins his first job singing—but not the blues, as he does in the film; here, he yodels "Bury Me Not on the Lone

Prairie." His success leads him to Chicago and finally to New York. By the time Kazan and Schulberg adapted the story, however, they had made significant changes in the story's setting and characterizations, shooting Rhodes's rise-to-fame sequences on location in Piggott, Arkansas, and Memphis (instead of Chicago), and depicting Rhodes as decidedly southern. By 1957, these alterations were undeniably politically charged. The new regional inflection of the story and the addition of overt racial commentary indicate the degree to which the filmmakers had shifted their attention from the tyranny of fabricated "Amuricanism" to a more immediate threat: the tyranny of *southern* populism.

Until Rhodes achieves national stardom, his performance in front of microphones and cameras walks a tightrope between shameless buffoonery and homespun naiveté, yet his willingness to play the minstrel seems "naturally" derived: his father was a con man, and his own "act" appears to have grown out of the rural culture of Riddle, Arkansas. Rhodes's meteoric popularity is predicated upon this perceived naturalness, yet the notion that "natural" behavior might itself be a performative concept, that our perception of ingenuousness might to varying degrees be conditioned by dramatic convention, is a notion strangely alien to Rhodes's media-savvy promoters. Why this is so says much about Kazan's understanding of his own audience and our willingness to believe, like Marcia, that "real American" artistry is no artistry at all. At every stage of his career Rhodes demonstrates a finely tuned awareness not only of his own facade but also of the very mechanics of popular entertainment. Continually demystifying the image industry for his audience, he appears to be an awe-struck naif encountering technology for the first time. He delights his radio listeners by letting them in on the details of production; his first time on television, he talks directly to the camera operator, turns the monitor toward the camera, and tells his viewers about the "big red eye" staring at him. Yet the obvious ease and sophistication he demonstrates in his television debut, which becomes a monologue about the loneliness of urban dwellers, bespeak homespun honesty to Marcia and Mel, a "realness" unattainable by those who are more educated. "The way he talks about walking the night," Mel marvels, "why, I couldn't write it that well."

In this scene, the film introduces a critique of the commodification of "country" culture, but the flim-flam of television appears trivial when compared to the pitch of the film's ultimate huckster, Rhodes himself. Before walking in front of the camera, Rhodes impatiently wipes off

the makeup applied backstage, and wastes no time removing the clichéd straw hat and hayseed thrust upon him by stagehands. "Just be perfectly natural, easy and relaxed, and real country," the director tells him, as the new star sits warily in front of a plantation-scene backdrop. Later, Rhodes dares to mock his sponsor on the air, a move which thrills his fans and enrages the sponsor. Not surprisingly, the sponsor's profits skyrocket from the publicity, yet Rhodes is ordered to submit his scripts for prior approval. "There ain't no scripts! It's just me!" he protests. His casting off of stereotypical props and hackneyed sales pitches in favor of an unadorned, direct address to the audience is another indication of his uncanny dramatic instincts, yet unlike typical "rise-to-fame" movies in which the main character's mystifying talent causes the character (who is after all only a *vehicle* for the talent) a fair degree of emotional pain and victimization, *A Face in the Crowd* casts its natural-born wonder as a fully conscious manipulator and exploiter of himself. It is he who victimizes others, and he—not a scheming manager—who fully grasps the commercial dimensions of his persona, crafting a sellable image for himself by tweaking the iconography of low culture into an electronically viable form. Like Kazan himself, who, with Brando, developed a new idiom of media naturalism, Rhodes carves a bright path through the phoniness of television imagery. But the sheer consciousness of *his* artistry (unlike that of Kazan's and Brando's) suggests an inherent cravenness on Rhodes's part, a willful flouting of artistic tradition. As an intelligent hillbilly, a self-aware pea-picker, Rhodes is a cultural mutant. His downfall is assured from the moment he performs for Marcia to win his release from jail.

The film's narrative tension, however, hinges on Marcia's protracted refusal to acknowledge that her jailhouse discovery has all along been a well-crafted persona. Marcia's devastating realization is clearly intended to be ours as well: *we* have been cheated and deceived. In the America envisioned by Kazan and Schulberg, folk culture is serious business. Corporate moguls like General Haynesworth (who bankrolls Rhodes's rise to glory) and politicians like Senator Worthington Fuller (for whom Rhodes provides some "Madison Avenue coaching") are expected to be adept panderers; rural jailbirds singing of freedom and whiskey are not. When they are, their motives seem particularly base, even demonic (unlike those of the film's advertising executives, for instance, which are "purely" economic). The immensity of Rhodes's cultural transgression is matched by the Sturm und Drang of his down-

fall. "The time is right to pull the mask off him, let the public see what a fraud he really is," Mel tells Marcia as he prepares to publish *Demagogue in Denim.* In turn, on behalf of *us,* Marcia switches on the microphone feed during the final credits of Rhodes's program, exposing to the nation at large the "real" Lonesome Rhodes. "Those morons out there?" he snickers, pointing into the camera lens. "Shucks, I can take chicken fertilizer and sell it to 'em for caviar. I can make 'em eat dog food and they'll think it's steak. . . . You stupid idiots," he sneers, looking out at his audience, "you miserable morons." All along, viewers learn with horror, Rhodes has been . . . an actor! Worse yet, an *insincere* one, keenly aware of the distance between persona and performer. "Why, he's a monster," one irate viewer exclaims after hearing his unguarded remarks.

Ironically, though, this overwrought—and some might say overplayed—scene functions more as a revelation of Kazan's underlying assumptions about the character than as a plausible turn of events in the narrative. As a purely rhetorical moment, it articulates a chilling political logic at work—not in Rhodes's creaky take on power but in the film itself, for what begins as an energetic warning of the dangers of fascism ends with a vigorous and perhaps unintentional embrace of elitism. "The mass has to be guided with a strong hand by a responsible elite," General Haynesworth lectures Rhodes early in the film, yet Rhodes, the intended puppet of that elite, overthrows his patrons to emerge a singularly lethal threat to democracy. He becomes a highly sought-after political consultant, teaching untelegenic presidential hopeful Senator Fuller the finer points of media manipulation, and develops a new program for himself, *The Lonesome Rhodes Cracker Barrel Show,* which he says will feature "a whole bunch of colorful, country-lookin' characters all settin' around listenin' to Lonesome Rhodes sound off on everything from the price of popcorn to the hydrogen bomb." He is, he tells the General, "an influence, a wielder of opinion, a force."

Mel limply reassures Marcia at film's end that although despots may rise to great heights in a democracy, "we get wise to them. That's our strength." But we, the people, do not get wise to Rhodes without being hammered with a barrage of coarse insults. The people, "just plain folks," are themselves gullible threats to their own system of government—indeed, they are the "trained seals" Rhodes accuses them of being. More frightening yet, Rhodes is simply one of millions, "a face in

the crowd." The crowd itself may harbor thousands of aspiring tyrants, a point made not so subtly when Rhodes's former promoter produces an instant replacement for the bottomed-out star: a "young Lonesome Rhodes" ready to be the next sensation. "Hey, I'm just a *country* boy," the new client smarmily quips, echoing Rhodes's refrain throughout the film. Like a horror film monster who can't be killed, the white southern rube lies in wait for an unsuspecting nation, always a potential threat to democracy. It is only through the overseeing of people like Marcia and Mel—the educated elite, in other words—that the tyranny of the "folks" is kept in check.

"This whole country is just like my flock of sheep," Rhodes brags to Marcia the night before his downfall. "Rednecks, crackers, hillbillies, hausfraus, shut-ins, pea-pickers—everybody that's got to jump when somebody else blows the whistle." His contemptuous description of his fans is the film's final outrage, the revelation that ensures Marcia's betrayal of him and exceeds the filmmakers' liberal tolerance. *He,* after all, is supposed to be the cracker. He has been the pea-picker good-naturedly offering his earthy, commonsense maxims and folksy charm for national entertainment. Incapable of intellectual distance from his own milieu, he has merely extended his culture "from the bottom up." Ironically, his greatest "fraud" is exposing the fraud of performance itself. Rhodes's psychological distance from his role dooms his public life as surely as Andy Griffith's lack of distance from the role of Lonesome Rhodes doomed his own personal life. For hillbillies, it seems, "acting naturally" is an unnatural act.

Clearly, Andy Griffith was just as adept at constructing and manipulating personae as any celebrated actor of his era, and, just as clearly, he, like his character Lonesome Rhodes, understood the commercial value of posing as an unschooled rube. Publicly, he never broke character and accepted roles that allowed him to embellish upon the country-boy persona of his comedy records. In 1954, in fact, in a canny career move, he contacted Mac Hyman, author of the novel *No Time for Sergeants,* about recording sections of the book. Griffith "seemed to be right enthusiastic about it and all," Hyman claimed, "and the reason is . . . that the character that he portrays is about the same kind as I wrote about; and he thinks it will be a big hit and all."[64] And indeed, each of Griffith's performances as Georgia Air Force draftee Will Stockdale in the three adaptations of the novel was "a big hit." But if Lonesome Rhodes was America's redneck shadow, the backwoods cultural threat

of the 1950s, Will Stockdale was the hillbilly ego, the smiling face of harmless contentment. Refusing to acknowledge that the barely literate, immensely gullible Stockdale was a stereotypical rural buffoon, Griffith has always insisted upon the character's dignity. "Will Stockdale wasn't a dumb southerner," Griffith insists. "He was a naive southerner, who believed anything anybody ever told him."[65] However Mac Hyman, himself a native Georgian, voiced the familiar performance problem haunting the rural artist. "Even though I think Griffith did a good job of playing Andy Griffith," he wrote a friend, "I don't think he did much of a job playing Will—that is, the way I see Will. But maybe all that is natural."[66]

The public perception of Griffith's talent as regionally indigenous undoubtedly owed much to the legacy of Alvin York, the heralded Tennessee sharpshooter of World War I. Promoted by biographers and publicists as "an American throwback, the unsophisticated yet instinctual child of nature,"[67] the born-again Christian soldier served invaluable political purposes in 1941 when Howard Hawks memorialized him in *Sergeant York*. With Gary Cooper playing the naive yet earnest York in an Oscar-winning performance, the film grounded its prowar argument in the same rhetorical appeal to "nature" that had created the York myth decades earlier. If a pacifist country boy is at heart a patriotic—even *instinctually* patriotic—killer, the movie suggested, then the war efforts of America itself are just as instinctual, just as Christian, just as "natural." Alvin York, after all, had needed no artillery instruction in basic training. He simply did what came naturally.

The perceived literalness of the hick persona, for whom deception and guile—*acting*—are inimical, is in fact an indispensable characteristic of the "country" sensibility. But, as Barbara Ching has pointed out in her study of country music, rusticity itself is often "a *performance* rather than a spontaneous expression of some pure emotion or state of being." Country music, she observes, "is capable of performing the rural role in such a way as to underline its construction and social purpose rather than its presumed natural essence, innocence, and / or bad taste."[68] That figurative language and performative gesture might be tools of the rural artist, however, is an idea that runs counter to cultural stereotype. As James Naremore has noted, for example, the "hipsterish posture" of Marlon Brando probably derived from Stanislavskian exercises in "affective memory," in which careful monitoring of one's physical state could produce emotional recall.[69] For someone already exist-

ing in a "natural" state, however, someone whom civilization has not psychologically affected, such an essentially mental project would be pointless. The glory of modern art is its *celebration* of the discontents of civilization, for without repression no "affective" metaphors and symbols lay waiting for excavation, no dreamwork is necessary for the discovery of hidden, transformed (in other words, artistic) meaning. Devoid of psychological depth, the hillbilly is a stranger to artistic invention.

Consuming the Yokel

The packaging of Andy Griffith as a natural, untrained, and untrainable actor was similar to that of other "southern" acts of the 1950s and early 1960s. Tennessee Ernie Ford's television success (his three variety series ran from 1955–1965) preceded that of Griffith and offered important lessons in the promotion of country performers. Ford's country-inspired pop and gospel singing, interspersed with monologues featuring his rustic "Ernie-isms" ("You don't have to be as restless as a worm in a bucket of hot ashes to go places"), proved immensely popular with national viewers. His persona was enhanced by magazine coverage of his trips back home to Bristol, Tennessee, to eat his favorite country food, and his continually expressed surprise that a "pea-picker" could achieve success in California. The *Saturday Evening Post's* Pete Martin wrote in 1957 that talking with Ford had made him "think of H.G. Wells' book, *The Time Machine*. . . . I found myself dropping my 'g's', and my 'can't's' becoming 'cain't's' . . . until I was practically chewing a cud of magnolia blossoms."[70] Most reporters, in fact, emphasized Ford's accent in exaggerated phonetics. *TV Guide,* for instance, quoted the singer as saying that he and his producer "fought like taggers (*translation: tigers*)" (italics in original).[71] According to Ford, "it amazes people that there's anything ordinary and simple about a man or a woman in show business. That's why I like to jaw with them on the air about simple, ordinary things. That makes me more of a friend of the family."[72]

Like Griffith, Ford had seriously studied music (at the Cincinnati Conservatory of Music) and had worked the national nightclub circuit (including Las Vegas). Nevertheless, he appeared to be a "natural" performer whom schooling and experience had not altered. This appearance was fostered by the star's crafty understanding of his reputation for untutored spontaneity. He had, he said, been ad-libbing his on-air

commercials since he first started in television: "Nobody told me how to get them in. . . . so I played it by ear. . . . the sponsor never had to show me a root my plow hadn't hit."[73]

The seemingly inherent "naturalness" of southerners like Griffith and Ford was exploited by CBS to promote its rural situation comedy, *The Real McCoys,* which premiered in 1957 and ran until 1962 and was seen on ABC from 1962 to 1963. The series' star, Walter Brennan, was the subject of numerous magazine profiles, all of which focused on a single theme. Playing "Grandpa McCoy," patriarch of a poor but hard-working farm family from West Virginia who had resettled in California, Brennan seemed to be "the real thing" to reporters. "Brennan's success story," *Newsweek* claimed in 1958, "has an apparent simplicity about it which, unlike a great many, turns out to be genuine. He never prepared for an acting career and never pursued it with the usual Hollywood frenzy." His three Oscars, it seems, were won by simply being himself, by giving audiences "an authentic portrayal of a sometimes lovable, sometimes hateful, rippish, raffish, shiftless, slightly uncouth, tobacco-drooling old bum."[74]

Brennan often offered advice in monthly magazines, always invoking the common sense of Grandpa McCoy and drawing connections between himself and the character. "These are simple things, but they've worked pretty well for me—and, I suspect, for Grampa McCoy, too," he wrote in *Today's Health.* On the other hand, on the subject of retirement, "I don't approve of it—and Grampa McCoy wouldn't either."[75] For such articles, the actor was photographed in his McCoy costume— overalls, open-necked denim shirt—even though "in the flesh," according to *Newsweek,* the Massachusetts native "looks like a Boston banker." His off-set life, however, "is as unpretentious as his conversation"; he reads very little, has been married to the same woman for thirty-eight years, and does not go out on the town.[76] Like his character, Brennan professed humbleness in the face of formal education. When he was awarded an honorary doctorate in 1958 by West Virginia's Morris Harvey College ("an Eastern college," he called it), he told an interviewer, "It's hard to explain how much this meant to a guy who's been playing tobacco-chewing cowboys and illiterate farmers all these years."[77] As for the show itself, "Kids won't learn English from this series, but this is one show that won't teach them better ways to ruin the furniture or throw food."[78]

The public fusion of character and actor so important to the na-

tional success of rural narratives was perfected by writer-producer Paul Henning in his promotion of *The Beverly Hillbillies* (1962–71). Although rebuked by critics for its mindlessness, within five weeks of its premiere the CBS series was the top-rated television show and was riding the crest of media fascination with the suddenly rich family of Ozark yokels. Henning's public relations rules, however, insisted upon a news blackout on the private lives of his actors. In a memo written to his press agents months before the show's debut, he warned, "For the present I would prefer that Buddy Ebsen, Irene Ryan, Donna Douglas, and Max Baer [principal performers] *cease to exist as themselves.* The dissemination and publication of personal biographies, idiosyncracies, so-called squibs, blurbs, plants in columns and photographic layouts of them at home *are to be discouraged by every means at our disposal*" (Henning's emphasis).[79]

Henning later elaborated upon this ruling, explaining to his agents that "seeing publicity layouts of Buddy Ebsen on his yacht or Max Baer attending a nightclub dressed in a tuxedo with some starlet is not conducive to believing in the characters."[80] Nor, it seems, were appearances on other television programs, unless the actors portrayed their *Hillbillies* characters. If the highly experienced Ebsen or Ryan harbored hopes that their comedic skills would be recognized, such tightly controlled and pervasive publicity tended to work against an appreciation of their professional training and talent. Earlier performances by Ebsen as Audrey Hepburn's backwoods husband (in *Breakfast at Tiffany's*) and Davy Crockett's sidekick (in the hit Disney television series of the mid-1950s) were no doubt helpful in creating the sense of Ebsen as a Jed Clampett "type," and Ryan's appearances in "southern" or "country" films (like *Desire in the Dust* [1960] and *Ricochet Romance* [1954]) facilitated the creation of a backwoods "granny" character. Similarly, Donna Douglas's past triumph as the hot-pepper-eating champion of Baywood, Louisiana, was one biographical detail Henning did not hide.

"Our hillbillies are simple, but not stupid," executive producer Al Simon told *Newsweek.* "They're always in character. The whole thing would be ruined if any of them ever winked knowingly at the audience."[81] By 1962, however, a number of television performers had been winking knowingly at audiences. George Burns, Jack Benny, and even Cleo the Bassett hound (in *The People's Choice*) had played dual roles in situation comedies: domestic character and distanced observer, the latter commenting verbally and physically upon the foibles of other

characters—not simply through asides but also through raised eyebrows and slow takes directed at the camera. Through identification with these performers, the audience felt not only "in on the joke" but at times superior to the bourgeois silliness of life in the suburbs (especially in the case of *The Burns and Allen Show*, for which Henning himself had been a writer). The role of domestic patriarch in these shows was clearly a *role*, and a ridiculous one at that. Jed Clampett, however, was "the real thing," a simple, rustic soul to whom any notion of psychological distance from his circumstance would be, in all senses of the word, unthinkable. The all-too-fabricated roles of suburban hillbillies were intended to be read as more ingenuous than those of the "snooty" California nouveau-riche, whose pretentions were to be read as patently false (i.e., hypocritical and materialistic).

Henning himself had spent considerable time researching hillbilly culture to ensure the "ancient authenticity" of his series (going so far as to seek out "barn dances" and "country hoedowns" in Los Angeles, listen to "a radio diet of guitars and hillbilly singers," and consult "out-of-print volumes on Ozark customs"). Far from being "bearded" and "vermin-infested" (in the words of the *Saturday Evening Post*), "our hillbillies," according to executive producer Al Simon, "are charming, delightful, wonderful, clean, wholesome people." Indeed, Simon promised the nation in 1963, "The word hillbilly will ultimately have a new meaning in the United States as a result of our show."[82]

The highly profitable merchandising of Hillbilliana during the early 1960s through games, toys, and clothes completed a cycle of accelerated popular interest in the rural southerner as a television spectacle. The participation of skillful performers in fostering the illusion of a natural, unschooled simplicity endemic to the backwoods of the South is a particularly illustrative irony, for the commercial benefits of the illusion were matched only by its political ramifications. When corralled into television fiction, the uneducated hillbilly could be rendered socially harmless and even supportive of the status quo. When stampeding unbridled into the culture at large, however, he presented a clear and present danger to the nation's social equilibrium.

FOUR

REEDUCATING THE SOUTHERNER

*Elvis, Rednecks, and Hollywood's
"White Negro"*

While Andy Griffith, Tennessee Ernie Ford, Grandpa
McCoy, and Jed Clampett demonstrated to varying degrees the rural
southerner's comic lack of sophistication, Elvis Presley presented a per-
sona more uncomfortable to mainstream sensibilities. It is one thing to
fail to be educated; it is quite another to *refuse* to be educated. Although
himself a rural southerner (having moved to Memphis from Tupelo at
the age of thirteen), Elvis veered dramatically from the established path
to national acceptance. He never appeased audiences with misbegotten
renderings of Shakespeare and Bizet, never offered up quotable "Elvis-
isms," and never permanently relocated in California. He stayed unre-
constructed to the end of his life (an incomprehensible fact to biogra-
pher Albert Goldman, who bases his dismissal of Elvis on the performer's
resolutely southern, working-class tastes).[1]

On the one hand, Elvis was a distinctly country presence; his first
mass exposure came on *The Louisiana Hayride* and *Grand Ole Opry*
radio broadcasts, both showcases for white rural talent, and his lifelong
admiration for white gospel music was legendary. On the other hand,
his adoption of black music, performance styles, and clothing con-
tributed to an equally distinctive urban (albeit southern urban) pres-
ence. Elvis's seemingly effortless integration of country and city, white
and black, allowed radically different members of his audience to iden-
tify with specific aspects of his persona. At the same time, however, the
overdetermined nature of his persona guaranteed a certain "slippage"
in his public reception and enabled political players of the era to manip-
ulate his image for divergent purposes.

To many white segregationists, of course, Elvis was the avatar of

"jungle" music, his mimicry and glamorization of black style a living example of mongrelization. He was, in short, an object lesson in the degradation of racial integration. Yet to white liberals, especially those outside the South, Elvis was, like Griffith, Ford, and their fictional cohorts, a hillbilly. "Like a jug of corn liquor at a champagne party," *Newsweek* called Elvis's Las Vegas debut in 1956,[2] while *Life* called him "a howling hillbilly success."[3] The same year, at the height of national Elvis-mania, Milton Berle and Steve Allen featured the singer on their television shows as a hick who had somehow stumbled into the urban big time. Berle, for instance, devised a sketch in which he himself played Elvis's twin brother, "Melvin," "a rube," biographer Peter Guralnick writes, with rolled-up pants, "oversize blue suede shoes," and "the broadest Catskills cornpone accent." Allen went further in his attempt to caricature the singer, having a tuxedo-clad Elvis perform a serenade to a Bassett hound on a Greek-columned set ("all part of Allen's comedic concept of presenting low culture in a high-culture setting," Guralnick observes) and take part in a "Range Roundup" skit in which Elvis played the part of "Tumbleweed Presley."[4] Ironically, the cowboy number also featured Andy Griffith (toting a fiddle). Perhaps to Steve Allen the combination of distinctly different southern talents in a western parody made cultural, if not regional, sense—for, after all, Griffith and Ford had demonstrated an easygoing adaptability to the ethnocentricity of nonsoutherners, and Elvis himself accepted the humiliation with characteristic good manners. But there the resemblance between Elvis and his southern colleagues stopped. Not trying to assimilate into mainstream America as the others had, Elvis signified an unrepentant ignorance, a menacing—even virulent—strain of hillbillyism.

It should hardly be surprising that characters from the predominantly white hill regions of the South encountered little resistance in their quest for popular affection; their intractable provincialism offered proof of the South's inherent social inferiority, while their acceptance of middle-class values like mobility and education seemed a correlative of their unimpeachable whiteness. As a son of the Delta rather than of Appalachia, however, a man whose genetic forebears could more easily be stereotyped as lowlands "trash" than as mountain yokels, Elvis presented a more culturally charged affront to sociopolitical correctness. "The poor white," Jim Goad writes in *The Redneck Manifesto,* "originally entered the national consciousness with a hillbilly clown puppet on one hand and a redneck villain puppet on the other." A "cultural

foreigner" who "walked a tightrope between amusing the audience and murdering it," he possessed "a limited ability to achieve and a massive capacity to destroy."[5] Elvis may have been packaged as a hillbilly clown by television producers, but their efforts only demonstrated a growing public discomfort with intractable white southerners. The years of Elvis's ascension to fame, we should remember, coincided precisely with the years of the Deep South's own televised descent into infamy. Long a target of derision and scorn in fiction and popular culture, the working-class southern white man—in particular, the working-class *Mississippi* white man—became an altogether repellent figure on the international landscape by the mid-1950s. "Whereas the hillbilly and the yahoo pointed to a place on the map," Goad has observed, "'redneck' could be said to designate a place in the *heart,* most commonly an attitudinal aneurysm pulsating with suicidal stubbornness and poisonous hatred."[6]

Bad to the Bone: The Mississippi White Man

As Elvis was working his way from regional to national attention in 1955 (culminating in his November signing with RCA), two other white Mississippians, half-brothers J. W. Milam and Roy Bryant, were achieving their own brand of attention. Their trial in Sumner (sixty miles from Memphis) that fall for the August murder of fourteen-year-old Emmett Till became the first southern race story covered by national television. *Jet* magazine's decision to publish the photograph of the horribly decomposed and mutilated child's body, coupled with Milam's and Bryant's swift acquittal by an all-white jury, ensured global condemnation of Mississippi racism. "In a survey of European opinion and press reactions," historian Stephen Whitfield notes, "the American Jewish Committee reported that the Sumner verdict had 'seriously damaged' American prestige."[7] At home, New York congressman Adam Clayton Powell called for a national boycott of Mississippi-made products and, with Michigan congressman Charles Diggs, promised to challenge the seating of any elected representatives from the state. In response, white Mississippians united, attacking critics of the state as instigators of a "plot against the South" ("Mississippi—The Most Lied about State in the Union," read many license plates). Sumner County Sheriff Harold Strider, who would become a template for a series of nationally reviled sheriffs over the next fifteen years, took on the nation

directly when he looked into a television camera, pointed his finger, and said, "I just want to tell all of those people who've been sending me those threatening letters that if they ever come down here, the same thing's gonna happen to them that happened to Emmett Till."[8]

Twenty years later, Robert Patterson, founder of the Citizens' Councils, suggested that the Till murder marked the beginning of the civil rights movement. "That made every newspaper on the face of the earth," he said. "And following that, whenever something happened to a Negro in the South, it was made a national issue against the South."[9] Of course, the fact that four months after their acquittal Milam and Bryant admitted to the readers of *Look* magazine that they had killed Till did little to lessen the national import of the case. Neither did the men's attitude toward their crime. According to William Bradford Huie, who interviewed Milam and Bryant for *Look,* "They didn't think they were guilty. They didn't think they'd done anything wrong."[10] From New York, NAACP Director Roy Wilkins offered a starker assessment of the men's violence: "You know, it's in the virus. It's in the blood of the Mississippian. He can't help it."[11]

Many white Mississippians, however, had been appalled by Till's murder when they first learned of it; newspaper editors across the state denounced the crime and demanded immediate justice (possibly, it should be noted, to allow their support of school segregation to remain "untainted" by the specter of racial violence). But as national condemnation of Mississippi mounted in the late summer, and as the state itself came to be held accountable for murder, whites began to rally behind Milam and Bryant. "The primacy of states' rights became so urgent," Whitfield has noted, "the feelings of defensiveness so raw and exposed, that the murder of an adolescent declined in moral magnitude."[12] Yet soon after the men's acquittal, white support swiftly waned. Following a black boycott, Milam and Bryant were forced to sell or close their stores. White landowners in Tallahatchie County who had contributed to the men's defense fund refused to rent land to the former "heroes." As Milam himself told Huie in his *Look* interview, "You can do som'pin that everybody says you ought'a done. Like killin' a German . . . or killin' a niggah who gets out'a place. Everybody slaps you on the back for it. Hell, they give you a medal! Then . . . after a while . . . those same folks won't come around you . . . they won't *even like* you . . . because you done it." Unable to make sense of this turn of

events, he painted himself as the agent—and the scapegoat—of white racism: "They want you to do it. They are glad you done it. Then they don't like you for doing it. . . . Crazy goddamn situation, ain't it?"[13]

Milam's confused sense of his exploitation was clarified by his own attorney, J. J. Breland. Calling the half-brothers "rednecks," and Milam "a scrappin' pine-knot with nuthin'," the Princeton-educated lawyer nevertheless found their actions politically advantageous. "Peckerwoods," he explained to Huie, were pivotal combatants in the war against desegregation: "Hell, we've got to have our Milams and Bryants to fight our wars and keep the niggahs in line."[14] These "fine young soldiers,"[15] as he had called them during the trial, would "put the North and the NAACP and the niggers *on notice.*"[16] But, as David Halberstam wrote of Mississippi in 1956, because it "is the peckerwoods who kill Negroes and the good people who acquit the peckerwoods,"[17] once "notice" was served, Till's murderers quickly became, in Huie's words, "landless white men in the Mississippi Delta . . . bearing the mark of Cain."[18]

J. J. Breland's self-assured explication of the men's "crazy goddamn situation" underscores the often overlooked *intra*racial class tensions of the region. To southern writer Lillian Smith, the responsibility for racist crimes could be laid at the feet of every estate and plantation owner in the Deep South. In a 1965 letter to a friend, she pondered the murders of civil rights workers James Chaney, Andrew Goodman, and Michael Schwerner the year before. Whom did the murderers "really hate," she wondered.

> I think they hate us: they hate the upperclass whites of the South who fed them the drug of "whiteness" until they have destroyed themselves spiritually. They hate us because they, too, are segregated: segregated as rigidly socially from the Big Wheels and their families as are Negroes. This never-talked-about segregation which must be like a white fog around the poor whites is the thing that makes them hate Negroes with a psychotic violence.[19]

Two years earlier, on the evening of Medgar Evers's murder in Jackson, Mississippi, Eudora Welty had found herself imagining the workings of this psychosis when she sat down to write "Where Is the Voice Coming From?," a story whose narrator would prove to be remarkably similar to Evers's assassin, Byron De La Beckwith. In recalling his decision to shoot black activist Roland Summers on a sweltering night in the fictional town of Thermopylae, the narrator claims:

I could find right exactly where in Thermopylae that nigger's living that's asking for equal time. And without a bit of trouble to me.

And I ain't saying it might not be because that's pretty close to where *I* live. The other hand, there could be reasons you might have yourself for knowing how to get there in the dark. It's where you all go for the thing you want when you want it most. Ain't that right?[20]

He may get caught, he concedes, but continues: "I advise 'em to go careful. Ain't it about time us taxpayers starts to calling the moves? Starts to telling the teachers *and* the preachers *and* the judges of our so-called courts how far they can go?" (607). After all, "even the President so far, he can't walk in my house without being invited, like he's my daddy, just to say whoa. Not yet!" Staking his claim to status, the murderer finally says that at the moment of Summers's death, he "was evermore the one" (607).

Welty's unusually perceptive grasp of what Smith called the "deep, sick" injuries of class was not shared by attorney Breland, who exonerated his peers by reprising the stale upper class / white trash dichotomy of Old South mythology. Huie, himself a native Alabamian, was struck by the proliferation of such stereotypes throughout the reporting of the Milam-Bryant trial. Carolyn Bryant, the woman at whom Till had reportedly whistled or winked, was not (to Huie's mind) "white trash." "Stories had her 'wearing shorts-and-bra in the Delta heat' before young Negroes," he wrote, "'making provocative gestures,' and 'running to her husband demanding death.' All lies. All efforts to make her into a Tennessee Williams or Erskine Caldwell character."[21]

The criminality of Milam and Bryant is, and was, incontestable. The mass perception of this criminality as somehow *inherent* in the white southern working class, however, proved to be as politically expedient to the nation at large as it was to members of J. J. Breland's caste. If the stubborn violence of such folk was "in the blood," if the "mark of Cain" was *genetic,* then class itself was an accurate gauge of sociopathology and the "virus" endemic to poor whites was possibly containable. Bracketed—we might even say quarantined—as an almost allegorical figure, the ailing redneck would find a home in popular narratives as a chastened emblem of racial redemption, a scapegoat, in essence, for the sins of his betters.

Retraining the Redneck: Elvis in the Movies

The reviled films of Elvis Presley begin to make cultural sense when considered within the context of this national morality tale. Taken as a distinctive genre, his thirty-one movies, produced between 1956 and 1969, contributed a persistently reproachful voice to the ongoing social dialogue about the place and function of the white southerner. The four films Elvis made before his induction into the Army in 1958 (*Love Me Tender* [1956], *Jailhouse Rock* [1957], *Loving You* [1957], and *King Creole* [1958]) all tell the story of the punishment and reeducation of the unreconstructed white southerner. Whether he is a headstrong Texas farmer, a laborer jailed for manslaughter, a country boy trying to be a singing star, or a New Orleans janitor, the Elvis character is always a "natural" boy, a working-class youth of uncontrolled passion whose penchant for violence repeatedly lands him in trouble with the law.

The first glimpse of Elvis in motion pictures (*Love Me Tender*) finds him plowing the fields of his East Texas farm. The shot occurs well into the action of the film, after the establishment of his older brother Vance (played by Richard Egan) as the stable, central character of the narrative. Elvis (playing a character named Clint) has been forced to stay at home with his mother while Vance fights for the Confederacy. Believing Vance to be dead, Clint marries his brother's sweetheart, only to go "out of his mind with jealousy" upon Vance's return. When Yankees occupy the family farm, Clint becomes a vengeful warrior. "He's more dangerous than any of 'em," Vance's buddy says of the young farmer, and Clint verifies this by shooting his own brother. Repenting his actions in the movie's final moments, Clint apologizes for his rashness ("Everything's going to be all right") just before dying in his wife's arms. As the gray ghost of Confederate vigilance, though, Clint is superimposed in the last sequence, singing "Love Me Tender."

Elvis's next incarnation, in *Jailhouse Rock,* was a contemporary version of rural, headstrong Clint. Here, however, his character (named Vince) is immediately defined as a violent delinquent. A physical laborer from "the backwoods," Vince accidentally kills an abusive man in a bar with his bare hands. Sentenced to hard labor, Vince achieves fame when he sings on a television program broadcast from the prison (fig. 17). Out of jail, the "rube" (as one character calls him) exploits and discards his friends, including a former cellmate who had introduced him to "hillbilly music." Finally turning pacifist, Vince refuses to fight

FIGURE 17. The redneck as criminal: Elvis performs from prison in *Jailhouse Rock* (MGM Studios, 1957). Wisconsin Center for Film and Theater Research.

back when his old buddy punches him. He loses his voice after a larynx operation, eventually regains his voice, and is redeemed by a final display of contrition.

Loving You refashioned Vince as an Elvis double, tracing the rise of yet another temperamental rube from obscurity to national fame. By the time Elvis starred in *King Creole*, as a high school dropout running with a bad crowd, his film persona had settled into a familiar and predictable profile: trouble. In this film, an adaptation of Harold Robbins's *A Stone for Danny Fisher*, Danny (Elvis) is a motherless child of working-class New Orleans, trying valiantly to graduate from high school. Having failed senior English the previous year, Danny finds that his work as a janitor in a nightclub consistently interferes with his ability

to get a diploma. "I've got a very average brain," he tells his wastrel dad, but he is determined to "be somebody." In desperation he joins a street gang (led by *Blackboard Jungle*'s head hood Vic Morrow) and follows the trajectory sketched by other teenage problem films, sinking downward into crime and delinquency. Despite the hope held out at the end of the film (a well-meaning hooker encourages him to face and defeat his problems—which include, as in *Jailhouse Rock*, an accidental murder), Danny remains a man with a criminal record, a marked man with little education and nonexistent resources.

As the last movie produced before Elvis entered the Army, *King Creole* seemed to offer him the possibility of a more culturally nuanced screen persona. Directed by veteran noir master Michael Curtiz, it managed to do what no other noir movies had (except perhaps Elia Kazan's *Panic in the Streets* [1950], also set in New Orleans): portray the South as an extension of contemporary *urban* America. Little in *King Creole* distinguishes it as a "southern" story; only Elvis and Vic Morrow have southern accents, and Morrow's is a mutation of the Brando-hipster affectation. New Orleans here is a study in black and white moodiness, its heavily shadowed alleys and bars no different from the familiar cinematic byways and dives of New York or Los Angeles. Within this context, delinquency carries an inherently political charge, for, as the product of an oppressive environment, Danny's fate is not just predictable but forgivable. Circumstances, not an essential badness, land him in harm's way. In a sense, *King Creole* employs the conventions of film noir to update the juvenile problem film, to extend the same existential leeway to delinquents which was extended to others in noir's rogues' gallery—including Curtiz's own Mildred Pierce (*Mildred Pierce* [1945]) and Rick Blaine (*Casablanca* [1942]). As a noir antihero, Danny Fisher's status as working-class southerner and juvenile hoodlum is subsumed under a much larger and more inclusive demographic category: the character trapped by circumstances.

Disrupting the liberal sensibility at work in *King Creole*, however, is a subtext often deliberately obscured in most noir studies: race. Though generally banished to the edges of classical noir *mise-en-scène* or to fleeting (often comic) moments in odd scenes, blackness is the central, defining context for *King Creole*'s action. In the opening scene of the film, black characters fill the streets of the French Quarter, melodically hawking their wares in the early morning. Foreboding music accompanies the tableau, complicated by a distinctive rock 'n' roll beat. Within this

cultural mélange, Elvis appears, sitting in a window above the singers. He joins the voices below, sounding as if he, too, is peddling his wares, and is soon accompanied by black rhythm and blues singer Kitty White, who sings the song "Crawfish" as a duet with Elvis.[22]

Michael Curtiz was not the first director to draw visual and aural connections between Elvis Presley and black southerners. Norman Taurog, who would direct most of Elvis's later movies, had blatantly depicted the singer as a contemporary slave one year earlier in *Jailhouse Rock*. Although Vince is first called a "cowboy" over the strains of "Red River Valley," then allied with a hillbilly cellmate as he learns to sing white country songs, his physicality and victimization are most dramatically represented in scenes freighted with Deep South racial connotations. His hard labor in prison, coupled with dirt and intense heat, literally turns him *black* soon after his incarceration. He is stripped and brutally whipped by jailers, and mourns his fate in a song about working "like a slave till day is done." The number he performs on the jailhouse broadcast is even entitled "I Want to Be Free."

With Elvis's return to the screen following his discharge from the Army in 1960, the racial ambiguity that had characterized his early films evaporated. Referring to *G.I. Blues* (1960), his first post-Army film, Peter Guralnick writes that "the character that Elvis played was at odds not just with the characters that he had played in all of his pre-army films but with the very image of rebellion that had always defined him. Far from being an outcast, this Elvis Presley was safe, 'social,' and cheerfully domesticated, a conventionally bland Hollywood stick figure."[23] After two attempts to recapture the old persona (*Flaming Star* and *Wild in the Country*, both in 1961), Elvis settled into eight embarrassing years of screen time.

Ironically, during the years immediately following Elvis's reemergence into public life, Hollywood was reaping vast profits from its decade-long love affair with the Deep South. The apex of this affair came in 1962, after which Hollywood would turn abruptly from things southern until the late 1960s. Unable to sustain its romantic vision of the South in the face of graphic news footage from Oxford, Birmingham, and Selma, the studios ceded the territory to television. Never accorded the status of "actor" in the first place, Elvis was virtually stranded in the mediascape. Although he had tried to study acting on his own, endlessly deconstructing the performances of Peter Sellers, James Dean, and Marlon Brando, he was condemned by managerial

imperatives, his own insecurity, and, most importantly, public perception to a career as "himself." As he said in 1972, "I had thought that they would give me a chance to show some kind of acting ability or do a very interesting story, but it did not change, it did not change, and so I became very discouraged." Actor Gene Nelson, who directed Elvis in *Kissin' Cousins,* believes that "he felt that he was uneducated and had nothing to contribute to a conversation. . . . I think he could have been a very good actor, but mostly he would just be his charming self and get away with it—because he was Elvis Presley."[24]

Psychological depth, affective memory, and performative transformation would become the province of Method actors like Marlon Brando and Paul Newman, as they rode to fame in a series of successful roles as southern bad boys. Elvis, the "real thing," was trapped in a cultural Catch-22: he couldn't learn to *play* low-rent southern because he already *was* low-rent southern; to be low-rent southern was, ipso facto, to be incapable of learning, incapable of persuasively displaying the results of rigorous mental training. Furthermore, if the psyche of the working-class white southerner was no mystery (existing as he did in a prepsychological, or natural, state), Method-inspired excavations could reveal few if any inner secrets.[25] When Paul Newman, playing rural barn-burner Ben Quick in *The Long, Hot Summer,* says to upper-class Joanne Woodward at the end of the film, "You couldn't tame me, but you taught me," he could easily be speaking for his generation of "rebel" actors, many of them college students, who, after years of self-analysis in New York, learned a "method" for dramatizing the behavior of country folks—and, perhaps more importantly, for explicating that behavior to the rest of the nation.

But Elvis had not "relearned" southern behavior. Unreconstructed, he was doomed to humiliation within the film industry both on and off the screen, a clock-punching toiler in the fields of Culver City. The critically despised Elvis films, in fact, provided the economic base for films of middle-brow taste. As the *Las Vegas Desert News and Telegram* reported in 1964, the profits from the films of "Sir Swivel Hips" made possible the production of *Becket* (1964), starring Richard Burton and Peter O'Toole ("two brilliant Shakespearean-trained actors"). "Don't laugh," the story warned. "It's not that Elvis refused either the role of Henry II or Becket."[26] He simply provided the labor.

Onscreen, by the mid-1960s, intellectual self-consciousness had become a convention of the Elvis film, his "very average brain" seen as a

requisite character trait. "I never did plan to be the brains of the outfit," he confesses to his business partner in *It Happened at the World's Fair;* and in *Blue Hawaii,* he pleads, "I'm young, I'm healthy, I'm not *that* stupid." In *Follow That Dream* (a film that rather good-naturedly trades on the bumpkin stereotype), a character says of him, "He's got the IQ of a grasshopper." Sometimes, with help from the right well-meaning woman, Elvis gets steered toward adult education. In *Wild in the Country,* for example, his "slow-witted country boy" finally manages to take the train to college; in *It Happened at the World's Fair,* by the end of the film a nurse sees to it that he fills out an application to work for NASA. Offscreen, though, it was during this period that Elvis began a serious study of 1960s-styled mysticism, voraciously reading hundreds of books with the passion of the convert. The disjunction between his private life and his screen image is not the striking fact here. Rather, it is the fact that "the sixties" and "Elvis" seem wildly at odds. As an icon born of the 1950s, Elvis connoted physical liberation rather than mind expansion, yet his relative freedom from racism and anti-Semitism was evident long before stars like Brando and Newman marched in Selma.

Another factor that complicated the public reading of Elvis helps to explain the political expediency of his carefully tended superficiality. In 1957, before shooting *Loving You,* Elvis decided to dye his hair black. He is, of course, remembered now as an ebony-haired performer, not as the light-haired man he *naturally* was, and yet this permanent turn toward constructed darkness is at the heart of his cultural ambiguity. Even in 1964, at the height of his movie domestication, he is described onscreen (in *Roustabout*) as "a young man whose charming appearance and boyish manner conceal the instincts of a Mau Mau," yet in the same sequence he is mocked by college boys as a hick ("I bet he never got further than grammar school," they snicker). As a black-inflected redneck, Elvis was the negative image of Hollywood stardom: his blond roots *always* showed beneath the black dye job. Neither de-educated bohemian nor uneducated racist, Elvis simply fell outside the generic conventions of the white outlaw story of the era.

Whatever anarchic physicality once activated his image was now neutralized by enervated displays of "womanizing," with Elvis mechanically executing the bourgeois tenets of the *Playboy* philosophy. With car and boat races not simply standing in for sex but actually replacing it, and with Elvis's potentially disruptive racial ambiguity undercut and patronized by his narrative alliances with a series of Mexican, Chinese,

and Polynesian children, Hollywood showcased the castration of the redneck in widescreen Technicolor. Cut loose visually from social reality, set adrift into surreal landscapes of back-projected, perpetually sunny resorts, Elvis became, in effect, an endlessly replicable logo for the commercialization of the exotic. Elvis in the wintry North was as unimaginable as a frigid southern courtroom. (His one uneasy encounter with snow, at the beginning of *Girl Happy* [1965], is abruptly cut short by a trip to Florida, where the rest of the film takes place.) Elvis was a man of the tropics, according to his movies. The hyperbolic color of those feature-length travelogues mirrored the high-gloss patina of their star, as Elvis's self-chosen darkness visually devolved into a key-lit signifier of MGM style. Like Jennifer Jones, Jeanne Crain, and Ava Gardner before him, Elvis was a black impersonator.

Eric Lott has suggested that "impersonating Elvis is a way of living the proximity of one's working-class whiteness to black culture while aggressively forgetting that proximity."[27] In the case of Elvis movies, though, few American viewers of the time were encouraged to forget that proximity. Instead, the very racism that had fueled many white Americans' contempt for poor southern whites continued to inform the representation and reception of Elvis on screen. For all of Elvis's attempts to recognize and possibly subvert that racism in the construction of his own image, within the context of the movies they constituted one more installment in the well-worn genre of "passing." Like working-class Barbara Stanwyck in *Stella Dallas* (1937), who parodies a poor woman's notion of upper-crust behavior in order to repel her wealthy ex-husband's family, mainstream film characters are rarely able to erase the tell-tale markers of class. In fact, much of the dramatic tension and humor of classic Hollywood narratives derives from the audience's hyperawareness that social class will inevitably come roaring out of the closet, ruining a carefully tended disguise. In the case of Elvis, it is the blond ghost of the all-white Lauderdale housing project in Memphis that threatens to destabilize the artificial darkness, the "hick" that shadows the "hip." In *Kissin' Cousins,* the hick is granted equal status, as Elvis plays twins—one a dark, sophisticated military pilot, the other a blond hillbilly. According to Peter Guralnick, Elvis "*hated* the [blond] wig" and "hated the way he looked." "It was," he writes, "probably the film that most embarrassed Elvis in his career to date."[28]

Just how one might read this "proximity" of working-class whiteness to black culture, however, is debatable. For many middle- and

working-class whites of the 1950s and 1960s, especially those whose racism was vocal, the proximity was by necessity fervently denied and the "inherent" differences between the races stridently insisted upon. Yet other whites of the same class (Elvis and countless other musicians, for example) celebrated their closeness to black culture. Not surprisingly, it was upper-class southern whites who contended that poor whites and blacks had much in common, and Hollywood agreed with this assessment. When one descended the social ladder, it seemed, "essential" markers of race began to blur. At the bottom, whites and blacks constituted a culturally porous population; if blacks were immutably inferior, poor whites were more contemptible because of their moral vulnerability—because of the permeable boundaries, that is, of their whiteness. The public chastening of Elvis Presley—through military conformity at the height of his success and through the unrelieved professional shame that followed—offers a morality tale in the postwar repercussions of such cultural permeability: Guilty by reason of class, and class in turn guilty by reason of racial impurity.

Tamed in the Country: Elvis and the Role That Never Was

In 1957, Elvis was approached by Robert Mitchum to play the actor's younger brother in *Thunder Road*, a film based on a story by Mitchum and produced by him the following year. The story of proud moonshine runners in Tennessee who refuse to exchange their independence for legal respectability, *Thunder Road* would have offered Elvis his only chance to play his stock character as completely unbowed. He was excited about the prospect, but the deal never materialized. The closest he came to playing an unrepentant rebel was four years later in *Flaming Star* (although here the rebel is an Indian "half-breed" whose anger is a justified response to white racism) and the following year, 1962, in *Wild in the Country*. Also released in 1962, *Follow That Dream* was a comic version of the marginalized rebel story, with Elvis and his father "homesteading" on a Florida beach despite the efforts of state agents to "run your sort out of the area." Law-breaking Elvis becomes sheriff of the beach and is even lauded by a judge for demonstrating "the spirit of the pioneers." "Our government needs it more than ever," he adds.

As Appalachian delinquent Glen Tyler in *Wild in the Country*, scripted by Clifford Odets, Elvis had numerous opportunities to rage against the injuries of class, but his anger is shown to be a cover for an artistically tuned sensitivity. In the ersatz Freudian logic of the film, his vio-

lence is simply misdirected sublimation. "I've got the mark of Cain on me, Ma'am," he tells his psychiatrist, and indeed, as in *Jailhouse Rock,* he kills a man accidentally. In Odets's original version of the script, Glen commits suicide, an unimaginable narrative turn for an Elvis movie.[29] Told by the studio in no uncertain terms to rewrite the ending, Odets simply substituted the (by now) conventional reeducation resolution. When a girl tells Glen, "You're wild and unsettled, like a porcupine that can't be held," he responds, "That's right. I'll never make a pet." But his ultimate domestication is never really in doubt. Acquitted of homicide in a courtroom dominated by a Confederate flag, Glen promptly embarks for college, seen off at the train station by the psychiatrist. Not wanting to be either "enslaved to the farm" or doomed to drunkenness like his parents, he makes a choice typical of reformed teen outlaws in films of the previous decade: education. Proving that a kid who, according to the doctor, has "been knocked around enough" is often a diamond in the rough, Glen decides to become a writer. After all, he is, in the words of one professor, "a real natural." The film ends with a shot of Glen, suitcase in hand, walking up the stairs of an imposing campus building.

Mitchum's *Thunder Road* offered no such spectacle of reformation. Submission to legal or cultural respectability, in fact, was unthinkable to "hard-headed hillbilly" Luke Doolin (played by Mitchum, fig. 18). The film focuses on the last days of Doolin's moonshine runs in Tennessee and his stubborn but doomed refusal to bow to either federal agents or a Mob boss who is muscling in on local operations. Just out of the service, Doolin returns to his old job of "drivin'" (or "tripping," as it was usually called in the South),[30] frustrating the agents with his cleverness and outraging the syndicate boss with his courage. Knowing his way of life has become archaic, he nevertheless continues his work. "How do I quit breathin'?" he asks. "I want to stop the clock, turn it back to another time in this valley that I knew before." In that earlier, prewar time, Doolin had worked his family's moonshine still with his father. It was illegal, he acknowledges,

> but my granddaddy'd done it before him, his daddy before him, and so on clear back to Ireland. They held that what a man did on his own land was *his* business. . . . When they came here, fought for their country, scratched up those hills with their plows and those skinny old mules, they did it to guarantee the basic rights of free men. They just took it

that whiskey-making was one of 'em. I don't remember anything dark and shameful. . . . I was just a little ole boy followin' my daddy's footsteps.

On the one hand, Doolin's eulogy for the ethic of self-reliance is the familiar battle cry of "free" Americans asserting their "basic rights." As a veteran speaking these words in 1958, moreover, Doolin voices a particularly resonant postwar lament for the self-employed man who was finding himself squeezed out of operation by burgeoning corporations. On the other hand, however, Doolin's assertion of the "basic rights" of people in his region to conduct business according to longstanding tradition sounds uncomfortably close to the rhetoric of massive resistance. Standing up to the encroachment of federal laws into the time-worn "rights" of southern states seemed to many segregationists a patriotic act. "A man's home"—and business—"is his castle," went the familiar mantra of anti-integrationists, and Doolin's willingness to fight for this principle places the film in an ideological bind. As a mainstream movie, *Thunder Road* pays surface tribute to the law from its opening moments, when the narrator tells us of the hard work of government agents to recover our "lost tax dollars" from the "wild and ruthless" moonshiners. But the film cannot resist expressing admiration for these diehard rebels. Doolin dies in spectacular fashion, and as the pursuing federal agent looks at the fireworks shooting from the wreck of his nemesis's car he can only marvel, "Mountain people. Wild-blooded, death-foolish." The film ends with Doolin's community paying tribute to its finest rebel in a long funeral procession through the valley.

Westerns and the Lost Cause

United Artists wasted little effort marketing *Thunder Road* to a national audience. First-run screenings in urban centers were dropped in favor of drive-ins and rural "grind houses," especially those in the South.[31] The perception of the film as a regional oddity is indicative of Hollywood's increasing nervousness about the southern outlaw, for, at its heart, *Thunder Road* was simply an updated western, and its ideological contradictions were typical of the genre. As Pete Daniel has noted, "Children from the Georgia mountains turned the game of cowboys and Indians into trippers and revenuers; the trippers were the good guys."[32] Like Luke Doolin, the westerner operated outside the law and seemed to embody and enforce an ethic far more righteous than civil

FIGURE 18. The hillbilly fugitive: Luke Doolin (Robert Mitchum) defies federal law in *Thunder Road* (United Artists, 1958). Wisconsin Center for Film and Theater Research.

statutes. *Shane* (1953), perhaps the era's most emblematic western, dramatized the contradiction forcefully. As Robert Ray has observed, "The film clearly turned on the gunfighter hero, with the interest center's confirmation of force as the only solution undermining the moral center's condemnation of violence."[33] In 1954, during a period in which the Hollywood western was experiencing a creative and profitable rebirth, Robert Warshow posed the central question concerning the genre:

> What does the Westerner fight for? . . . If justice and order did not continually demand his protection, he would be without a calling. Indeed, we come upon him often in just that situation, as the reign of law settles over the West and he is forced to see that his day is over; those are the pictures which end with his death or with his departure for some more remote frontier. What he defends, at bottom, is the purity of his own image—in fact his honor.[34]

By the mid-1950s, however, the "purity" of this image was a politically charged convention, for, like Doolin, the gunfighter was at once

a nostalgically rendered figure of American independence and a displaced signifier of contemporary criminality. Warshow noted that "where the Westerner lives it is always about 1870—not the real 1870, either, or the real West—and he is killed or goes away when his position becomes problematical."[35] When he lives, in other words, is in the years immediately following the Civil War, the years of social and racial dislocation within the South; indeed, the gunfighter was often a defeated southerner taking his battle westward, like Ben Trane in *Vera Cruz* (1954). Other times he was, like the southerner, simply a man who could not live within the confines of civil law or civil life. Again, as Ray has said of *Shane,* "Despite the overt allegiance paid to the values of the homesteader community, the narrative reinforced the sense of civilization's ultimate dependence on the self-determined, unentangled individual. Nevertheless, the movie's end, with Shane riding away alone, confirmed Robert Warshow's observation that the western form implicitly recognized that individual as an anachronism."[36]

If the "self-determined" man of the West had become anachronistic in the increasingly conformist 1950s, the process had begun nearly one hundred years before, when the Lost Cause became linked to the mythology of the Old West. The marriage of insurrection and pioneer freedom proved to be both politically knotted and romantically durable, offering as it did a *cultural* justification for lawlessness and a century's worth of lore upon which contemporary southern rebels would draw for ideological validation.

With the Indian-European conflict functioning largely as a displacement of America's racial crisis, countless films of the era turned on the issue of miscegenation and "mixed blood." His unbridled lust for white women and savage guerrilla warmongering, however, marked the Indian himself as a half-breed: half racial monster, half ideological phantom. A projection of the era's sexual and political obsessions, he was the worst nightmare of both the segregationist and the anti-Communist, the true Red Menace. The marriage of race and ideology was popularly acknowledged in the color-coded McCarthyist politics of the time: one's "red" background could land one on a "black" list, the no man's land of economic and social exclusion.

The postwar novels of Alan Le May reflect the era's conflation of racial liberalism with leftist politics. In *The Unforgiven* (1957), Matthilda Zachary, a white settler who has raised a Kiowa girl as her own daughter, confesses her growing anxiety to her son:

"I'll never take her to a Texas town again—never. I'll not see her heart broken. . . . The whisperings, the snubs, the turned backs. . . . How long can that go on before somebody says it to her face?"

"Says what to her face?" Cash asked sharply.

"Do I have to say it? I will then! Red nigger. *Red nigger!*"[37]

It was John Ford's 1956 adaptation of Le May's 1954 novel *The Searchers*, though, which most clearly delineated the ideological connections between southern resistance and frontier self-determination. As argued by Brian Henderson and Richard Slotkin most notably,[38] *The Searchers* places a fairly despicable character in the role of hero, asking its audience both to admire his bravery and to question his racism. As played by John Wayne, former Confederate soldier Ethan Edwards is a near-psychotic, obsessed for years on end with recapturing his abducted niece from an Indian chief before she reaches puberty and meets inevitable sexual corruption. For him, the timely retrieval of little Debbie, his one surviving female relative, is tantamount to the reclamation of white purity itself. White girls who are rescued too late from Indian raids risk permanent racial exile, for, as Ethan proclaims definitively to a cavalry officer after seeing a settler's daughters gone mad from abduction, "They aren't white—anymore."

Unadulterated whiteness, however, becomes a progressively problematic notion in the film, just as it does in Le May's novel. In the original version of the story, Laurie Jorgenson's vicious racism shocks Ethan's sidekick, Martin, who observes that "her face was dead white . . . hard as quartz." Ethan, too (originally named Amos), betrays the morbidity at the heart of racial obsession near the novel's end, as he leads a raid on an Indian camp. He "looked like a dead man riding," Martin observes, "his face ash-bloodless, but with a fever-craze burning in his eyes."[39] In the film, Martin is part Indian, and Laurie's love for him, along with her sympathetic and often comic frustration with his romantic evasions, tempers the seriousness of her vitriol. At times, Ford depicts Ethan's racism as similarly ambiguous. In one scene, for example, Ethan whoops with hilarity when Martin cruelly abuses an Indian woman; in the next sequence, however, he seems disgusted to find her murdered by the U.S. Army. Ethan searches for his beloved niece for years, yet does not hesitate to draw his gun on her when he finds her; the proof of his "love" is his willingness to murder the undoubtedly deflowered woman, to eradicate the traces of a fate worse

than death. Although the film walks a fine line between the racism it condemns and the racist misogyny it to some degree endorses, it nevertheless leaves little doubt about the psychological dislocation of the southern white male in American society.

The ending of the film, in which a suddenly reformed Ethan delivers his sullied niece to the care of neighbors, has generated critical confusion over the years. Such a sudden turnabout seems unmotivated, for the weight of the film would argue for his continued rage and violence. Yet coming in the year of southerners' openly declared massive resistance to the *Brown* decision, this ending is not just socially and politically "correct" but also acutely reflective of the accelerating tendency in Hollywood films to chasten and reform the recalcitrant southern white man. Significantly, when the character of Amos is transformed into Ethan for the screen, he becomes an unreconstructed Confederate who had refused to surrender his sword after Appomattox, a clearly illegitimate operative. Acting outside the law in flagrant, repeated violations of the tacit rules of engagement with an enemy, he is, quite simply, a criminal. Although westerns are largely populated by gunfighters operating as self-appointed agents of justice, *The Searchers'* clearly defined arena of cultural connotation allows only two possible endings for Ethan. With punishment (i.e., death) nearly unthinkable for a star of Wayne's invincible stature (at least in a film like *The Searchers*, in which his death would be antiheroic), reformation—if merely behavioral—becomes politically mandatory.

Disturbingly, however, Ethan's obligatory bow to the narrative dictates of the era fails to create a convincing sense of closure. Discussing the famous final shot of the film, in which a cabin door shuts Ethan out of the embracing warmth of a family reunion, Garry Wills writes that "Aristotle said that a man without a polis is either a god or beast, above or below the compromised and accommodating world of interdependent creatures. Ethan is both above and below that plane, divine and bestial in the scale and ferocity of his willpower. His end is not commonplace, but heroic; not patriotic but tragic. He *must* be left outside. Achilles must die."[40] Perhaps. But lest we forget, Ethan is not the only exile in no man's land. When the cabin door finally closes on him, he is left on the desert with a crazed, ridiculed old man (the cheerfully addled Mose, sitting just off-screen in his rocking chair)—a man whose detective work has nevertheless been superior to Ethan's throughout the film. The segregation is telling; the behavior of this tragic hero may

have changed, but Ford gives no suggestion of a change in psychology. In his analysis of the film, Brian Henderson rightly comments on Ethan's function as a "scapegoat on the race question," but if Ford's exquisite framing of Ethan's social exclusion was a way of "mythically purging us"[41] of prejudice and guilt, it left the door open, so to speak, for future visitations. Cast out of one narrative, with a babbling fool his only companion, the gray ghost of unresolved racial anxiety was set free to wander into many more over the coming decades.

He found ready welcome in the work of Asa Earl Carter. A founder of his own branch of the Ku Klux Klan in the mid-1950s, Carter became notorious as one of the most radical segregationists in the Deep South. "In one eighteen-month period beginning in January 1956," historian Dan Carter writes, "his followers joined in the stoning of Autherine Lucy on the University of Alabama campus, assaulted black singer Nat King Cole on a Birmingham stage, beat Birmingham civil rights activist Fred Shuttlesworth and stabbed his wife, and, in what was billed as a warning to potential black 'trouble-makers,' castrated a randomly chosen, slightly retarded thirty-three-year-old black handyman."[42] Asa Carter was also instrumental in the conversion of activist John Kasper to the gospel of segregation (with violent consequences for Clinton, Tennessee) and was implicated in a plot to bomb several southern synagogues by the time he was hired to be a speechwriter for George Wallace in 1962. Carter is credited as the author of newly elected Alabama governor Wallace's 1963 inaugural challenge: "I draw the line in the dust and toss the gauntlet before the feet of tyranny. And I say: Segregation now! Segregation tomorrow! Segregation forever!" Breaking from Wallace in the late 1960s, Carter ran unsuccessfully for the governorship of Alabama and attempted to found a neo-Confederate paramilitary organization before disappearing from public life.

He reemerged in 1973 as "Forrest Carter" (his nom de plume was a tribute to Nathan Bedford Forrest, Confederate founder of the Ku Klux Klan), author of the western novel *The Rebel Outlaw: Josey Wales.* He later published another Josey Wales novel as well as *The Education of Little Tree,* a best-selling self-proclaimed "autobiography" chronicling Carter's "Cherokee" upbringing, which would be exposed in the 1990s as purely fictional. Clint Eastwood directed and starred in the popular film adaptation, *The Outlaw Josey Wales* (1976), which told the story of an "insurrectionist rebel" fighting to avenge the massacre of his family at the hands of Union raiders. However, the story is also, as journalist

Dana Rubin observes, "about Asa Carter—or about the author as he saw himself persecuted by the federal government."[43]

A man born in the Tennessee mountains, Josey Wales becomes a bank robber after refusing the Union army's offer of an amnesty-pardon for his guerrilla activities during the war. To him, the national government "meant only an occupying army," and the war against it continues after Appomattox. The veteran guerrillas "already had their War. It was not a formal conflict with rules and courtesy, battles that began and ended . . . and rest behind the lines. There were no lines. There were no rules. Theirs was a war to the knife, of burned barn and ravaged countryside, of looted home and outraged womenfolk. It was a blood feud" (ellipses in original).[44] These "untamed Rebels" from all over the South "were tough and mean; stubborn to defend their 'propitty'; they had never been whupped, and they aimed to prove it" (86, 87). Wales, "the pistol fighter with the lightning hands and stone nerves who mastered the macabre art of death from the barrels of Colt .44's" (77), is the most feared of the insurrectionists. With the "black rage of the mountain man," he has one thought alone: "His family had been wronged. . . . No people, no government, no king, could ever repay. . . . He only felt the feeling of generations of the code handed down from the Welsh and Scot clans and burned into his being" (11).

Throughout the 1950s and 1960s, Asa Carter had employed similarly romantic rhetoric in his Anglo-Saxon crusade against the "second Reconstruction" he and other segregationists saw Washington imposing on the South. He vowed publicly to shed his own "blood on the ground" to prevent integration, because "if it's violence they [the federal government] want, it's violence they will get." "A defeated man," Rubin writes, "Asa Carter did what so many other Southerners had done when faced with failure—carved 'GTT' on the porch post, and headed West, gone to Texas." To create a new identity for himself, that of novelist Forrest Carter, "all he had to do was dress up in cowboy clothes and alter his Southern self-reliant ideology to a Western frontier guise."[45]

In Carter's version of the West, the enemy is not the Indian or the Mexican; it is the federal government, which is steadily encroaching upon the "rights" and "propitty" of honorable white men. Mainstream westerns that were set on the nineteenth-century frontier often derived their thematic tension from just such a conflict, with "official" and "outlaw" heroes (as Robert Ray calls them) locked in an ideologically

complicated battle for cultural supremacy. But when Hollywood set
such a conflict within the contemporary South, the outlaw quickly lost
his ambiguous appeal. No question existed in the viewer's mind about
how such a conflict would end: punishment or reformation were the
only narrative options.

Southern Fugitives and the White Negro

Although *Thunder Road* tempers its last-stand rhetoric with con-
sistent reminders of the ultimate "rightness" of the law, its mountain
man rebel had posed little *social* threat to society; Luke Doolin and his
kin were content to live unimpeded in their valley enclave, separated
from the rest of the South by their own anachronistic way of life. Prob-
ably because of this, and because of the film's conservative politics,
Mitchum and director Arthur Ripley were able to portray working-
class whiteness in a manner far different from that of more liberally
minded filmmakers of the era. Unlike *The Long, Hot Summer* (1958),
The Defiant Ones (1958), and *The Fugitive Kind* (1959), directed by po-
litically conscious directors Martin Ritt, Stanley Kramer, and Sidney
Lumet, respectively, *Thunder Road* featured an antihero who was un-
ambiguously white—who, in other words, revealed no markers of the
class-bound blackness so often associated with redneck criminality.
Ritt, Kramer, and Lumet, on the other hand, offered overt social mes-
sages through the familiar color-coding of southern iconography.

"To play the Star-Spangled Banner it takes both the white keys and
the darkeys," Lenny Bruce joked in a parody of *The Defiant Ones*. Pro-
ducers like Kramer and Darryl Zanuck *"believe* in equality," he asserted.
"Yessir," he dead-panned, with producers like Kramer at the helm "it's
gonna be a Message World."[46] Missing in Bruce's well-placed attacks
on the easy liberalism and veiled racism of contemporary Hollywood
"messengers," however, was a sense of their equally stereotypical per-
spective on class. For, in attempting to make politically liberal state-
ments on race, relevant directors of the era tended to follow an old
generic pattern: round up the usual suspects. Avoiding institutional tar-
gets, training their sights instead upon the conventionally agreed-upon
culprit, they unintentionally reinforced the very racism they had set out
to attack. In all three films, the white outlaw is visually and themati-
cally linked to stereotypical blackness, primarily by his fugitive status
in the Deep South but not the least by his palpable sexuality.

Ben Quick (played by Paul Newman) in *The Long, Hot Summer*

(based loosely on a small portion of William Faulkner's *The Hamlet*) is, in western outlaw fashion, a drifter, a man on the run from a stigmatized past. The film begins with Ben's expulsion from a southern county by a country-store court of farmers on the charge of barn burning; his life, it seems, is imitating that of his father, who had been an infamous arsonist in the area. After "knockin' around this whole countryside, floatin' around from town to town, lookin' in on other people's kitchen windows from the outside," he lands at the Delta estate of Will Varner (played by Orson Welles), a self-proclaimed "ugly, fat old redneck." Varner promptly seizes upon Ben, whom he perceives to be a "stud," as the answer to his twenty-three-year-old daughter's frustrated spinsterhood. The daughter, Clara (played by Joanne Woodward), is repelled by the suggestion, but finds herself attracted to the unruly Ben after her long-time beau, a mild-mannered man from a "fine" family, refuses to say that he wants her "the way a man wants a woman." The beau, it turns out, is emotionally tied to his mother, and Clara turns her attention to the overtly lusting Ben, finally accepting him after he bows to the "lessons" she insists on teaching him. "I didn't take too easy to the idea," Ben tells Will Varner. "In fact, I've been a little long comin' round to it, but life's a pretty valuable thing and ought to be treated with a certain amount of respect. Now, you're old enough to know that, and I'm young enough to learn it."

Ben's conversion to middle-class respectability occurs at the end of the film, immediately following his near-lynching at the hands of a mob of men convinced he has burned Varner's barn. "The story of my life. Why didn't anyone ever want to consult with me peaceable?" he says as the men approach. Clara rescues Ben in her late-model convertible, and their reconciliation follows swiftly upon returning to the estate. The reconciliation, however, is hardly the unlikely union of social opposites that it appears to be. The impropriety of Clara's union with a lower-class drifter turns out to be merely illusory, a fiction that has allowed the film's reeducation theme to be developed. For Ben, after all, is no barn burner. From the beginning of the film, criminality is projected upon him as a genetic condition, an inescapable feature of his white-trash heritage. With the proper nurturance and education, however, the son of a condemned cracker can find his way into decent society.

Ben's class mobility, not coincidentally, is inextricably linked to his *racial* transformation. From the beginning of the film, his sexuality dis-

turbs the blonde gentility of Clara, and his open-shirted, sweaty phys-
icality is contrasted to the repellent or absent sexuality of the other men
at the plantation (Will Varner's obscene girth, his son's crybaby de-
meanor, Clara's beau's buttoned-down lack of interest). His body is bla-
tantly incendiary (the film begins with the fiery explosion of a barn), a
provocation to white men and women. Perceived as such, he is treated
according to racist tradition, told to leave the county "by sunset" in the
first scene and set upon by a lynch mob near the film's end. Yet when
he is cleared of criminal charges—when his "innocence" is established
and his reeducation in civility demonstrated to Clara—he becomes the
image of middle-class white respectability. At film's end, Ben, in a long-
sleeved white shirt and bow tie, embraces his new love in the recesses
of her family's plantation mansion.

Irving Ravetch, who along with Harriet Frank Jr. wrote the screen-
play for *The Long, Hot Summer,* has said that although Flem Snopes,
the character upon whom Ben Quick was based, is "possibly, the most
evil and vicious character in American literature." "We turned him
around into a romantic hero." He has also noted that his and Frank's
work with Faulkner (they would go on to adapt *The Sound and the Fury*
in 1959) "led us to the South, and the South is the landscape where the
greatest evil committed by Americans occured [*sic*]." "We have our own
social concerns," he has acknowledged, and he and Frank, he says, have
been drawn to stories that "make a social comment, which we are not
ashamed to make."[47] Yet by displacing stereotypical and historically
based black southern imagery onto the story of a white southern man,
The Long, Hot Summer in effect offers an apologia for the white South.
Within the socially conscious portrait of the contemporary Deep South,
the white misfit *stands in* for the victimized black man, suffering injus-
tice and prejudice at the hands of rural bigots, escaping lynching only
through the intercession of people in the big house. His reward for his
trials is racial *and* class metamorphosis: all vestiges of his previous life
as both cracker and surrogate black man are erased as he is accepted
into a life of Delta leisure.

The conflation of white outlaw and black victim also occurs in
The Fugitive Kind with Marlon Brando's portrayal of Valentine Xavier,
a guitar-playing drifter who lands in a small Mississippi town and
promptly unleashes the pent-up emotions of everyone he encounters.
Like *The Long, Hot Summer,* Sidney Lumet's adaptation of Tennessee
Williams's *Orpheus Descending* (with a screenplay by Williams and

Meade Roberts) opens in a court of law. Like Ben Quick, Val Xavier has been accused of a crime and now faces a judge; like Ben, Val is expelled from town (unlike Ben, he offers to leave, but he has little choice); and like Ben, Val is next seen hitting the road during the opening credits of the film. Val's sexuality is just as disturbing to his new acquaintances as Ben's is to his, yet here it is exaggerated by Brando's almost self-imitative sensuality. His trademark snakeskin jacket telegraphs his phallic presence; he is, in fact, even called "Snakeskin" several times in the film.

The audience, though, is as much the target of Val's seductions as the characters within the film, having been in effect directly addressed by him in the opening monologue (in which he recounts his misfortunes to an unseen judge and promises to "split out of this city for good" if released from jail). The film relies on Brando's charisma to carry the weight of its rhetorical appeal, for the character of Val will function as the town's conscience, provoking and illuminating the suppressed violence and frustration of a region that, according to fallen woman Carol Cutrere (yet another southern character played by Joanne Woodward), "used to be wild but now [is] just drunk." Carol tells him of her time as a "church-bitten reformer" who protested "the gradual massacre of the colored majority in the county," and the "dago bootlegger's daughter" Lady Torrance confesses the terrible fate of her father, who was burned alive by vigilantes for "selling liquor to Negroes." "You've lived in Two River County and you've seen some terrible things," Val says to Vee Talbot, the sheriff's wife. "Lynchins, beatins." "Yes," she responds. "I've been a witness and I know."

Although Val chafes against his "stud" image in the town, his exaggerated physicality allows Lumet to exploit its racial connotations. Val's past life in the French Quarter apparently involved "night places" and male prostitution; his final arrest is for "smashing up" a party he was paid to attend (it made him "sick"). "I lived in corruption but I'm not corrupted," he tells Lady in *Orpheus Descending* and vows to begin a new life in Two River County. His past is a world of "heavy drinking and smoking the weed and shacking with strangers," and he once "served time on a chain gang for vagrancy," but Val says he is "all through with that route."[48] All that remains of that "route" is his cherished guitar, a gift from Leadbelly, which bears the autographs of other famous blues artists.

The association of sexual excess with blackness is not only rein-

forced here but also mystified through the character of Uncle Pleasant, a black conjure man who appears twice, first with the drunk and lewd Carol and then at film's end when he finds the only remnant of Val in the smoldering ashes: his snakeskin jacket. In a manner typical of liberal narratives of the era, this association is portrayed sympathetically, as evidence of the main character's devalued sensitivity, yet the inherent racism of the association *guarantees* the fall of the character.[49] And, in fact, Val's connection to the world of black art, coupled with the racial connotations of his "dark," highly sexualized past, sabotages his reformation. The sheriff spells out the connection when he tells Val that the sign reading "Nigger, don't let the sun go down on you in this county" applies to him as well. "Boy, don't let the sun *rise* on you in this county," he warns the drifter, just as the farmers had warned Ben Quick at the beginning of *The Long, Hot Summer* and Boss Finley's son would warn Chance Wayne in Williams's *Sweet Bird of Youth* (1959).

When Val, like Ben, attempts to convert to middle-class respectability (even shedding his snakeskin jacket in favor of a white shirt and tie), the gesture is futile. As a cultural mulatto, the kind of person "that don't belong no place at all," he suffers the fate of those who try to "pass." His unjust death in a fiery apocalypse is both a moral indictment of the cruelty of the white townsmen and a spectacular form of martyrdom. Tennessee Williams's sensitivity to the position of male outsiders in southern culture lends *The Fugitive Kind* a relatively rare critical perspective on repressive authority, yet even here the connotative blackness of the white outsider restricts the character's fate to one of Hollywood's two generic options. Unlike *The Long, Hot Summer,* however, the film manages to straddle the options, suggesting in its final conflagration a redemptive punishment worthy of its mythic aspirations. Here, the benighted wasteland—"this hell," Lady calls it—is razed rather than resuscitated.

While Two River County was arguably the most vicious portrait of the cinematic South until the freak-studded landscape of Jon Boorman's *Deliverance* twelve years later, the South of Stanley Kramer's *The Defiant Ones* was more consistent with other mainstream depictions. With its setting bearing little resemblance to the Deep South (it was clearly shot in California), the 1958 film announced its symbolic interest in the region by hinging its story on one controlling metaphor. The two main characters, black convict Noah Cullen (played by Sidney Poitier) and white convict John Jackson (played by Tony Curtis), escape

a wrecked transport truck in chains and remain shackled together for a good two-thirds of the narrative. On the run from state troopers, dogs, and deputies, the two men must cooperate in order to survive. Although the film is peopled with fairly malicious crackers, the South itself emerges as capable of reformation. The county sheriff is benign, even tolerant, and the meanest-looking laborer in the region rescues the main characters from certain lynching. More importantly, the central character, Natchez racist John Jackson, is redeemed while on the lam, suffering for and shedding his racial prejudice by film's end.

"At first they said I was too good-looking for the part," Tony Curtis writes of the role in his autobiography. "I didn't look enough like the asshole 'nigger-hater' I was supposed to play. So I wore a false nose and made myself look uglier."[50] Curtis's and Kramer's sense of how a "nigger-hater" should look was hardly unconventional, yet it reveals the degree to which stereotypical imagery could inform socially conscious filmmaking. Taking their cues from both fiction (*Tobacco Road* and its progeny) and nonfiction (news footage from Sumner, Montgomery, and Little Rock), both actor and director initially adopted a physiognomic approach to character development that owed less to Method "observation" than to the internalization of cliché. An astute observer of news coverage of the contemporary South, for example, would have failed to see misshapen noses on either of Emmett Till's murderers or repugnant features on Columbia graduate John Kasper; strident Jim Crow proponents in Congress were not known for their gross ugliness. Yet in perpetuating the melodramatic notion that spiritual degeneration is reflected in physical features, filmmakers like Kramer demonstrated the boundaries of their liberalism. By suggesting an economic basis for prejudice, liberal Hollywood might have hinted at the larger, institutional nature of racism; instead, racism became not just a function but an indicator of class, an inherent characteristic—like physical ugliness—of an unaccountably depraved group. Its debasement, moreover, was replicated in the "fallen" nature of its cinematic representative: the spoiled features of movie idol Tony Curtis.

The cosmetic distortion of Curtis's face to convey moral ruin is not the only physical alteration required by the narrative. At a crucial moment in the film, upon orders from Cullen, he literally "blacks up," smearing his face (with Cullen's help) with mud to hide his "shining white face" in the moonlight. The gesture is clearly intended to be both humiliating and instructive: Jackson is "brought down" to Cullen's level

while acting out the first stage in his ultimate identification with his black "chainmate." However, the scene makes crudely symbolic not the *white* man's similarity to the black man but the *poor* white man's similarity to the black man. Like yokel ranch hand Jett Rink in *Giant* (1956), who blackens his face with the newly discovered oil on his property—and thereby implicitly signifies the futility of his quest for "class"—Jackson is a study in ignorance and vulgarity. Moreover, like Ben Quick and Val Xavier, John Jackson is a "marked" man, a fugitive not simply from southern (in)justice but from the monolithic whiteness he himself has embraced. It takes Cullen to point out to Jackson, who claims he will rejoin his old local syndicate when he gets out of prison, that he is in fact a "nobody," a "monkey on a stick" for "that cracker mob back there."

Jackson's recognition of his true position in the world—a poor, desperate white man with no prospects of advancement—signals the beginning of his redemption. Yet the film reinforces his inherently servile status by showcasing his body. When the men are taken in by a lonely white country woman, she wastes no time sizing up Jackson's charms; when Jackson falls ill, he awakens in the night to find her staring at him. As he lies prostrate on her bed, the key-lit object of her lust, he muses upon his old dream of making it to a city "where tall buildings reached up into the sky," but his survival depends entirely on his sexual performance in a rural shack. Significantly, it is immediately after cutting the chain between him and Cullen that Jackson collapses; without his black "half" he is reduced to pure physicality. As a plot device, of course, his freedom from Cullen and subsequent weakness prepare the way for the film's sex scene (in which movie star Tony Curtis revivifies his romantic persona). Because the scene occurs within several feet of the sleeping Cullen, though, it is the black man who emerges as somehow "above" carnality, a fact surely not lost on Kramer, who no doubt walked a tightrope between reinforcing sexualized racial stereotypes (and ensuring an unreleased movie if he filmed an illicit interracial love scene) and reinforcing equally racist—yet liberal—notions of the spiritual superiority of minorities. Regardless of intent, Jackson's "blackface" performance follows generic convention by demonstrating the poor white man's social and moral debasement; he is, according to the logic of movie liberalism, *beneath* the black man by virtue of his own ingrained blackness.

The Defiant Ones offers Jackson redemption only through the renunciation of his racial ambiguity. The country woman becomes the

"vehicle" for the process, demonstrating her own racism to the revulsion of her new lover. In another unsubtle metaphor, Jackson refuses to use her car to escape when he realizes she has led Cullen to certain death by giving him false directions through a quicksand bog. Although her desperation is similar to Jackson's, the film consigns her to her Tobacco Road shack with its paint-by-numbers wall decorations. Never having been more than "twenty miles" beyond her house, she remains mired in swampland frustration and prejudice. The blatant absurdity of a young woman seeing her only economic hope in an escaped convict notwithstanding, Jackson's moral reeducation is dependent upon his rejection of her offer of freedom and sexual companionship. His "better half" waits in the bog, and Jackson, wounded yet again—this time by a bullet from the woman's young son—rushes to save him, thereby saving himself from the permanent darkness of a white-trash coupling.

Cullen, in turn, sacrifices his own freedom to be with Jackson, jumping from a train when his failing partner cannot run fast enough to grab the black man's outstretched hand. As the sounds of the dogs close in upon them, the men wait patiently for the sheriff's approach, Cullen cradling Jackson in what Michael Rogin has called "a black and white pietà" (reprised, he points out, from the climax of Kramer's 1949 film *Home of the Brave*).[51] Playing "mammy" to the slow-learning white man, Cullen has gained little from the enterprise. His moral education has never been an issue, since he has been "enlightened" from the beginning of the film. Meanwhile Jackson, the punished and chastened outlaw, wins his redemption the hard way, receiving a resigned, knowing look from the sheriff at film's end.

:: By the end of the 1950s, the white southern rebel was firmly entrenched as an American cinematic figure. Piecing together a code of behavior from the self-reliant rhetoric of the fading gunfighter and the disaffected idiom of the emerging delinquent, he was at once anachronistic and timely, nostalgic and threatening. The patchwork ethic, however, began to unravel by the 1960s. As the civil rights movement entered its most publicly visible stage, white self-reliance devolved into anarchy, disaffection into thuggery. In a series of socially relevant films of the 1960s, Hollywood abandoned its fantasy of the social and moral reeducation of the insurrectionist, turning with renewed conviction to the spectacle of punishment.

Unlike revisionist westerns of the previous decade, in which out-laws increasingly became sympathetic antagonists of the establishment, the new southern films untangled their former political ambiguities and reformulated their narratives as allegories of racial purification. With the lawman recentered as romantic hero and the redneck reconstructed as irredeemable villain, the new frontier of the South became an intrara-cial battleground as white fought white in a struggle for social su-premacy. Exposing the conservatism beneath Hollywood liberalism of the 1950s, socially conscious filmmakers argued that racism was less a matter of politics than of manners; it was purely and simply a matter of social class. This vision of America's racial crisis would prove to be remarkably durable. Weathering major political and social upheavals in the culture, it would provide the narrative and ideological founda-tion for a new Hollywood genre in the 1980s: the civil rights film.

FIVE

CIVIL RIGHTS FILMS
AND THE NEW RED MENACE
The Legacy of the 1960s

In 1996, producer Fred Zollo pondered the strange his-
torical connections between his two "civil rights" films, *Mississippi Burn-
ing* (1988) and *Ghosts of Mississippi* (1996). "Oddly enough," he noted,
"when some of the critics said we rewrote history with *Mississippi Burn-
ing,* we *did*—in the bigger sense. The movie was essential to the re-
trial and successful reprosecution of Byron De La Beckwith."[1] As Zollo
saw it, the path leading from a film widely condemned as historically
execrable to the sentencing of civil rights leader Medgar Evers's mur-
derer began with an almost laughable lawsuit. In 1989, former Neshoba
County Sheriff Lawrence Rainey filed an $8 million libel suit against
Zollo and Orion Pictures, claiming he had been "portrayed unfavor-
ably" in their fictionalized retelling of the 1964 Philadelphia, Missis-
sippi, civil rights murders. "They have sure done some terrible harm,"
Rainey said. "Everybody all over the South knows the one they have
playing the sheriff in that movie is referring to me."[2]

While researching his defense, Zollo's Mississippi attorney, Jack
Ables, came across John Birch Society member William McIlhany's
book on Delmar Dennis, the FBI informant who had helped break the
Philadelphia case. The book, entitled *Klandestine,* resurfaced in legal
circles several years later when Hinds County Deputy District Attor-
ney Bobby DeLaughter was stalled in his attempt to reopen the Beck-
with case, and it would provide crucial evidence of Beckwith's public
acknowledgment of the murder of Evers. DeLaughter (according to
Zollo) would not have reopened the thirty-year-old Beckwith case in
the first place had it not been for the investigative articles of Jackson
newspaperman Jerry Mitchell, who claimed to have been "charged up"

147

by *Mississippi Burning.* Within *Mississippi Burning,* in other words, lay the key which would unlock the rusted chains of southern injustice: "No movie, no Jerry Mitchell, no Jack Ables, no *Klandestine,* no Delmar Dennis," producer Zollo reasoned. "And Beckwith is still living up in Tennessee a free man" (83).

For all of its self-serving convolutions, the line of succession posited by the Hollywood producer—in which reality begets fiction begets reality—describes fairly accurately the tangled contemporary relationship between history and historical reenactment. As Mississippi writer Willie Morris noted in his journal of the making of *Ghosts of Mississippi,* the "uncanny blending of the 'real' and the re-created 'unreal,' between the authentic fact and the filmed fact, between the shadow and the act" created "layer upon layer of ironies . . . surreal to me in their unfolding" (31). Most surreal to Morris was the recreation of Byron De La Beckwith. Under pounds of latex and paint, actor James Woods seemed literally to *become* the Klan killer—mimicking the voice and mannerisms of both the young and old Beckwith with a dramatic flair that earned him an Oscar nomination for Best Supporting Actor. Oddly, Fred Zollo's account of the historical impact of *Mississippi Burning* failed to add this critically successful performance to his chain of causation: no *Mississippi Burning,* he might have suggested, no *Ghosts of Mississippi,* no reinvention of Byron De La Beckwith.

For Hollywood's public relations purposes, of course, the impact of a movie generally regarded as historically distorted must by necessity stop at the imprisoning of Byron De La Beckwith, not his compelling reincarnation. But the paternity of the resuscitated Beckwith can hardly be contested. With his scenery-chewing proclamations, flamboyant arrogance, and all-purpose "southern" accent, he is the geriatric descendant of the postwar Hollywood cracker. With his cosmetic overhauling in the 1980s, the cracker became the civil rights film's dramatic centerpiece, its narrative raison d'être. He (and it was always a "he") would initiate and complicate the action, and he would be vanquished at movie's end by the only character capable of driving a stake through the heart of a Delta racist: his alter-ego, the man of law, the redeemed southern white man.

Beginning with the release of *Mississippi Burning,* in 1988, this has been America's most popular version of the civil rights story, its favored interpretation of several decades' worth of complex social change. Dur-

ing the year prior to the first stirrings of Hollywood's interest in retelling the postwar southern story, however, American audiences had seen the first broadcasts of Henry Hampton's multipart documentary *Eyes on the Prize* on public television, a work that graphically challenged many of the historical clichés associated with the era. The new visibility of archival news footage of the era, along with increasing public interest in the movement (as witnessed by the commercial and critical success of Taylor Branch's *Parting the Waters* in 1988 and the 1989 Hartford conference on the life and times of the Student Nonviolent Coordinating Committee), created a critical demand for greater historical authenticity in media recreations of recent historical events. How Hollywood responded to this demand, however, says much about the power not only of stereotype in American culture but of ingrained ways of imagining and representing the past.

Television drama had made several forays into civil rights history before movies entered the territory, most notably with *Attack on Terror* in 1975 (the first retelling of the FBI's investigation of the Chaney, Goodman, and Schwerner murders), a four-hour biography of Martin Luther King in 1978, and *Crisis at Central High* in 1980. Alan Parker's *Mississippi Burning*, however, was the first major cinematic recreation of events in movement history, and, like *The Deer Hunter,* the 1978 film that triggered an avalanche of Vietnam films culminating in 1989's *Born on the Fourth of July,* it appeared to mark a significant shift in public interest. The controversy surrounding its blatant disregard for historical accuracy only intensified its contemporary "importance"—and its commercial popularity. The door was opened for less sensationalized, made-for-television movies focusing on personalized, biographical tales of the era: the Freedom Summer work of Mickey Schwerner (*Murder in Mississippi* [1990]), an aspiring reporter's reminiscence of Watts (*Heat Wave* [1990]), the pre-*Brown* legal maneuverings of Thurgood Marshall (*Simple Justice* [1993]), the travails of Mississippi newspaperwoman Hazel Brannon Smith (*A Passion for Justice* [1994]), the life of Vernon Johns (*The Vernon Johns Story* [1994]), the rise and redemption of George Wallace (*Wallace* [1998]), the Disney Channel's child's-eyes stories of New Orleans school integration (*Ruby Bridges* [1998]) and the Selma March (*Selma, Lord, Selma* [1999]), the generational tension between a black father and his activist son in the Deep South of 1961 (*Freedom Song* [2000]), and, most ambitiously, the evolving relationship between a

white lawyer and his black housekeeper in early 1960s small-town Georgia (the short-lived but critically acclaimed NBC series *I'll Fly Away* [1991–93]).

As a body, these works testify to the sustained popularity of stories related to the civil rights movement throughout the 1990s. In their studied adherence to biographical conventions, however, they also reveal television's reverence for its own history. As a phenomenon experienced by millions as broadcast-quality (as opposed to projection-quality) images, the movement was an inherently televisual spectacle. Increasingly lightweight handheld cameras with synched sound enhanced the ability of camera operators to capture spontaneous events, while the influence of cinéma vérité techniques prompted many to wade into the midst of dangerous confrontations. The privileged, engaged point of view came to dominate "crisis reporting," hence the reliance of teledramas on "eyewitness" accounts. Narratives structured on journals and diaries abound in the genre, as does voice-over narration. The first "civil rights" docudrama, *Attack on Terror,* was adapted from Don Whitehead's nonfiction book on the FBI and was narrated by actor William Conrad in thunderous, Walter Cronkite fashion; excerpts from Little Rock teacher Elizabeth Huckaby's diary of 1957 are heard throughout *Crisis at Central High;* the memoirs of *Los Angeles Times* reporter Robert Richardson provide the narrative foundation of *Heat Wave;* and the soundtrack of *King* contains voice-over testimonies by many characters, including cameo narration by Ramsey Clark and Tony Bennett, both playing themselves.

The civil rights teledrama's investment in journalistic realism is most clearly revealed in its extensive use of archival news footage. Documentary or documentarylike shots are often edited into the film, as if the fictionalized narrative were simply an extension of photographed history. Abby Mann, for example, in his 1978 feature *King,* reshot well-known news coverage of Birmingham, Selma, and Memphis using professional actors, and liberally spliced this black-and-white footage into archival footage, hoping, one assumes, to create a seamless merger of documented and restaged history. Major sequences in *Heat Wave* are introduced by news footage of Watts, and *Murder in Mississippi* contains clips from a 1964 NBC news special on Freedom Summer. In docudramas like these, news footage often fills the screen and characters are embedded within it.

Most feature films that have attempted to recreate the civil rights

era, however, have refused to yield ground to television's documentary capacity, insisting instead upon what film has long claimed as its cultural prerogative to reshape and mystify the past. Like cinematic bookends, *Mississippi Burning* and *Ghosts of Mississippi* span Hollywood's first decade of trying to "get the story right." Situated squarely within the decade, functioning as fulcrum to the project, is the John Grisham phenomenon. As film adaptations of his best-selling novels regularly sprang forth throughout the 1990s, revisioning the civil rights era took on the appearance a national obsession, with popular movies like *A Time to Kill* and *The Chamber* (both 1996) updating Deep South iconography for a contemporary audience.

Getting the postwar southern story "right" has meant different things to different people. To director Alan Parker, it was less a matter of history than of psychology: "If [*Mississippi Burning*] makes people feel something, viscerally and emotionally," he said in 1989, "if it makes them question the racism that exists in all of us now—and not just in 1964 among a bunch of Mississippi rednecks—only then will I have been true to the memory of James Chaney, Michael Schwerner, and Andrew Goodman."[3] To a great many historians and critics, Parker's "all of us" said it all. The film was a fable for, by, and *about* white characters (primarily FBI men), an irresponsible representation at best. Taking his cue from this critical reaction, Rob Reiner took a preemptive strike at charges of narrative racism seven years later when he defended his direction of *Ghosts of Mississippi:* "It's not just the Beckwith story or the Myrlie Evers or Medgar Evers story, it's also the DeLaughter story. Here was a white person who walked into this civil rights case and had to face his own feelings of racism. I can tell this story through this guy. I can start examining my own feelings through this character."[4]

Despite the influence of *Mississippi Burning* on the next generation of civil rights–themed films, however, the movie itself was hardly the urtext of a new genre. The story of a lawman who rides into a dusty town to bring marauders to justice and rides out victorious with his sidekick is the most familiar American story of them all. Tipping his hand, perhaps, to reveal that the film was no more about historical reality than old westerns, director Alan Parker had the FBI set up local headquarters in an abandoned movie theater rather than in a replica of the Delphia Courts Motel, where real agents had worked in Philadelphia during the summer of 1964. Given this, the parameters of the fictional agents' investigation should hardly have been surprising: Launching

their investigation from a rundown dream palace, what they ultimately "discovered" were well-worn characters in well-worn scenes—the shadows and ghosts of Hollywood past.

It is perhaps fitting that filmmakers would turn to the conventions of the western in their retelling of civil rights stories, for the genre in its postwar phase had been a major cultural arena in which Americans had dramatized issues of race. But if most fictional frontiersmen of the 1950s and early 1960s had stalked the plains on a mission of racial and ideological purification, by the 1980s the gunfighters of the South had long since shed their racism and political conservatism, claiming only righteous wrath as their frontier heritage. Like John Wayne's Ethan Edwards in *The Searchers* thirty years earlier, *Mississippi Burning*'s FBI agent Rupert Anderson (Gene Hackman) understands "the enemy" with a passion bordering on obsession. A former Mississippi sheriff wise to the ways of small-town southern bigots, Anderson functions as the FBI's— and the audience's—guide through the wilds of frontier barbarism. Just as Ethan "talks Comanche good," so does Anderson, an opponent of segregation, know how to "talk southern" to Klan members. Like Ethan, he knows how to play as dirty as the enemy (fig. 19), castration being the preferred method of vengeance over scalping; also like Ethan, he even employs the old gunfighter's tactic of exploiting enemy violence against white women to justify barbaric revenge. When the Klan savagely beats a member's wife for confessing her husband's part in the triple murders, Anderson's Ivy League partner finally agrees to bring in the villains by any means necessary—"*your* way," he promises the enraged Anderson.

Nevertheless, a significant difference marks the depictions of gunfighter violence from the two eras. By the mid-1950s, white vengeance could not be convincingly portrayed as unambiguous. With evidence of white brutality increasingly on display in newspapers and newscasts, the vigilante became a troubling figure in the media. In fact, director John Ford took pains to imply that Ethan Edwards and his enemy, Chief Scar, were alter egos. Scar had lost his family in a cavalry raid, just as Ethan had lost his in a Comanche raid; each spoke the other's language; and each committed similar acts of savagery. Ethan's violence, however, was often disturbingly unmotivated, his barbarism nothing short of pathological. Paving the way for the liberal westerns of the late 1960s and early 1970s, in which Indians and Mexicans unsubtly called to mind victimized Vietnamese, postwar westerns like *The Searchers* be-

FIGURE 19. The redeemed southern lawman: FBI agent Rupert Anderson (Gene Hackman) ambushes Klan murderer (Brad Dourif) in *Mississippi Burning* (Orion Studios, 1988). Wisconsin Center for Film and Theater Research.

trayed a deep ambivalence about the imperatives of white America. Following the *Brown* decision, in fact, the genre increasingly questioned the "massive resistance" of frontier settlers and their army protectors, and filmmakers made several attempts to portray Indians sympathetically. White thieves and poachers gradually supplanted Indians as acceptable villains, and even these characters were finally replaced in the late 1960s and early 1970s by corrupt institutions—banks, railroads, and the cavalry itself—as the genre became a popular vehicle for social criticism.

This kind of evolving political complexity, however, has not been a characteristic of the civil rights film. Steadfastly refusing to call institutional racism into question, the genre takes aim at character: the updated Indian fighter (now outfitted with suit, tie, and briefcase) squares off against a suitably updated villain. But for liberal-minded Hollywood, the fashioning of an appropriate "them" to a new rainbow-coalitioned "us" has required a reorganization of the cinematic family tree. The new frontier savage no longer dwells in collectivist camps on the

plains; his home is his castle and private property his creed. And his skin is no longer an emblem of otherness. All that remains of his "red" ancestry is the back of his neck: the raw mark of social exclusion, the stigmata of class. In Hollywood's revisit to the battlefields of freedom fighters, the new Red Menace is that most reviled of palefaces: the cracker vigilante, the white-trash thug, the Redneck. In his forceful removal of this diseased whiteness from his society, the southern man of law reclaims his homeland and redeems his race, eradicating racial tension as a social problem.

Andy, Atticus, and the Reinvented Lawman

The question of how the low-paid southern attorney or rural federal agent managed to metamorphose into a contemporary action-adventure hero cannot help but raise another question: When did such a metamorphosis occur? At what point after the *Brown* decision did the terms *southern lawman* and *hero* become culturally compatible rather than oxymoronic? At what point could an image of southern law be created that did not, to the nation at large and the rest of the world, connote *illegality?*

In the summer of 1955, Harold Strider, the obese, tobacco-chewing sheriff of Sumner County, Mississippi, lumbered onto national television screens during the Emmett Till murder trial. As network news expanded into live coverage and longer nightly telecasts, Strider was followed by a succession of near lookalikes—Bull Connor of Birmingham, Jim Clark of Selma, Lawrence Rainey and Cecil Price of Philadelphia—all seemingly indistinguishable in manner and diction, and by innumerable men of law—governors, senators, mayors—who were visibly and vigorously resisting the law of the land. Pitting state and municipal law against national law, they lodged rhetorical appeals to the spirit of American independence and individualism, insisting that they and they alone were mustering resistance to a communist-inspired "invasion" and "takeover" of the country.

Unfortunately for them, their "resistance" to northern aliens and black citizens looked like assault—an assault not just on protesters but on anyone perusing the newspaper or tuning in to the evening news. In 1963, for example, policemen in Clarksdale, Mississippi, posed for civil rights photographer Danny Lyon as a group of ministers from the National Council of Churches marched past. The lawmen's obscene gestures—directed toward both Lyon and the ministers—translated

FIGURE 20. The southern lawmen of photojournalism: Police in Clarksdale, Mississippi, gesture to a passing group of ministers from the National Council of Churches, 1963. © Danny Lyon / Magnum Photos.

on the page to a direct insult to the viewer (fig. 20). When Jim Clark's deputies physically attacked a news camera operator on the steps of the Dallas County courthouse in 1965, no one at home saw the man behind the camera; people watching television only saw faces and hands approaching the lens, images whirling in space, and blood and rain splattering their field of vision.[5] Racist crowds who spat on the lenses of cameras capturing the Selma-to-Montgomery march several months later might as well have been spitting on the viewers at home.

Many of the assailants, of course, were aware of this effect; they *intended* to attack all of those behind the camera who deigned to judge the white South. To their way of thinking, civil rights protests followed the press, rather than the other way around. Police chief Laurie Pritchett of Albany, Georgia, is perhaps the lone example of a southern lawman who understood on some level the nature of broadcast journalism, and his counterefforts to command the story helped to undermine a powerful local movement. But this aberration only underscores the general rule that news cameras, whose operators were usually welcomed

among civil rights groups, captured images of southern lawmen from the vantage point of those on the other side. Reversing the practice of narrative film, news footage objectified not African Americans but their opponents. The practical and safe method of shooting at, rather than from among, the defenders of segregation, then, inherently validated the subjectivity—and hence the cause—of civil rights protesters.

By the mid-1960s, the image of the southern lawman had become so estranged from national identification, so discredited as a point of view, that satire seemed the most appropriate mode for depicting the upholders of segregation. "During National Brotherhood Week," satirist Tom Lehrer sang, "Sheriff Clark and Lena Horne are dancing cheek-to-cheek."[6] Lenny Bruce and Woody Allen took on redneck sheriffs in their skits; the American version of the British television series *That Was the Week That Was* featured tunes by the "Singing Segregationist Plumbers" (the class connotations of the occupation suggesting overtones of Strider, Connor, and Clark), while one of the show's lead performers, singer Nancy Ames, told *Life* magazine, "They ought to take a big scoop and just shove Southerners into the Gulf of Mexico."[7]

Stanley Kubrick proved Ames's point when he directed *Dr. Strangelove,* making fanatical Major Kong (Slim Pickens) ultimately responsible for the end of the world. Gleefully straddling a nuclear bomb as it fell to earth, Kong was the hick from hell, eagerly instigating the Final Solution in the name of patriotism. After John F. Kennedy was assassinated, during postproduction on the film, Kong's persona suddenly became connotatively linked to the event, necessitating a word replacement in his famous recitation of survival kit items (the "pretty good weekend in Dallas" that a "feller" could have with the condoms, nylons, and lipsticks became a "pretty good weekend in Vegas"). But audiences could not miss the similarity between a fictional Texas Air Force major who blithely set off global annihilation and a new Texas president who inherited and escalated an illegal war. Despite Lyndon Johnson's liberal domestic achievements, he would often be mocked as what one biographer has called "the last of the really big hicks,"[8] the despised cultural shadow of Bostonians and Harvard graduates. From deputies to the president himself, the southern authority figure was an easy mark for satirists.

In the midst of the media's sheriff-saturation, however, an odd phenomenon occurred: much of the nation fell in love with a southern sheriff. On 3 October 1960, *The Andy Griffith Show* premiered on CBS.

FIGURE 21. The southern lawmen of prime-time television: Andy Griffith and Don Knotts on *The Andy Griffith Show* (CBS, 1960–68). Wisconsin Center for Film and Theater Research.

From that year through 1967 it ranked in the top eight prime-time series on television and was the top-ranked show in its final season, 1967–68. Revolving around the domestic adventures of Andy Taylor, sheriff of tiny Mayberry, North Carolina, the show posed a strikingly odd contrast to the images filling the nightly news. Not only was Sheriff Taylor a normal-sized nice guy who did not chew tobacco, but he didn't even wear a gun. He was, in fact, almost a practicing pacifist, who repeatedly taught others the lesson that calm common sense could solve most problems. The comic center of the show was his deputy, Barney Fife (Don Knotts), an incompetent authority-monger who proudly toted a gun (with its one bullet, on orders from Andy, kept buttoned in a shirt pocket). The idea for the show had evolved from a special episode of *The Danny Thomas Show* which had aired earlier in 1960.

(Another Desilu production, *I Love Lucy*, had introduced Tennessee Ernie Ford to national television audiences in 1954 as a country bumpkin out of place in New York City.) In that episode, New York performer Danny Thomas is arrested by Andy for speeding through Mayberry on his way back from Florida. Throwing money at the hick sheriff and demanding to be recognized as a star land the slick Yankee in Andy's jail, where he finally apologizes for his arrogance. Learning that he should "slow down" and not expect "fast solutions" to problems, Danny comes to appreciate the reasonableness of southern ways and the kind of sense a small-town sheriff can dispense.

As a weekly testament to the ideal of minimal social change, *The Andy Griffith Show* was ironically situated. Not only did it premiere the same year as the first student sit-ins in Greensboro, North Carolina, but its setting, the fictional Mayberry, was based on Griffith's own hometown of Mt. Airy, North Carolina—sixty miles north of Greensboro. Although the show was set in contemporary times, the town of Mayberry seemed distinctly uncontemporary. Moreover, it was entirely white. Trouble occurred usually when outsiders—from the North or from California—came to town with nefarious schemes for bilking the citizens or introducing some kind of modernizing plan. Time and again, Mayberry, under the thoughtful leadership of Andy, resisted outside pressure to change. The static peacefulness of the setting was exaggerated by the producer's refusal to film the series before an audience. Using only one camera instead of the usual three, the show could move outside into "real" locations, where "long silences," according to Griffith,[9] could punctuate the dialogue without the interruption of audience laughter.

For a comedy series so intent on capturing an unusual level of emotional realism, the studied remoteness from the connotations of its setting was remarkable. But it was no accident. Describing his own work as writer on the show, Andy Griffith claims that both he and costar Don Knotts "respected the small-town environment." Both men came of age in the South of the 1920s and 1930s, and it is this sense of a *remembered* community that is most striking about the series. "Even though we shot it in the sixties," Griffith says, "nobody talked about it, but it was like it was the thirties."[10] Mayberry, in fact, is nothing so much as a southern version of Carvel, the mythical white town of MGM's immensely popular Andy Hardy series of the 1930s and early 1940s (the series

which, it should be noted, was the prototype of future television situation comedies).

Clearly, any mainstream television program set in the contemporary South of the early 1960s faced politically sensitive staging problems. Although a number of social-problem films that focused on race had been made in the immediate postwar years, the HUAC investigations of the film and television industries, which began in 1947, coupled with well-organized media surveillance by southern segregationists, made similar productions unthinkable for decades. In 1958, Rod Serling's teledrama based on the Emmett Till case was radically rewritten to omit any reference to the South, largely in response to Citizens' Councils letters of protest (the new version was set in New England, the victim was European, and even bottles of Coca-Cola—the ubiquitous southern drink—were banned from the set).

"An alien voice" is what arch-conservative South Carolina Senator "Seab" Cooley called a liberal northern senator in Otto Preminger's 1962 *Advise and Consent.* "Perhaps it's the new voice of my country," he mused. "These old ears aren't tuned to these new sounds." Neither were most southern television stations, and many refused to broadcast national programs featuring black performers throughout the 1950s and 1960s. Their censorship efforts were aided by groups like the Louisiana-based Monitor South, which attempted to coordinate regional rejection of television shows with anti-South (i.e., antisegregationist) bias. National sponsors repeatedly canceled support of programs which might offend the white South. Mississippi Senator James Eastland called in 1959 for a constitutional amendment to give each state the authority to decide for itself what should be censored in the movies: states' rights, in other words, for moviegoers. Aware of the increasingly negative representation of their region in the national news, the Mississippi State Sovereignty Commission even sent public relations emissaries north to give free lectures to civic groups about the virtues of "the most lied-about state in the Union." In this climate, it seemed a prime-time series about a modern-day southern sheriff wouldn't have a chance.

The canniness of Griffith and producer Sheldon Leonard, however, ensured the immense success of just such a show. As Ronald Reagan learned decades later, historical displacement is a powerful rhetorical tool. Reconstructing the Depression as a kinder, gentler time for white America, *The Andy Griffith Show* offered the tantalizing spectacle of a

southern Shangri-la. Of its time, yet charmingly frozen on a studio backlot, Mayberry was CBS's prime-time challenge to its own evening newscasts. Coming into living rooms in the "family" hours following Walter Cronkite's stories from Birmingham and Selma, it suggested a different kind of realism—one of selective memory, silences, and omissions.

If the temporal displacement of this program was purely suggestive and subliminal, though, that of another highly popular southern story from 1960 was not. Like the Mayberry of *The Andy Griffith Show,* the Maycomb of Harper Lee's *To Kill a Mockingbird* was thinly based on its creator's hometown (this time, Monroeville, Alabama). But unlike Mayberry, Maycomb was a town divided by race and social class. By setting her story in the past, Lee was able to address mainstream television's taboo subject, yet here, too, the South took shape as a memory, a fantasy tempered by an acute awareness of its remoteness from present-day urgency. As Eric Sundquist has noted, "the novel harks back to the 1930s . . . to move the mounting fear and violence surrounding desegregation into an arena of safer contemplation."[11]

As remembered by the grown Scout Finch, her father Atticus was an early champion of tolerance, a small-town lawyer who dispensed legal assistance and common sense with enlightened equanimity (fig. 22). Like his prime-time brother Andy Taylor, he was a widower with children, an inherent pacifist, a fair-minded southern man of law. Around Atticus, however, revolved other men who would haunt his daughter's memory: Tom Robinson, a crippled black man wrongly accused of rape; Bob Ewell, Robinson's white accuser; and Boo Radley, Scout's reclusive neighbor. Robinson and Ewell are killed in the course of the novel, Robinson when he tries to escape from prison and Ewell when he attacks Scout and her brother Jem. It is Ewell's death at the hands of Boo Radley that ends the novel and brings to closure Scout's coming of age. Realizing that the "malevolent phantom" she had thought resided behind the rotten shutters of a once fine old house across the street has actually been her guardian angel,[12] Scout must now recognize who the true ogre in her community has been all along: Robert E. Lee Ewell, the "bantam cock of a man" (170) who bore "no resemblance to his namesake" (170), the patriarch of a dump-dwelling brood of illiterates. "People like the Ewells lived as guests of the county in prosperity as well as in the depths of a depression," Scout recalls. "No truant officers could keep their numerous offspring in school; no public health

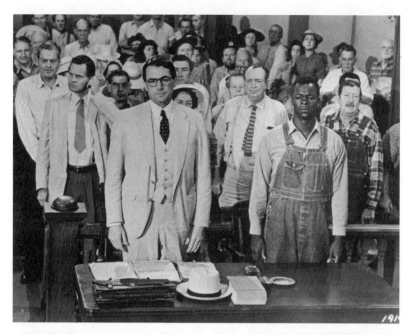

FIGURE 22. The southern attorney as tolerant patriarch: Gregory Peck as Atticus Finch
in *To Kill a Mockingbird* (Universal Studios, 1962). Wisconsin Center for Film and
Theater Research.

officer could free them from congenital defects, various worms, and the
diseases indigenous to filthy surroundings" (170).

Bob Ewell, the violent man whose "face was as red as his neck" (170),
is killed by Boo Radley, the gentleman with "sickly white" skin, "dead
hair," and "gray eyes so colorless I thought he was blind" (270). After
saving Scout's life and escorting her down the sidewalk "as any gentle-
man would do" (278), the valiant Boo disappears forever on Halloween
night into his crumbling house. As Atticus reads aloud from *The Gray
Ghost,* Scout falls asleep, guilt-free and secure in the knowledge that not
only her father but also her very own gray ghost stand vigilant in her
protection. Boo Radley, the fading specter of southern gentility, need
never stand trial. "Taking the one man who's done you and this town
a great service an' draggin' him with his shy ways into the limelight—
to me, that's a sin," the local sheriff tells Atticus, interpreting the law
for the community. "There's a black boy dead for no reason, and the
man responsible for it's dead. Let the dead bury the dead this time, Mr.
Finch" (276). With the sacrifice of the black man and the compensatory

slaying of the redneck, the novel draws to a close. "Thank you for my children," Atticus tells Boo (276). And, indeed, the chain of events that culminates in Bob Ewell's death awakens in Scout the social conscience that will produce, twenty years later, *To Kill a Mockingbird.*

The film of Harper Lee's novel appeared in 1962, the role of Atticus Finch winning an Oscar for Gregory Peck. Coincidentally, Peck had just completed another film about southern justice when he began work on *To Kill a Mockingbird.* That film, *Cape Fear,* was set in contemporary North Carolina (although shot in Savannah, Georgia) and told the story of district attorney Sam Bowden (Peck), whose family is terrorized by a man Bowden once sent to jail. With its condemnation of laws that protect the rights of vagrants, outsiders, and "unwanted elements," *Cape Fear* seemed to turn the liberal politics of the moment on its head, for it argued that not only was vigilante justice the correct response of upstanding white men to those who threatened their security, it was the *only possible* response. With this premise, the film could easily have been the product of a state sovereignty commission, except for one point: the unwanted element in *Cape Fear* was neither a black agitator nor a white troublemaker from the North. It was a low-rent white man, a farm-boy rapist fresh from jail come to take revenge on the man who had put him away.

Coproducer Robert Mitchum's decision to play the role of vulgar villain Max Cady was layered with irony, for in Savannah in 1933 Mitchum himself had been sentenced to a term on a chain gang, probably for vagrancy. Although various versions of his encounter with southern justice exist, Mitchum's family confirmed that he had made a dramatic escape into the swamps, where he was aided, much like John Jackson in *The Defiant Ones,* by "three backwoods sisters."[13] Mitchum verified the story in an interview in the local paper, a move that no doubt increased public interest in a film that seemed to trade on his "criminal" history (his 1948 arrest in Hollywood for marijuana possession and subsequent jail time had been nationally publicized). When a Savannah resident asked Mitchum if he'd come far from his days as a Georgia fugitive, the star replied, "Not necessarily."[14]

Enhanced by Mitchum's outlaw persona, Max Cady appears as the lewdest of crackers (fig. 23). With straw hat pushed back on his head and shirt hanging outside his trousers, he strikes a discordant note the moment he appears in the film. In the first scene he strolls across the town square of a picturesque southern town and enters the courthouse.

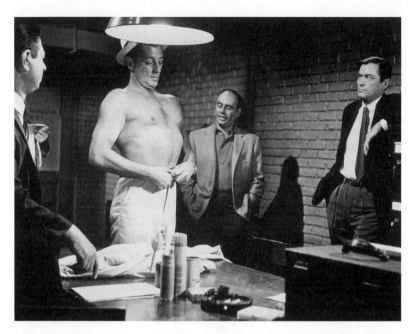

FIGURE 23. The cracker from hell: Max Cady (Robert Mitchum) terrorizes southern attorney Sam Bowden (Gregory Peck, right) in *Cape Fear* (Universal Studios, 1962). Wisconsin Center for Film and Theater Research.

"Hey, daddy," he says to a black janitor, a crack that tells the audience all they need to know about his social class and, implicitly, his racial attitudes. Cady's casual violation of propriety expands into savage explosions of violence as he circles his primary target: the moss-draped, white-pillared home of Sam Bowden. Bowden finds he can do nothing to stop Cady's stalking and imminent attack on his family. "I can't arrest a man for what might be in his mind," the police chief tells Bowden. "That's dictatorship." "A man like that doesn't deserve civil rights," Bowden's wife replies, and she is proved right in the film, for Cady is no man at all. He is in fact "an animal," "a beast," "a shocking degenerate." (Bernard Herrmann's score, like those he composed for Alfred Hitchcock and a number of science fiction films, only intensifies the horror of Max Cady's haunting of the Bowden family.)

When Bowden realizes that his daughter will most likely be raped by Cady, he is forced to abandon his dependence on the law and defend his family himself. With reassurances from his wife that their "pioneer stock" will ultimately triumph, Bowden plans and executes his own ver-

sion of frontier warfare. Sequestering his women on a houseboat, he lures Cady into hand-to-hand combat in a primeval swamp and reclaims the territory for white decency. Disappearing into mist and sludge at film's end, however, Max Cady, the cracker from hell, does not die. Like all mythic demons, he only takes a breather—this time for six months, after which he reappears in Maycomb, Alabama, on Halloween night, in the guise of Bob Ewell.

Though both *Cape Fear* and *To Kill a Mockingbird* constructed their respective villains as products of the South's underbelly, they could not agree on the causative factors. The conservative politics of *Cape Fear* point in the direction of inherent evil yet hint at a possibility which would have been unthinkable to Harper Lee: the intimate relationship between the redneck and the tolerant white man. Throughout the film, Max Cady is positioned as Sam Bowden's alter ego, his repressed double who voices that which Bowden cannot (in Martin Scorsese's 1990 remake, this subtext is brought to the surface). Cady knows the law as well as Bowden, and each man is able to think like the other and predict the other's moves. The central horror in the film is the lawman's recognition of this connection and his awareness that he must, by film's end, confront his despised kinsman.

No such recognition is required of Atticus Finch; in fact, the prospect of confrontation is so obscene that it cannot even be visualized, only recollected by his child as the Halloween-eve sounds of a gray ghost vanquishing a drunken monster. *To Kill a Mockingbird* indicted systemic poverty to some degree for the Bob Ewells of the South, but the film held the moral center of the story, the white man of law, inviolate, unimplicated in the lawlessness that surrounded him. Both narratives, however, in their insistence upon the inherent badness of their archvillains, shared a class-based view of sociopathology. By portraying Max Cady's violence as simultaneously *unconscious,* a function of animal-like cruelty, and *conscious,* a campaign of revenge, *Cape Fear* managed to encode its criminal as both Indian savage and lynch-mob racist. By doing so, the film was able not only to disguise its concern for the threatened civil rights of *white* men as a concern for the rights of *good* men but also to cast its story as a conventional tale of frontier justice. To a lesser degree, Bob Ewell served a similar function in *To Kill a Mockingbird,* his violence, alcoholism, and racism fueling a mission of revenge against the family of a lawyer. In the fictional Deep South, the embattled men of law were the brave new cavalry scouts, all that stood

between peaceful communities below the Mason-Dixon Line and the new rednecked hordes.

Roger Corman and the Undermining of Mayberry

The communities protected by such tolerant lawmen, of course, bore little resemblance to actual towns in the contemporary South. Atticus Finch and Andy Taylor resided in a fantasy of the past, and Sam Bowden's North Carolina town seemed to have just one black resident. The immense critical acclaim that greeted *To Kill a Mockingbird*'s displaced attempt to address contemporary racial politics notwithstanding, only one southern film of the era—a low-budget, little-reviewed Roger Corman production—not only set its action in a more socially realistic location but also told its story of a racial crisis from both black and white points of view. Released in 1962, the same year as *To Kill a Mockingbird* and *Cape Fear,* Corman's *The Intruder* focused on the reaction of a small Missouri town to the segregationist campaigning of an outside agitator. Clearly based on the 1956 Clinton, Tennessee, school integration standoff, the film stayed remarkably true to its source material, Charles Beaumont's 1959 novel of the same name (Beaumont himself was the screenwriter). In adapting a recent historical event to the screen, Corman and Beaumont were forced to reverse the entrenched character stereotypes of the genre. Here, the cracker villain is replaced by an articulate and educated man, and the middle-class hero, forced by circumstances to defend law and justice against a racist mob, is a working-class tough guy, Max Cady's cinematic cousin.

Beaumont's description of his villain in the novel leaves little doubt that the character was based on John Kasper, the Columbia University graduate who, after living a somewhat bohemian life in Greenwich Village in the early 1950s, fell under the spell of fascist-sympathizer poet Ezra Pound and came to the South as a segregationist activist. Adam Cramer, Kasper's fictional persona, was, Beaumont writes, "a fairly handsome, masculine young man, the sort you would be likely to encounter in some minor New England college. The hair, dark brown, almost black, was straight. The nose was somewhat bent, though not noticeably, and the lips were rather thick."[15] The description closely matches the image of John Kasper that appeared in national magazines and newspapers from 1956 to 1957 (fig. 24). An article in *Look* titled "Intruder in the South" featured three photographs of the dark-haired, bent-nosed Kasper and one Clinton resident's initial response to him: "There was

FIGURE 24. Northern segregationist John Kasper in 1957, the inspiration for Roger Corman's *The Intruder* (1962). *Look*, 19 February 1957.

something compelling about the stranger's hazel-gray eyes, something faintly hypnotic about the way he gestured with his pale, long-fingered hands. This John Kasper was, clearly, a man of book learning. He looked and talked like a college professor."[16] In the novel, a young resident of the town (which Beaumont named Caxton) finds herself attracted to Adam Cramer: "This was a stranger to town. Someone from the East, probably. You could see that" (21).

Like Kasper, Cramer mesmerizes the town with his assertions that the *Brown* decision is evidence of a Jewish and Communist conspiracy to mongrelize the nation and, like Kasper, sees himself as the protégé

of an older, flamboyantly intellectual fascist. In Beaumont's version of the story, Ezra Pound is replaced by UCLA political theorist Max Blake, who has taught his student that in order to win power over "the Great Unwashable," one must "play on their ignorance; underline and reflect their prejudices; make them afraid," for "their prejudices keep them afloat—it is the only strength they have" (232–33). The well-traveled and formerly racially tolerant Cramer decides to test the theory, but his success earns him no respect from his old professor. Blake turns out to be all talk; his fear of losing his position leads him to beg Cramer to stop his activities in Caxton, which include the formation of a "White Citizens College." Stung to learn that his mentor never intended theory to evolve into practice, Cramer contemptuously dismisses Blake and continues organizing the town. The book climaxes in the public exposure of Cramer's plot to frame a black high school student for attempted rape. Shaming Cramer in front of a lynch mob, local white salesman Sam Griffin forces the alleged victim to retract her story, sets the black student free, and abandons the disgraced Cramer in a schoolyard.

The film version of *The Intruder* omits the college mentor subplot, focusing instead on Cramer's "hypnotic" sway over the small town. Corman accentuated the unstereotypical nature of both his racist villain and upstanding hero by casting blond, conventionally attractive William Shatner in the role of unctuous Adam Cramer and burly, rough-featured Leo Gordon in the role of Sam Griffin. (Gordon, in fact, could easily be imagined in the familiar role of racist southern sheriff.) Like the novel, the film looks at the phenomenon of white community uprisings in the post-*Brown* era, asking, in the words of the novel's newspaper editor, "What is it that stays so close to the surface that a few words from a Yankee stranger can send it flooding out?" (22).

The racism of the townspeople is graphically demonstrated for a film of this era, but Corman and Beaumont refuse to endorse social class as an "explanation" for racial violence. Wealthy plantation owner Verne Shipman is depicted as crudely intolerant, and his presence in the lynch mob at film's end is a highly unconventional moment in a genre that had steadfastly refused to connect upper-class and working-class racism. Further, Cramer's affectation of rural southern colloquialisms and down-home facade when publicly addressing the people of Caxton mark the politics of *The Intruder* as radically different from those of a film like *A Face in the Crowd,* for here intellectual elitism that

poses as grassroots thinking is a means to a specific political end. Unlike Elia Kazan's polemic against the viciousness residing among "just plain folks" in *A Face in the Crowd,* Corman's critique focuses upon intellectuals, the "Vanderbilt '44" types, who are as racist as the backwoods crackers they ridicule. No socially conscious journalist or well-educated crusader (like Kazan's Mel or Marcia) comes to rescue the town from the seducer in their midst; the newspaper editor, in fact, who is personally opposed to integration but takes up the fight for "the law," is savagely beaten. Their savior, the brave rhetorician who succeeds in exposing the fraud of racist propaganda, is one of their own, a local salesman who understands that "you can sell people all kinds of things they don't need, easy, you can make them do things they never would think of doing, just as long as they believe they're special, important, getting in on the ground floor—you know?" (48).

Like the white residents of Hoxie, Arkansas, and Clinton, Tennessee, those of the fictional Caxton, Missouri, were not monolithically united against federally mandated desegregation; and, as the events in Clinton dramatically demonstrated, racial demagoguery was hardly a southern product. But *The Intruder's* refusal to mystify racism as a class- and region-bound pathology was a cinematic aberration—and a little-seen one at that. Far more historically accurate than big-budget southern films, the film nevertheless left no mark on others that would follow; oddly, though, its unconventional big-screen iconography was soon entirely conventional on the small screen.

Television and the New Realism of the South

By the mid-1960s the visual discrepancy between television news and mainstream narrative films and television shows could appear surreal. Nervous networks continued to back away from realistic representations of the South, instead sending hillbillies to California (*The Real McCoys,* 1957–62, followed by *The Beverly Hillbillies,* 1963–71) and to the Marine Corps (Andy Taylor's friend Gomer Pyle was featured in his own spin-off from 1964 to 1969), while MGM created cartoonish settings for Elvis Presley each year (a Dogpatch-like mountain settlement in the 1964 *Kissin' Cousins,* a nineteenth-century riverboat in the 1965 *Frankie and Johnny,* a Florida resort in the 1967 *Clambake*). On the drive-in circuit, the rural South became the setting for numerous "splatter" films (notably, those of Herschell Gordon Lewis, a former literature professor at the University of Mississippi), a trend that would

culminate ten years later with the cult hit *The Texas Chainsaw Massacre.* Lewis's *Two Thousand Maniacs* (1964) introduced horror audiences to the conventional plotline of "southern gore" films: innocent outsiders (here, northern tourists) stranded in the rural South meet horrific ends at the hands of backwater monsters (here, Confederate ghosts avenging the destruction of their town by Union forces).

Between 1963 and 1966, the average number of feature films set even partially in the South dropped from nine per year between 1956–62 to four. *This Property Is Condemned,* Sydney Pollack's 1966 adaptation of Tennessee Williams's one-act play, signaled the exhaustion of the playwright's flamboyant imagery after over a decade of dramatic political changes in the region. Mary Badham, who four years earlier had played the optimistic Scout in *To Kill a Mockingbird,* was now cast as the bedraggled and abandoned Willie, the last resident of a boarded-up Mississippi town. As in the earlier film, Badham's character tells the viewer of spectacular events in her community's past, but, unlike Scout's Maycomb, Willie's town has been utterly consumed by the Depression. "It was somethin'," Willie says of the old Dodson, Mississippi; now it is merely condemned property.

While Hollywood shied away from depictions of the contemporary South, the few attempts to make "relevant" racial statements on film were commercial failures (*Black Like Me* [1964], *Nothing but a Man* [1964], and *A Man Called Adam* [1966]). Television news filled the conspicuous void, broadcasting more than eight major studies of civil rights issues between 1963 and 1966. The stylistic proficiency of many of these reality-based productions only exacerbated the tension between fiction and nonfiction on the nation's television and film screens. It seemed, in fact, that an alternative South existed on the news, one far more compelling than the Technicolor, widescreen version.

ABC was the first network to showcase the new "observational" style in its prime-time news specials. Working as a semi-independent unit within the network, the team of former *Life* magazine correspondent Robert Drew and cameraman Ricky Leacock produced a number of documentaries that employed the now classic techniques of American-styled cinéma vérité: the use of hand-held 16 mm cameras, available light sources, and mobile, synchronized-sound shooting. The intimacy of this "fly-on-the-wall" effect suggested nothing so much as "reality" itself, with seemingly omnipresent cameras and microphones penetrating private conversations and volatile confrontations to capture

unflattering close-ups and off-handed remarks. Drew's and Leacock's earlier ABC-sponsored portrait of the 1960 New Orleans school desegregation crisis, *The Children Were Watching,* had demonstrated the ability of such techniques to communicate the immediacy of the intensifying southern drama, but their study three years later of George Wallace's attempt to block integration at the University of Alabama, *Crisis: Behind a Presidential Commitment,* left little doubt that the observational style of broadcast documentary carried an implicit rhetorical power.

Using three film crews, Drew, Leacock, and Greg Shuker followed Wallace on his rounds in Montgomery, Attorney General Robert Kennedy at home and at work in Washington, and students Vivian Malone and James Hood in Tuscaloosa for the final thirty hours of the federal-state showdown that climaxed on 11 June 1963 in Wallace's infamous stand in the schoolhouse door. Although *Crisis* appears thoroughly "observational" in its avoidance of interviews and intrusive narration (only the most cursory voice-over narration provides contextual orientation in several sequences), its parallel editing makes comparisons of each central player's "performance" unavoidable. Opening with shots of Confederate statues and state government buildings in Montgomery—accompanied by a rousing rendition of "Dixie" on the soundtrack—the film shows Wallace posing for cameras and shaking hands on the Capitol steps, then walking briskly (in the famous Wallace "strut") with guards and reporters. A cut takes us inside a car to the pensive faces of Malone and Hood as they are driven to an appointment with their NAACP advisors. The setting abruptly switches to Washington, where—to the accompaniment of "The Battle Hymn of the Republic"—shots of the Washington Monument, the Justice Department, and the Lincoln Memorial provide the context for the first image of Robert Kennedy (seen working in his office). Silent, focused, and remarkably intense, Kennedy's face is soon mirrored by his brother's, as we see a similarly intense John Kennedy staring off-screen in apparent contemplation. In the first two minutes of the film, then, before the title comes up, the battle lines of the story have been clearly drawn: public performance versus private reflection, showmanship versus statesmanship. The radical difference between the Wallace and Kennedy performance styles provides the central narrative tension of *Crisis,* for without the pugnacious grandstanding of the governor the political strategizing

of the Kennedys would lack not only dramatic force but also the clear-cut ethos so necessary in a tale of vanquished bigotry.

Seeming to understand this, Drew, Leacock, and Shuker create an alternating moral rhythm of integrity and disingenuousness. The narrative proper opens at the Kennedy household in McLean, Virginia, with shots of Kennedy's many children enjoying a casual, somewhat chaotic breakfast while the shirt-sleeved Attorney General moves easily through the brood and even has a serious telephone conversation as the children laugh and shout in the next room. A cut to Montgomery finds a blond toddler (Lee Wallace) alone at a piano, plucking out notes while an indulgent black nurse hovers nearby. A zoom-in to a portrait of a Confederate officer underscores the political connotations of the scenario. Unlike Kennedy's raucous home, Wallace's mansion is eerily devoid of human commotion; the Governor descends a staircase to join his daughter only when he is on his way out of the house (or so it appears). Wallace leaves her in the care of her nurse and takes the filmmakers on a tour of the mansion, pointing out the paintings of famous Alabamians, like William Lowndes Yancey, who, Wallace claims, said that he would "rather live a short life of standing for principle than a long life of compromise." "Of course," Wallace says to his Yankee guests, "that probably wouldn't mean much to you folks." As he continues his commentary on the history of southern defiance, the film suddenly cuts back to McLean, where Robert Kennedy kisses several daughters on his way out the door to work. Another cut from almost precisely the same angle finds Wallace exiting his house, tossing a baseball to a boy (most likely his eleven-year-old son, George Jr.), and greeting a group of state convicts working on the grounds. He is obviously unengaged in the "photo-op" game of catch with the boy and cuts it short after a few obligatory rounds ("I'm gettin' too old for this").

The contrast between Kennedy warmth and Wallace remoteness is heightened by the attitudes of the men toward the presence of a wandering film camera in their homes. Kennedy displays remarkable ease, ignoring the camera and giving every indication that his actions and comments are entirely "natural." Wallace, on the other hand, confronts the filmmakers, looks directly into the camera and at the cameraman, and challenges them with questions and assertions sure to rile their liberal predilections. Looking back at the men while being driven to work, he delivers a lecture on the place of "the Nigra citizen" in southern soci-

ety, while his aides chime in with supporting comments. Wallace's undisguised awareness of the camera—and his eagerness to seize the opportunity for political hay-making—casts doubt on the authenticity of *all* of his behavior throughout the film. The Kennedy brothers' understanding of television's effects (not to mention their family's personal and professional coziness with Hollywood) ensured that any image battle between a Kennedy and a southern politician would be a rout. The Drew-Leacock team had already portrayed John F. Kennedy in a highly flattering light in their 1960 documentary *Primary* (which had aired on a number of stations across the nation), and Robert Kennedy was familiar with the filmmakers' style and technique. Regardless of the Attorney General's certain consciousness of his own performance in front of the vérité camera, however, George Wallace's naked, but equally calculated, presentation of himself seemed to scream one overriding "truth": the status quo in the South was a sham, as transparently artificial as Blanche DuBois's plantation belle act.

Of course, observational documentaries—and the news reports whose style they were beginning to affect—carried their own implicit assumptions about "reality," not the least of which was a notion of "performance" that owed much to Method acting. Like Marlon Brando and Paul Newman, the Kennedy brothers understood on perhaps an instinctual level the conventions of naturalistic acting, but, like Andy Griffith and Elvis Presley, George Wallace seemed hopelessly grounded in rural literalness. Struggling to persuade through an antiquated performance style, he appeared as only "himself": a shamelessly ambitious politician. It was this grotesque facade of white southern power that fascinated many news correspondents and practitioners of cinéma vérité—those image-makers, in other words, who were most invested in the moral necessity of representing "reality." Their fascination, ironically, would revitalize Hollywood's flagging interest in the South, and their work would provide the industry's filmmakers with a journalistically based lexicon for depicting—and glamorizing—the region's turmoil.

Crackers, Rebels, and 1960s Realism

With growing public absorption in live coverage of the intensifying conflicts in both the civil rights movement and the war in Vietnam, it stood to reason that any movie attempting to deal with contemporary social problems would need to exhibit similar signs of realism. Bor-

rowing techniques from documentary filmmakers (as well as French New Wave directors), a number of mainstream directors and cinematographers began to craft a new style for Hollywood movies. Handheld camera shots, elliptical editing, and relatively graphic violence characterized a series of films released in 1967, all of which exploited "southernness" as a marker of daring realism.

The "southernness" of both *Bonnie and Clyde* and *Cool Hand Luke*, in fact, was the thematic axis around which their tales of social injustice revolved, the atmospheric element that ensured their reception as works of contemporary "relevance." But although it has long been seen as a watershed cultural text in its depiction of violence, its embrace of New Wave editing and tone, its sympathetic treatment of criminals, and its blending of genres, in several significant ways *Bonnie and Clyde* simply recycled the conventions of the postwar southern film.

Opening with shots of a frustrated and bored Bonnie Parker (Faye Dunaway) pounding bedposts and pacing restlessly in her cramped room, the movie in effect chronicles her journey out of the entrapment of Depression-ravaged, small-town Texas. In Bonnie's desperation to escape her dismal hometown, she is similar to earlier characters who fought their way out of the backwater South. Like Eve White in *The Three Faces of Eve*, Carol Baldwin in *Wild River*, Helen Keller in *The Miracle Worker*, and Tammy Tyree in her series of films, Bonnie struggles to learn a new vocabulary, a more "modern" sensibility, and, like them, she is "rescued" from cultural impairment by an emissary from what seems to be a more sophisticated milieu. Under the tutelage of Clyde Barrow (Warren Beatty), she eagerly combs out her white-trash spit curls, studies Hollywood musicals, and remakes herself into a sleek, fashionable "knockout." Bonnie's physical transformation, like that of Eve White, stimulates an intellectual one: she begins to write poetry. And like her cinematic predecessors, she finds her social "reeducation" rewarded with a suitably progressive lover, for it is her facility with words, not her glamour, which calls forth the eroticism of sensitive (and erstwhile impotent) Clyde. But Bonnie's metamorphoses do not end with this reward. Again, like Eve White, she finally evolves into a demure, pastel-clad wife figure when her ultimate goal—romance—is attained, a conventionally "appropriate" transition that makes her slaughter all the more heinous.

In its merging of the figure of the reeducated southerner with that of the southern outlaw, *Bonnie and Clyde* seemed to promise a radical

cinematic possibility. Bonnie's growing aesthetic inclinations, coupled with Clyde's sensitivity to economic inequity and his relative lack of racism, suggest a revised perspective on white poverty, one that did not exclude social progressivism. Further, although the couple's crimes were not portrayed in an entirely sympathetic manner, their resurrection from certain death, redemption after a pastoral idyll, and cold-blooded betrayal left no doubt that their murder was an act of unjustified brutality. The film's antiestablishment sentiments were clearly on display in the horrific, slow-motion "overkill" of Bonnie and Clyde, yet the establishment on trial was, finally, not national or corporate. It was unquestionably regional and unquestionably corrupt.

As the film pushed its heroes deeper into the South, to the Louisiana cabin of C. W. Moss's redneck father, it trapped them not only in a crossfire of Texas Rangers operating outside their jurisdiction but in an iconographic ambush as well. By representing national immorality in the figures of Ranger Frank Hamer and his "official" lynch mob, *Bonnie and Clyde* managed to reinstate southern—not American—white lawlessness as Public Enemy Number One. Two years later, *Easy Rider* would offer its own version of *Bonnie and Clyde*'s ending, its counterculture biker heroes shot down by vicious rednecks in Louisiana. Terry Southern, who cowrote the script for *Easy Rider* (and who was partially responsible for the creation of Texas hick-turned-global annihilator Major Kong in *Dr. Strangelove*) would later explain, "In my mind, the ending was to be an indictment of blue-collar America, the people I thought were responsible for the Vietnam War."[17]

The association of redneck racism with aggressive nationalism was common in the 1960s, and it was exacerbated by the tendency of outspoken segregationists to hold forth on international politics. To men like Alabama governor George Wallace, Louisiana activist Leander Perez Sr., Mississippi Citizens' Council chief Bill Simmons, and Georgia restaurant owner Lester Maddox (who would become the state's governor in 1967), the American South was as much a battleground in the war against communism as South Vietnam. The "Stalin conspiracy," Perez told *Esquire* in 1964, had long tried "to stir up the racial strife and turmoil and national disunity" in this country by fomenting "revolution in the Black Belt . . . among the Negroes and the sharecroppers."[18] In 1967, a Louisiana Klansman told psychiatrist Robert Coles that the "Asiatics" were "trying to beat this country." "The President has got their number," he asserted. "It's about time he stopped trying to in-

vade us here in the South, and force all that integration stuff down our throats—and instead took after the Communists over there in Asia."[19] Roy Blount Jr. has called Vietnam "the war which Southerners remained steadfastly in favor of, according to the polls, long after the rest of the nation had given up on the idea of destroying something to save it (although that is pretty much what the rest of the nation did to the South during the sixties and seventies of the *last* century)."[20] Caught in the undertow of southern ideology was Lyndon Johnson, a president whose twin-fronted war on domestic inequality and international Communism, aided by a Secretary of State from Georgia, doomed him as both a scalawag dupe (to opponents of integration) and an imperialist hick (to opponents of the Vietnam War). Pleasing few, the Texas rube certified the crude nature of southern authority, namely its appalling inability to charm a national audience and to communicate anything other than brute strength.

In a number of movies of the mid- to late 1960s, southern authority came to play an oddly self-reflexive role, tacitly representing a growing national corruption that was ultimately *southern* in nature. However "universal" or metaphorical many filmmakers' intentions might have been, southern iconography was an all too literal register of the region's political idiom. Restricted to a highly codified vocabulary, the familiar cinematic imagery of the South was finally untranslatable as anything other than itself, a signifier not of "social conditions" but of "the southern problem." The connotative limitations of "southernness" in the mid-1960s were most dramatically demonstrated in *Cool Hand Luke,* a film structured upon its characters' "failure to communicate."

The choice of Paul Newman to play the title character carried its own cinematic connotations, for Newman had come to fame in the 1950s playing a series of southern men in crisis: Brick Pollitt in *Cat on a Hot Tin Roof* (1958), Ben Quick in *The Long, Hot Summer* (1958), and Chance Wayne in *Sweet Bird of Youth* (1962). Like *Bonnie and Clyde, Cool Hand Luke* took the unusual step of imagining the 1960s-styled rebel as a hard-pressed white southerner, an attractive cynic who, having dispatched belief in authoritarian structures long ago, now finds himself searching in vain for "meaning." Sentenced to two years of hard labor on a Deep South road gang for drunkenly decapitating parking meters, Luke is thrown into an absurd universe of "rules and regulations and bosses." His amused detachment from his situation destabilizes the inmate hierarchy and threatens the prison camp's chief

"boss," who cannot understand why a decorated war veteran would end up in his domain. "You came out the same way you went in" he reads from Luke's military record. "Buck private." "I was just passin' time, Captain," the new prisoner replies.

Luke's alienation from "the system" clearly positions him as a contemporary hero, an existentialist rebel more in search of "elbow room" than a cause. But each attempt to find that room, each escape from the camp, results in capture and progressively abusive punishment. The photograph of Luke living the high life in Atlanta, which he mails to the prisoners during one of his brief periods on the lam turns out to be a fake, an illusion created by him to sustain their belief in a world beyond the camp. Luke himself knows what they do not: that nothing, in fact, exists beyond the reflection of oneself mirrored in the opaque sunglasses of the boss they call "No Eyes." "Are you still believing that big, bearded boss up there?" he taunts his fellow gang members as he calls upon God: "Love me, hate me, kill me, anything." As No Eyes watches, Luke concludes his invocation with the admission that he's "just standin' in the rain, talkin' to myself."

"What we've got here is failure to communicate," the captain lectures the prisoners once Luke is captured after a second escape. "You're gonna get your mind right. And I mean right," he warns the beaten escapee, who is now hobbled by two sets of leg irons. As evidence of being in his "right mind," Luke plays the smiling lackey to the bosses, an Uncle Tom act that loses him the respect of his peers and causes one prisoner to tear up the revered phony photograph of high-living Luke. He regains their respect with a third escape, yet, finally understanding the inherent futility of the very notion of "escape," Luke sits in an empty church to await recapture. In his last chat with a silent God, he demands to know the divine meaning in a life of misfortune. "You got to admit you ain't dealt me no cards in a long time. It's beginning to look like you got things fixed so I can't never win out," he says, looking at the vacant rafters. As if in answer to the accusation, the captain and his henchmen arrive on the scene. Mocking the now valid words of the captain, Luke laughingly calls out to the assembled police, "What we got here is a failure to communicate!" He is immediately shot by No Eyes. Although his unconscious body is claimed by the captain ("He's ours," he tells one officer), driven away to die en route to the prison hospital, the prisoners reclaim Luke as a mythic legacy, "a natural-born world shaker." As the camera pulls back into a long shot of the shack-

led, sweating men working along the road, a superimposed image expands to dominate the frame: the fake photograph of free man Luke, now pasted back together.

In its sympathetic treatment of the martyred misfit, *Cool Hand Luke,* like *Bonnie and Clyde,* seemed not only to revise the image of the southern outlaw but also to encourage audience identification with his plight. Like the bank robbers, his "crimes" are ambiguously contextualized. "I know I'm a pretty evil fella," he confesses in his final monologue in the church. "Killed people in the war, got drunk and chewed up municipal property and like." And like them, he is slaughtered unmercifully after a scene of redemption. But if in death Luke managed to ascend from the rank of Deep South buck private to national hero, his persecutors escaped a similarly appropriate demotion—a descent, in other words, to national villains. They were, in fact, little different from Texas Ranger Frank Hamer or *Easy Rider*'s "blue collar" Louisiana murderers. Their heritage was deeply rooted in red clay and murky swampland, their morality predetermined by an inbred family tree stretching back to Simon Legree. Their immediate forebears were the wardens in the 1932 film *I Am a Fugitive from a Chain Gang,* itself based on Robert E. Burns's autobiography of the same year, *I Am a Fugitive from a Georgia Chain Gang!* The film adaptation's erasure of geographical specificity had fooled neither anyone familiar with the sensationalized press coverage of Burns's unjust imprisonment nor any perceptive viewer of Mervin Le Roy's film, which traces its northern hero's journey toward his fate on a map of the United States with a dissolving pan toward the Deep South. "I have just suffered from a catastrophe that would destroy the average man," Burns wrote while in hiding. "I have escaped the bottomless depths of Hell."[21]

The hell of *Cool Hand Luke,* from which Luke, unlike Burns, finds no delivery, may be an unnamed southern state, but it is hardly a "universal" locus, a place of the spirit which could be anywhere, anytime. Like its cinematic predecessors, the film grounds its social critique in the regional specificity of its setting. *I Am a Fugitive from a Chain Gang* had blatantly criticized southern racism, not just visually detailing the racial segregation of the prison camp but making its hero's initial liberation dependent upon the assistance of a black inmate. Preston Sturges's *Sullivan's Travels* (1941) had comically suggested a similar theme, with its unjustly condemned Hollywood director finding spiritual—and commercial—salvation while watching cartoons with his racially inte-

grated chain gang in a backwoods black church. *The Defiant Ones* (1958) extended the scene's metaphor into a story of two escaped convicts, one black, one white, both handcuffed together in their run toward freedom.

The profoundly southern connotations of wrongful imprisonment even made their way into a nonsouthern film of 1962, *The Birdman of Alcatraz*. When reformed inmate hero Robert Stroud (Burt Lancaster) is transferred to Alcatraz from Leavenworth, the birds he has lovingly collected and studied are taken from him. "Solitary again, huh?" he asks a guard. "Not called solitary here. Segregation," the guard replies. "Interesting name," Stroud says, emphasizing the politically sensitive word. Popular music reiterated the association. Sam Cooke had written his 1960 hit "Chain Gang" after encountering a shackled road gang in Georgia. "Sam heard the sound of the men working," his biographers claim, "the call-and-response as the gang answered the lead, chanting in time to the long day's work—and started writing, there and then. After all, this was underneath all blues and gospel—as old as slavery."22

Cool Hand Luke trades on this popular legacy to dramatize the spiritual redemption of its hero. Breaking out of the all-white prison camp, Luke alone defies the racial segregation of the narrative and is rewarded (if temporarily) for the effort. In his second escape, in a scene reminiscent of one in *I Am a Fugitive,* he asks two black children for help and they bring him an ax to break his chains. Like southern outlaws in films of the 1950s, however, Luke's association with blackness, his fugitive status which marks him as distinctly "other," dooms his struggle. Because his redemption is redundant (he is not "bad" to begin with), he is, in the film's liberal politics, doubly condemned in the captain's racist and conformist society, itself a microcosm of the reactionary South. And though, if set in a previous film, his redemption would have concluded the story, here it exists to underscore the treachery of the establishment. For with the development of the southern criminal's Janus-faced role as reformed redneck and nonconformist dropout, an incarnation that reincorporated Norman Mailer's long-lost Hipster, his antagonist would by necessity be called upon to play dual roles as well. But try as he might, the southern lawman of the late 1960s could not convincingly implicate a larger constituency in his local villainy. His own villainy was too finely etched into the national narrative, too vividly understood as a regional peculiarity. For generations he had served as federal exorcist, calling forth and embodying the country's racism and hatred, yet the

new insistence upon his national significance begged questions central to creators of popular images: Could white authority itself survive the sustained narrative assault upon one of its own? Did the moral degeneracy of southern white authority necessarily incriminate national white authority? If so, was a convincingly redemptive image of contemporary southern law even possible in the late 1960s?

Liberated Lawmen and Crackers from Hell: In the Heat of the Night *and the End of the 1960s*

In 1967, the same year that *Bonnie and Clyde* and *Cool Hand Luke* were released, one film tackled these questions, and in the process it finally broke Hollywood's silence about the contemporary South. *In the Heat of the Night* was the first feature film produced by a major studio since 1949 that appeared to deal directly with what everyone had been seeing in the news for thirteen years: the racism of the southern legal system. With its opening shot of a sign proclaiming, "You are now entering the town of Sparta, Mississippi. Welcome!" and its archetypal southern police chief Bill Gillespie (played by Rod Steiger as a composite of Harold Strider, Bull Connor, and Jim Clark), the film announced its liberation from the evasions and displacements of previous films and television shows. The *mise-en-scène*, filled with the props denied to Rod Serling nine years earlier in his doomed attempt to tell the Emmett Till story, impressed upon viewers the "realism" of the location. With Dr. Pepper bottles in the foreground, Coca-Cola machines in the background, malfunctioning air conditioning units, rifle racks, cotton fields, dingy jail cells, and transistor radios squawking country music, the South that took shape onscreen was far removed from the familiar decadent plantation landscape of Tennessee Williams–inspired movies. The story that unfolded within this set also contained immediately resonant details: a black man wrongly accused and imprisoned by racist cops, a police chief hostile to outsiders (and who, in a fairly daring bit of scripting, confused Philadelphia, Pennsylvania, with Philadelphia, Mississippi), and a nonsouthern character who got to ask the questions begged by a decade of news footage: "My God, what kind of people are you? What kind of place is this?"

Giving indications that it might actually provide clues about, if not answers to, the source of endemic racism, the film's plot revolves around the murder of a white Chicago businessman whose plans to build a progressive factory in Sparta have raised the economic hopes of black

townspeople. Philadelphia detective Virgil Tibbs (Sidney Poitier), who is inititally arrested for the crime while sitting in the local train station, tries his best to pin charges on a wealthy plantation owner, the man whose way of life has been most threatened by the propect of change. "I can pull that fat cat down! I can bring him right off this hill!" he passionately tells the sheriff. The film, however, is not about to tread on that territory. All ends up right with the system: the fat cat is blameless, the racist deputy turns out to be a Barney Fife buffoon, and the white rural police chief, himself a lonely outsider as it turns out, joins forces with the urban black man to unveil the real criminal in Sparta, Mississippi: white cracker Ralph Henshaw, night worker at the diner, the man whose intense, sweaty face is the first one seen in the film as he tries to shoot a fly with a rubber band.

One need only contrast this turn of events with those in Arthur Penn's *The Chase* (1966), Otto Preminger's *Hurry Sundown* (1967), or even John Huston's *Reflections in a Golden Eye* (1967) to understand the underlying generic conventionality of *In the Heat of the Night*. In their indictment of the southern upper class for social inequality and the ineffectiveness of sheriffs, judges, and military officials, respectively, all three films threatened long-held assumptions about southern criminality. None of these films, however, achieved the cultural resonance of films like *Bonnie and Clyde* and *Cool Hand Luke,* perhaps because of either a lack (in the case of *The Chase*) or an excess (in the case of *Hurry Sundown*) of directorial control. While Penn's story of Texas injustice seemed to many critics an inconsistent, even incoherent, allegory of the Kennedy assassination, Preminger's adaptation of Bert and Katya Gilden's 1964 novel was more abruptly dismissed ("an offense to intelligence," Bosley Crowther called it in the *New York Times,* filled with "stereotypes lifted from the bottom of the Southern cracker barrel"[23]). Huston's adaptation of Carson McCullers's story earned more respectable reviews, and its provocative treatment of a southern Army major's repressed homosexuality (with Marlon Brando offering an ironic reprise of his character from *Sayonara*) placed its sensibility far from the gender norms of *In the Heat of the Night.* But its ambiguous setting ("a few years ago" in a "fort in the South") diluted its rhetorical power. All three films, in other words, appeared to look to the past, either for political subtext, dramatic style, or setting.

In the Heat of the Night, in contrast, seemed distinctly of the moment. Regardless of the fact that the South's "moment" had been struck

years before with the serial events of Birmingham, Freedom Summer, and Selma, and that the urban North (and Los Angeles) was rapidly approaching its own racial "moment," the film appeared strikingly contemporary. *In the Heat of the Night* won Oscars for Best Picture and Best Actor (Steiger), but in the long run its most significant achievement may have been the impact of Stirling Silliphant's Oscar-winning script, which would become a blueprint for future films attempting to recreate the South of the 1960s. Although the plot varied little from that of John Ball's 1965 novel of the same name, Silliphant had moved the action from the North Carolina mountains to rural Mississippi, changed Tibbs's hometown from Pasadena to Philadelphia, and transformed Police Chief Gillespie from a tall young Texan to Steiger's familiar overweight, middle-aged quasiredneck.

Alterations like these carried an implicit message: "serious" films about the South should provide at least surface tribute to recent political history. Indeed, a year later, Robert Ellis Miller would film his adaptation of Carson McCullers's *The Heart Is a Lonely Hunter* in Selma, Alabama (the original story is set in Georgia), and would shoot a crucial scene near a poignant marker of civil rights history. Three years earlier, James Reeb, a Unitarian minister from Boston who had just arrived in Selma to take part in the march to Montgomery, had been killed by local whites outside of the Silver Moon Cafe. Miller recontextualized this location, framing the reluctant decision of the story's black doctor to treat a white alcoholic for self-inflicted wounds directly in front of the neon-lit Silver Moon sign. Drawing ironically upon Selma's recent history to define and clarify his characters' choices was a pointed choice on Miller's part in light of the updating of the film's setting from the 1940s of McCullers's story to the late 1960s.

For all of his apparent attempts to make a significant statement about contemporary Mississippi, however, Stirling Silliphant took his character cues from film history. By not implicating the white power structure in the major crimes of the story and by exonerating, in effect, the legal and economic institutions of the Deep South, Silliphant's screenplay managed to create a "social realism" that was both politically acceptable and commercially viable. Central to this strategy was the white working-class villain, the character whose inherent criminality would be the sine qua non of the new southern story.

Literally overnight, the enforcer of illegitimate law—states' rights and Jim Crow—metamorphosed into the protector and defender of

legitimate law. In the figure of Bill Gillespie, the southern sheriff received his media clearance to become an American hero. By redeeming southern political authority, *In the Heat of the Night* resuscitated and refined a genre that had grown moribund. In the process, it redeemed whiteness itself by projecting the criminality of the race onto its lowest member. True to John Ball's novel, Stirling Silliphant's screenplay breathed life into a villain familiar to American audiences: the malingering redneck, "unschooled, prejudiced, and of a low level of intelligence," a man of "warped mind."[24]

The cretinous redneck would become an increasingly popular film villain in the coming years. He would join with his buddies to murder Billy, Wyatt, and George in *Easy Rider;* to rape Joe Buck and his girlfriend in *Midnight Cowboy* (1969); and, of course, to wreak apocalyptic damage in James Dickey's 1970 novel *Deliverance.* In the 1972 film adaptation of Dickey's novel, the crackers from hell become the most relentless of warriors, following up sexual assaults with guerrilla warfare. In contrast, the southern sheriff, played by author James Dickey himself, is a shrewd voice of common sense. The residents of Rabun County, Georgia, were not happy when director John Boorman photographed mentally handicapped townspeople as evidence of the "horror" of the backwoods South.[25] But the images proved compelling for the rest of the nation, and *Deliverance* entered popular consciousness as a cautionary tale of the unrepressed savagery awaiting civilized white men just off the road in the southern wilderness.

The rise of the hillbilly from hell was an essential factor in the public redemption of the southern lawman, for in vanquishing the ghost of racial barbarism the lawman in effect rewrote history as a campfire horror story, a triumph of white valor over the forces of dark vulgarity. Essential to this instructive tale was the erasure of the nightmare cracker's alternative persona, the harmless hillbilly. In 1970, the year of *Deliverance's* publication, CBS almost single-handedly effected the disappearance of country buffoons on the nation's airwaves in a move that became known as the "rural massacre." Hoping to attract a more "sophisticated" audience to the network,[26] CBS head William Paley canceled the hit country comedies *The Beverly Hillbillies, Mayberry R.F.D.* (the successor to *The Andy Griffith Show*), *The Jim Nabors Hour, Green Acres, Petticoat Junction, Hee Haw,* and two new series in development by Andy Griffith, replacing them in the coming years with urbane, non-southern fare like *All in the Family, Maude, The Mary Tyler Moore Show,*

The Bob Newhart Show, and *M*A*S*H.* With the waning of the rural clown, the South assumed the moral contours of the Old West, as the newly respectable lawman stood poised on the horizon to exterminate his vile Doppelgänger and vindicate the race.

The Fashionable Redneck: Southern Redemption and the Carter Years

The redemption of southern white authority was made official in 1976 with the election of Democratic Georgia governor Jimmy Carter to the presidency. In contrast to the shadowy, scandal-ridden Nixon and Ford administrations, Carter seemed uncorrupted, a shining symbol of New South reformation. "Georgia is a place you get sent to or you come from or you march through or you drive through," native Georgian Roy Blount wrote in the late 1970s. "Convicts settled it. It's got some fine red dirt, hills, vegetables, and folks, but I don't believe anybody has ever dreamed of growing up and moving to Georgia. But now," he marveled, "the President of the United States is from Georgia."[27]

Carter's election coincided with the growing national interest in a chastened, domesticated South, and for several years "redneck chic" defined a highly marketable national taste. Folk and rock musicians had led the way, beginning with Bob Dylan, who traveled south to record his *Nashville Skyline* album in 1969; by the end of the next decade, groups like Lynyrd Skynyrd and the Eagles would elevate "country rock" into a distinctive genre. *Your Cheatin' Heart,* the ill-timed 1964 film biography of Hank Williams, had failed to ignite mainstream enthusiasm for country music; by 1971, however, Peter Bogdanovich had created a soundtrack dominated by Williams's songs for his critically acclaimed treatment of generational malaise, *The Last Picture Show.* Country music soon became more than a synchronous indicator of atmosphere; it became a suitable subject in itself for movies like *W. W. and the Dixie Dance Kings* (1975) and *Coalminer's Daughter* (1980). Robert Altman even dared to set his trenchant Bicentennial ode to the nation in the capital of country music. Contrary to Hollywood's long-standing tendency to portray southern crises as distinctly and exotically regional, *Nashville* (1975) aimed its critique of national political and celebrity culture from a southern setting; here, the commercialized South became an emblem of Hollywoodized America. At the same time, the new white South shared space in the popular imagination with accelerating trends in black liberation. The mainstream popular-

ity of both redneck style (particularly the citizen's band trucker argot memorialized in the 1975 hit song "Convoy") and Africanist sensibility crystallized in an ironic conjunction of events in early 1977. The inauguration of Jimmy Carter on 20 January preceded by three days the premiere of television's most highly rated event to date, the eight-night broadcast of *Roots* on ABC. With a white Georgia peanut farmer newly installed in the White House, 130 million Americans became absorbed in the epic saga of an African family's centuries-long struggle to survive slavery and bigotry in the American South.

In the movies, the new southern lawmen like Jimmy Carter were not implicated in the region's criminal history. Real-life Tennessee sheriff Buford Pusser, for example, attained heroic status in the *Walking Tall* series (1973, 1975, 1977) for his relentless pursuit of the McNairy County mob; moreover, he took his place alongside characters like Clint Eastwood's (Dirty) Harry Callahan and Charles Bronson's Paul Kersey (in the *Death Wish* series beginning in 1971) as an icon of upright *American*—not lawlessly southern—vigilantism. The sudden impulse toward domestication transformed some southern lawmen into humorous figures, like the fictional Buford T. Justice (Jackie Gleason) in the immensely popular *Smokey and the Bandit* series (1977, 1980, 1983) and Jefferson Davis "Boss" Hogg and Sheriff Rosco Coltrane in the CBS series *The Dukes of Hazzard* (1979–85).

In this new embrace of southern respectability, only one film, *Mandingo* (1978), risked an alternative perspective on white southern authority. A film summarily rejected by critics as "trash" when it was released, *Mandingo* has been reappraised by film scholar Robin Wood as "the greatest Hollywood film on race"[28] for its unsparing treatment of white patriarchal rule in the Old South. But the fashionable approach to the South now focused on regional *progress,* not reaction, in stories about idealistic teaching in the face of racism and poverty (*Conrack* [1974]), union organizing in the face of industrial hostility and persecution (*Norma Rae* [1978]), domestic harmony in the face of a tyrannical, gung-ho Marine father (*The Great Santini* [1979]), and, on television, togetherness and achievement in the face of Depression-era poverty (*The Waltons* [1972–81]).

The mainstream embrace of the contemporary South, like its embrace of Jimmy Carter, was not long-lived. The region's trendiness could be charted in the brief fame of the President's brother Billy, whose unabashed redneck persona provided entertaining media fodder for sev-

eral years. "He started out as a folk hero," Roy Blount wrote in the late 1970s, "gigging American Celebrity and the American image of the Cracker." But after repeated exposure to his sincere, uninflected tackiness, "people think he is about what you would expect from a Cracker."[29] The public devolution of Billy Carter, however, paradoxically signaled the reemergence of the virulent, *unfashionable* redneck in American popular culture. With Jimmy Carter's failure to win reelection in 1980, the cracker menace reclaimed a central role in the national racial narrative. All along, it seemed, he had been simply lurking—and festering—in the previous decade's tableaux of southern enlightenment.

The Return of the Repressed: Rednecks and the Post-Reagan Civil Rights Film

Ronald Reagan's 1980 campaign appearance near Philadelphia, Mississippi, beckoned the specter into the open. Proclaiming his commitment to states' rights at the Neshoba County Fair ("a traditional forum for the outpourings of segregationists,"[30] the *Washington Post* observed, and, more importantly, a setting just miles from the site at which Freedom Summer volunteers James Chaney, Andrew Goodman, and Michael Scherner were murdered), the Republican presidential candidate staked his claim in the killing fields of 1964 and served advance notice of the rural racist's inflammatory comeback six years later in *Mississippi Burning*. Since then, the rampaging redneck has breathed life into otherwise stale narratives of the "nature versus civilization" variety. In *The Prince of Tides* (1991), the repressed memory of a childhood rape by backwoods prison escapees haunts a sensitive South Carolina high school coach. Only after he has escaped the South and entered the care of a New York psychiatrist does he dare remember the humiliation of his own white trash upbringing and the violent act that occurred "down there." Billy Bob Thornton brought Boo Radley back to life as the mentally impaired Arkansas killer Carl Childers in his 1996 film *Sling Blade* (with an ironic cameo by Robert Duvall, who had played Boo in *To Kill a Mockingbird*, as Carl's contemptible, shack-ridden father). In Thornton's story, once again a haunted, sensitive man saves a child from certain death at the hands of an unstable cracker. The film left little doubt that Carl's slaughter of the alcoholic, homophobic construction worker Doyle, a "closed-minded redneck," according to one character, was a courageous social service. On television, a 1997 episode of *The X-Files* merged *The Andy Griffith Show*, *Deliverance*, and

Two Thousand Maniacs into a tale of repellent, Confederate-loving hill-billies who murder a black sheriff named Andy Taylor in a northern town called Mayberry. In a particularly odd configuration of the rural villain, Gus Van Sant reimagined Norman Bates as a country music fan in his 1998 remake of *Psycho*.

The redneck killer found a redemption of sorts in *Dead Man Walking* (1995), Tim Robbins's adaptation of Sister Helen Prejean's memoir of her relationship with Louisiana Death Row inmate Matthew Poncelet. As an anti–capital punishment statement, the film takes a certain risk in asking for mercy for an unsympathetic character who, it turns out, has been rightly convicted of murder and rape. Sister Helen acknowledges that Poncelet, the son of a sharecropper, is "filled with hate," and his overt racism (he even sports a swastika tatoo) is implicitly attributed to poverty, ignorance, and posturing machismo. But it is precisely this heritage which lends genuine horror not only to the crimes depicted in the film but to the film's rhetorical message. Much of the narrative's power derives from its comparison of the state's barbarism to that of backwoods criminals. As Poncelet faces his death from lethal injection while strapped crucifixion-style to a clinical table, Robbins intercuts flashback shots of the killer's rampage against two innocent white teenagers in a dark, swampy lovers' lane. Trading on decades of convention and connotation (from *To Kill a Mockingbird, Cape Fear, Deliverance,* and even the southern "splatter" films), *Dead Man Walking* poses the worst among us—the midnight redneck stalker—as an emblem of the moral corruption of the state.

The horror-inflected iconography has proved easily adaptable to the series of civil rights–themed films inaugurated by *Mississippi Burning*. Like Bob Ewell, Max Cady, Ralph Henshaw, and the mountain mutants of *Deliverance,* the new enemies are all rural rednecks, their villainy emblazoned on their costumes: red, the color of the Grand Dragon's robes in *A Time to Kill,* the color of Klansman Sam Cayhall's death row jumpsuit in *The Chamber,* the color of Byron De La Beckwith's jacket, which he wears shamelessly throughout his third trial in *Ghosts of Mississippi.* Just as evident is their ancestral link to the demons of earlier films. The spirit of Byron De La Beckwith seems to animate the bottle tree outside Bobby DeLaughter's daughter's room, frightening him into the decision to stop singing "Dixie" to her at night. "Maybe the ghosts are gone," Adam Hall says after Sam Cayhall

is finally executed at the end of *The Chamber,* but the genre insists otherwise.

Opposing and conquering the new savages are the rehabilitated southern white men of law. *Mississippi Burning's* FBI agent and ex-sheriff Rupert Anderson led the way in 1988, but southern lawyers did not begin their onslaught on the movies until 1993—coincidentally, the same year that Arkansas lawyer Bill Clinton became President. Audiences of the 1990s, it seems, could not see enough of the new regional avengers: Assistant District Attorney Bobby DeLaughter in *Ghosts of Mississippi;* Jake Brigance in *A Time to Kill;* Adam Hall in *The Chamber;* and the posse of other Grisham attorneys like Darby Shaw in *The Pelican Brief* (1993), Mitch McDeere in *The Firm* (1993), Reggie Love in *The Client* (1994), Rudy Baylor in *The Rainmaker* (1998), and Rick Magruder in *The Gingerbread Man* (1998) who have covered the region in their search for corporate villainy. (Even a comedy like Robert Altman's *Cookie's Fortune* [1999], which conspicuously lacks a redneck criminal, features a fair-minded, unracist Mississippi sheriff, played by Ned Beatty.) Like most western heroes, the new lawman fights practically alone; his victory demands a stripped-down, man-to-man battle against the Other—his repressed double, the unprogressive, ignorant cracker. In this battle, women can only look on, lending support but not sharing the knock-out punch. Rupert Anderson seduces a Klansman's wife into betraying her husband; Jake Brigance's wife leaves him, to be supplanted by a friendly female attorney; and Adam Hall is assisted by a woman in the state government. Bobby DeLaughter's wife Dixie (the real name of DeLaughter's first wife) leaves him, allowing him to find a symbolically progressive second wife, and, oddest of all, Myrlie Evers sits at home or in the courthouse, waiting for DeLaughter's legal abilities to win or lose the day.

The ascension of real-life lawyers like DeLaughter to cinematic stardom has lent this narrative trend a peculiar historical validity. New Orleans District Attorney Jim Garrison was mocked for decades in the mainstream media for his persistent investigation of a Kennedy assassination conspiracy. In 1990, however, Oliver Stone not only cast clean-cut superstar Kevin Costner as Garrison in *JFK* but also portrayed the D.A. as the Last American Hero, a righteous courtroom contender whose devotion to the laws of the nation ultimately wins vindication for his maligned theories. (True to the genre, Garrison's wife resents his

absorption in the case but finally accepts his wisdom and attends the Clay Shaw trial as a supportive spouse.) Most ironic of all, a Mississippi courtroom became an arena of justice in *The Insider* (1999) as Mississippi Attorney General Mike Moore, playing himself, reprised his role as the defender of southern states' interests against the nefarious corporate power of Big Tobacco. (Here again, the Louisville belle wife of Moore's chief witness finally leaves her husband when their lives are threatened.) In a stunning inversion of post-*Brown* history, films like these reimagine the resistant South as a liberal-minded David taking on corrupt federal and corporate Goliaths. The reborn lawmen in these tales reinvoke a progressive version of "interposition" by facing down encroaching behemoths with the unwavering passion of the gunfighter. In the process, the old emasculation of Dixie is nullified, transformed into merely a battle scar of a new, remasculinized South.

The dominance of this pattern becomes clear when we consider the few films that have attempted to tell a different kind of civil rights story, one in which white men play consistently adversarial roles. *Heart of Dixie* (1989), *The Long Walk Home* (1990), and *Love Field* (1992) all focus on southern white women caught in political and social crises: in *Heart of Dixie* it is the integration of a fictional college in the 1950s, in *The Long Walk Home* it is the Montgomery bus boycott, and in *Love Field* it is the days following the assassination of John Kennedy. While all three films make their heroines the centers of their narratives, they also attempt to link the civil rights struggle with a more general struggle against white male authority. In *Heart of Dixie* and *The Long Walk Home,* each heroine leaves her husband or fiancé and visually bonds with a black woman; in *Love Field,* she falls in love with a black man. The ramifications of such an alliance, however, are never fully explored in the films, and each ends with the white woman's successful break from her past (although *Love Field* does suggest that its newly divorced heroine will choose to stay with her black lover). Despite this, the films have nevertheless nudged the generic formula of the civil rights film into more complicated narrative territory—territory, it should be noted, which has not proved to be commercial successful.

What *has* proved to be commercially successful is the spectacle of the redemption of white authority. If Gene Hackman's federal agent in *Mississippi Burning* operated primarily as a bust-'em-up gunfighter (with his heart in the right place), the lawyers of the 1990s displayed the decade's fondness for public confession. By accepting his black

client's description of him as "one of the bad guys," Jake Brigance plans a winning courtroom strategy in *A Time to Kill:* the raped black child could have been white; she could have been his own daughter. By extrapolation, then, Jake discovers that he is no different than his black client. Ironically, his argument is merely a restatement of the Old West creed of *The Searchers'* Ethan Edwards. Violence against *white* women, it seems, can justify first-degree murder—particularly, in *A Time to Kill* and in *Mississippi Burning,* murder of the rednecked menace. In *The Chamber,* Chicagoan Adam Hall must travel to Mississippi's Parchman Prison and accept his southern heritage. He, unlike others in his family, will look the racism of his ancestors in the eye and defend his Klansman grandfather on death row (a grandfather who, it conveniently turns out, was not nearly as racist as others in his klavern). Bobby DeLaughter imagines himself as Medgar Evers, a leap that allows him to push onward in his case. In turn, director Rob Reiner imagined himself as DeLaughter, which allowed him to push onward in his film.

Throughout the South of civil rights films, it seems, white lawyers have been especially busy, cementing emotional bonds with criminals and victims, reaching out to take on the burden of racial guilt—feeling others' pain, as Bill Clinton would say. As such, they have functioned as cinematic historians, researching the past, explaining it, and bringing it to closure. So convinced are filmmakers of the social importance of their work that they have filled their movies with centrally placed signifiers of "reality": in *The Chamber,* a famous photograph of a dual lynching in Marion, Indiana, in 1930 becomes "evidence" of Klansman Sam Cayhall's childhood experiences in the Mississippi Delta (the word "Daddy" is scrawled by the image of a child in the foreground of the photograph), and documents supposedly from the state Sovereignty Commission are formatted precisely like real documents from the Commission. For *Ghosts of Mississippi,* Reiner's crew went to inordinate expense to ensure the authenticity of props—even, for the final scene, flying trash barrels from the Hinds County Courthouse to Hollywood.

Nothing, however, signifies historical authenticity as strongly as videotaped images. As the medium of television news (although only network-wide in the United States since 1967), videotape connotes reality for film viewers in much the same way that black-and-white photography connotes the past, and filmmakers intent on convincing

viewers of the historical accuracy of their productions rarely hesitate to employ both conventions. When Willie Morris pitched his film idea for *Ghosts of Mississippi* to producer Fred Zollo, he suggested "going first and at considerable length with black-and-white, documentary-type footage of Mississippi in 1963 . . . then on in color to the new investigation and trial of the 1990s."[31] Rob Reiner used the convention in his opening credit sequence, showing a montage of sepia-toned archival news footage that concludes with the title, "This Story Is True." The appearance of documented truth, however, can create peculiar postmodern moments. In *A Time to Kill,* Jake Brigance (Matthew McConaughey) admires himself on simulated local news programs; in *The Chamber,* Adam Hall (Chris O'Donnell) watches and rewatches black-and-white video footage of his grandfather (Gene Hackman), supposedly from 1967; and in *Ghosts of Mississippi,* Bobby DeLaughter (Alec Baldwin) studies Byron De La Beckwith (James Woods) in meticulously recreated videotaped footage, just as Myrlie Evers (Whoopie Goldberg) watches authentic archival film footage of John F. Kennedy in the early moments of the film.

Certainly there is nothing new about fabricated news footage in the movies. *Citizen Kane, JFK,* and *Wag the Dog* may seem wildly dissimilar in their use of doctored or restaged footage, but each film is, in its own way, concerned with the power of media to shape, even invent, historical events. With what Willie Morris called their "spirit of accuracy,"[32] post-Reagan films about civil rights and the South seem to be odd throwbacks to an earlier cinematic era. Directors like Rob Reiner, in fact, resemble no one so much as D. W. Griffith, whose meticulously created "historical facsimiles" in *The Birth of a Nation* served a number of rhetorical purposes, not least of which was the construction of Griffith as popular historian. Like Griffith, the end-of-the-century tellers of the southern story set out to "heal" cultural wounds, to reunite the nation by reclaiming the alienated white southerner. In order to do this, however, someone else needed to fill the role of un-American Other. For Griffith it was the descendants of slaves; for the later storytellers it was the descendants of white tenant farmers and sharecroppers. Under the protective cover of the documentary conventions of their times, though, the master and the disciples of the historical facsimile school told the same Halloween stories of demons and "malevolent phantoms" haunting the southern landscape.

Finale: Forrest Gump Reclaims the South

Despite Willie Morris's surreal sense of the "uncanny blending of the 'real' and the re-created 'unreal'" in films like *Ghosts of Mississippi,* perhaps the only truly uncanny story of the contemporary South since the reinvigoration of the civil rights film has not been one of burnings, killings, or ghosts, but of innocence rewarded. While not generally regarded as a "civil rights film" (it appears on the surface to be an homage to *No Time for Sergeants,* while its natural-born speed-running war hero pays tribute to *Sergeant York*), the immensely popular *Forrest Gump* (1994) is nothing if not a retelling of postwar southern history. The film signals its historical designs, in fact, in the first scene, in which a black woman waits for a southern city bus. Although the scene is set in present-day Savannah, the Rosa Parks connotations are unmistakable. As if taking his cues from the scenario, the dimwitted Forrest proceeds to offer up to the woman a virtual apologia for southern racism.

Although many critics expressed concern about the sheer *fact* of the apologia, it is the *form* of the defense that may well be the most problematic aspect of the film. Yes, the innocent Forrest is named after the founder of the Klan, and yes, his understanding of Klan terror amounts to "Sometimes we all do things that, well, just don't make no sense." But the footage that accompanies this narration isn't a historical facsimile in the tradition of Rob Reiner and company. It is, in fact, simulated footage from *The Birth of a Nation,* made parodic by Tom Hanks's cameo role as Nathan Bedford Forrest himself (we first see Hanks as Forrest in a sepia-toned freeze-frame, itself a simulated Matthew Brady photograph, which then becomes the opening shot of nightrider footage). Suggesting that the real Klan was somehow archived in *The Birth of a Nation* may be morally reprehensible, but, from a postmodern perspective, director Robert Zemeckis's instincts as a popular filmmaker are accurate: the culture does "know" history from Hollywood productions.

Further, by simulating Griffith's simulations, Zemeckis implicitly validates the authenticity of the fiction film (after all, Reiner and others signify reality by similarly replicating older news footage). By placing Hanks in the footage, though, Zemeckis collapses film history and American history into one seamless, thematically unified document. Fiction and nonfiction tell the same story throughout the film, teaching viewers to revisit historical images with a keener eye. Looking closely,

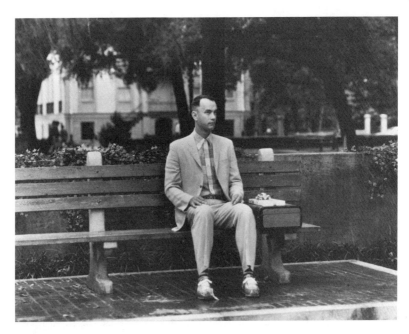

FIGURE 25. Rewriting southern history: Tom Hanks as New South patriarch in *Forrest Gump* (1994). Courtesy of Paramount Pictures. Photograph courtesy of the Academy of Motion Picture Arts and Sciences. *Forrest Gump* Copyright © 2000 by Paramount Pictures. All Rights Reserved.

we see that all along, obscured by the thunder and violence of race-related narratives, a kind and decent spirit haunted our screens—Forrest leading the Klan in silly bedsheets, Forrest following Vivian Malone through the schoolhouse door in Tuscaloosa like a guardian angel. Thanks to Zemeckis's industrial light and magic, we can detect a repixillated, gentle gray ghost in the machinery of southern racism: the good white man, the new Boo Radley. To prove his worthiness to the mantle, millionaire Forrest not only becomes landed gentry but bulldozes down the last vestige of crackerdom in the film: the shack of Jenny's white-trash demon father.

Just as the film begins with a visual salute to the civil rights movement—the desegregation of public buses—it ends with the movement's erasure. A rural Alabama schoolbus stops to pick up Forrest Jr. completely empty except for the white driver. In this final sequence, the issue of school integration effectively disappears as Forrest Sr. reigns over an eerily homogeneous South—white, wealthy, decent. Moreover,

the history of the modern South itself seems irrelevant, if not simply fabricated. It is Forrest who asks Jenny in horror if their child is like his father, and with her reassurance that little Forrest is "very smart, one of the smartest in his class," the legacy of Nathan Bedford Forrest—even, in fact, the very notion of inheritance—magically dissolves. The birth of a shining, intelligent, new Forrest signifies in no uncertain terms the birth of a culturally cleansed South.

The fact that *Forrest Gump* was the most popular movie of 1994, the same year that Republicans swept national elections (led by a former history professor from Georgia named Newt Gingrich), says much about America's investment in the image of the law-abiding southern white man. In his vigorously asserted difference from his redneck and cracker cousins, the Gumpified southerner heralds not only a reclaimed region but a redeemed race. According to the movies, the southern problem has never been white people; it has, it seems, always been social class.

NOTES

Introduction

1. *Covering the South: A National Symposium*, videotape, University of Mississippi, 1987.

2. *Dateline Freedom: Civil Rights and the Press*, videotape, University of Mississippi, 1987.

3. "Notes on Photographs," Margaret Bourke-White and Erskine Caldwell, *You Have Seen Their Faces* (Athens, Ga.: University of Georgia, 1995), 51.

4. Dan Wakefield, "Intrusions in the Dust," *Between the Lines* (New York: New American Library, 1966), 44–47.

5. Lewis Nordan, *Wolf Whistle* (Chapel Hill, N.C.: Algonquin Books of Chapel Hill, 1993), 212–14.

6. Elizabeth Spencer, *The Voice at the Back Door* (Baton Rouge: Louisiana State University Press, 1984), 101.

7. Leon F. Litwak, "The Birth of a Nation," in Ted Mico, John Miller-Monzon, and David Rubel, eds., *Past Imperfect: History According to the Movies* (New York: Henry Holt and Co., 1995), 136.

8. Peter A. Soderbergh, "Hollywood and the South, 1930–1960," *Mississippi Quarterly* 19 (winter 1965–66): 1.

9. Gordon F. Sander, *Serling: The Rise and Twilight of Television's Last Angry Man* (New York: Plume, 1992), 117.

10. J. Fred MacDonald, *Blacks and White TV: African Americans in Television Since 1948* (Chicago: Nelson-Hall, 1992), 50.

11. "Faubus Defiance of Federal Rule," *Life*, 21 September 1957, 30–31.

12. "What Orval Hath Wrought," *Time*, 23 September 1957, 12–13. My thanks to Roy Reed for drawing my attention to this story.

13. *Time*, 7 Oct. 1957, 6.

14. Cabell Phillips, "Integration: Battle of Hoxie, Arkansas," *New York Times Magazine*, 25 September 1955, 68.

15. *Life*, 25 July 1955, 30.

16. *Life*, 15 Aug. 1955, 18.

17. William D. Workman Jr., *The Case for the South* (New York: Devin-Adair Co., 1960), 231.

18. Author interview, 18 January 1997.

19. Author interview, 15 February 1997.

20. From petition titled "Resolution Adopted Last Night by Foes of Integration at Hoxie," courtesy of Howard Vance.

21. Pete Daniel, *Lost Revolutions: The South in the 1950s* (Chapel Hill: University of North Carolina Press, 2000), 265, 267.

22. *Covering the South: A National Symposium.*

23. The 1993 film was produced, directed, written, and edited by David Appleby, Allison Graham, and Steven Ross and is distributed by California Newsreel, San Francisco.

24. Ralph Ellison, *The Shadow and the Act* (New York: Random House, 1953), 280.

25. Lillian Smith, *Killers of the Dream* (New York: W. W. Norton, 1949), 12.

26. *Through the Eyes of Forrest Gump*, promotional video, Paramount Pictures, 1995.

One: *"The Purest of God's Creatures"*

1. Tom Brady, *Black Monday* (Jackson, Miss.: Citizens' Councils of America, 1955), 46.

2. Ibid.

3. Calvin Hernton, *Sex and Racism in America* (New York: Anchor, 1965), 14.

4. David Halberstam, *The Fifties* (New York: Fawcett Columbine, 1993), 421.

5. "Beauty Queens to Spare," *Life,* 25 August 1961, 64.

6. Dorothy Allison, *Two or Three Things I Know for Sure* (New York: Plume, 1996), 33.

7. William Bradford Huie, *Wolf Whistle and Other Stories* (New York: New American Library, 1959), 50.

8. Barbara Kingsolver, *The Poisonwood Bible* (New York: HarperPerennial, 1998), 526.

9. Pat McGilligan, ed., *Backstory 3: Interviews with Screenwriters of the 1960s* (Berkeley: University of California Press, 1997), 287.

10. Virginia Spencer Carr, "Introduction," *Collected Stories of Carson McCullers* (Boston: Houghton Mifflin Co., 1987), viii.

11. Carson McCullers, *The Ballad of the Sad Cafe*, in *Collected Stories*, 197. Further citations are included in the text.

12. Carson McCullers, *The Member of the Wedding*, in *Collected Stories*, 371. Further citations are included in the text.

13. Carson McCullers, *The Heart Is a Lonely Hunter* (New York: Bantam, 1953), 124. Further citations are included in the text.

14. *Flannery O'Conner: Collected Works* (New York: The Library of America, 1988), 213.

15. Ibid., 553, 555, 567.

16. Lillian Smith, *Killers of the Dream*, rev. ed. (New York: W. W. Norton and Co., 1960), 25.

17. Harper Lee, *To Kill a Mockingbird* (New York: Warner Books, 1960), 23. Further citations are included in the text.

18. James Dickey, *Deliverance* (New York: Dell, 1970), 51. Further citations are included in the text.

19. Erskine Caldwell, *God's Little Acre* (Athens, Ga.: University of Georgia Press, 1995), 86.

20. Ibid., 87.

21. Richard Dyer, *White* (New York: Routledge, 1999), 78.

22. Ibid., 36.

23. David Savran, *Communists, Cowboys, and Queers: The Politics of Masculinity in the Work of Arthur Miller and Tennessee Williams* (Minneapolis: University of Minnesota Press, 1992), 100.

24. *The Theatre of Tennessee Williams* (New York: New Directions, 1972), 4:71, 107.

25. Jeff Young, *Kazan: The Master Director Discusses His Films. Interviews with Elia Kazan* (New York: Newmarket Press, 1997), 230, 261.

26. Donald Bogle, *Toms, Coons, Mulattoes, Mammies, and Bucks: An Interpretive History of Blacks in American Films* (New York: Continuum, 1973; 3d ed. 1996), 9.

27. Tennessee Williams, *A Streetcar Named Desire* (New York: New American Library, 1947), 13.

28. Ibid.

29. Toni Morrison, *Playing in the Dark: Whiteness and the Literary Imagination* (Cambridge: Harvard University Press, 1992), 6, 7.

30. Tennessee Williams, *Orpheus Descending* (New York: New American Library, 1976), 21.

31. Williams, *A Streetcar Named Desire*, 139.

32. Memorandum from Mississippi State Sovereignty Commission to State Superintendent of Education and Jasper County Superintendent of Education, 12 December 1963. McCain Archives, University of Southern Mississippi.

33. Memorandum from Erle Johnson Jr. to Paul B. Johnson, 14 February 1964. McCain Archives.

34. Memorandum from Tom Scarbrough to the Mississippi State Sovereignty Commission, 25 January 1965. McCain Archives.

35. Bogle, *Toms, Coons, Mulattoes, Mammies, and Bucks,* 192.

36. Ralph Ellison, *Shadow and Act* (New York: Random House, 1953), 280.

37. James Fenlon Finley, review in *Catholic World* 186 (March 1958): 463.

38. Ava Gardner, *Ava: My Story* (New York: Bantam, 1990), 144.

39. Brady, *Black Monday,* 1.

40. South Carolina journalist William Workman credited the term *Paper Curtain* to Thomas R. Waring, editor of the Charleston, South Carolina *News and Courier.* See William D. Workman Jr., *The Case for the South* (New York: Devin-Adair Co., 1960), 68.

41. Bosley Crowther, rev. of *The Three Faces of Eve,* dir. Nunnally Johnson, *New York Times,* 27 Sept. 1957, 16.

42. Dorris Johnson and Ellen Leventhal, eds., *The Letters of Nunnally Johnson* (New York: Knopf, 1981), 149–50.

43. "Good Acting," *Saturday Review* 40, no. 26 (28 Sept. 1957): 26.

44. Chris Costner Sizemore, *I'm Eve* (New York: Doubleday, 1977), 392.

45. Interestingly, *Lizzie* employs a similar pattern of racialized color-coding. The blonde heroine's psychic disintegration is revealed to have occurred in childhood, when her mother's dark lover molested her. Before that, she had overheard the man and her bleached-blonde mother conspiring to desert "the brat" and head for Mexico. "Blondes are popular in Mexico," he had told the mother. As "Lizzie the slut," the heroine impersonates her false-blond mother by cruising a rundown bar for "Latin" men. Underscoring the racial subtext is Johnny Mathis's appearance in several scenes as a singer in the bar—the only African American performer in the film.

46. Corbett H. Thigpen and Hervey Cleckley, "A Case of Multiple Personality," *Journal of Abnormal and Social Psychology* 49, no. 1 (1954): 148.

47. Corbett H. Thigpen and Hervey Cleckley, *The Three Faces of Eve* (New York: McGraw-Hill, 1957), 105–6.

48. Thigpen and Cleckley, "A Case of Multiple Personality," 138, 140.

49. Thigpen and Cleckley, *The Three Faces of Eve,* 144.

50. Thigpen and Cleckley, "A Case of Multiple Personality," 145.

51. "Joanne Woodward: The Fugitive Kid," *Look,* 23 December 1959, 123.

52. Dorris Johnson and Ellen Leventhal, eds., *The Letters of Nunnally Johnson,* 157.

53. Ibid., 150.

54. Sizemore, *I'm Eve,* 342, 334, 341.

55. Thigpen and Cleckley, "A Case of Multiple Personality," 147.

56. "Joanne Woodward: The Fugitive Kid," 122.

57. "Tension and Triumph for a Young Actress," *Life,* 7 April 1958, 81.

58. "The New Pictures," *Time*, 23 September 1957, 48.

59. "Good Acting," 26.

Two: Sentimental Educations

1. Dorothy Allison, *Two or Three Things I Know for Sure* (New York: Plume, 1995), 1.

2. Elia Kazan, *Elia Kazan: A Life* (New York: Doubleday, 1988), 597.

3. Brock Brower, "An Untheatrical Director Takes the Stage," *New York Times Magazine*, 20 May 1962, 32.

4. Cid Ricketts Sumner, *Tammy Out of Time* (Indianapolis: Bobbs-Merrill, 1948), 25. Further citations are included in the text.

5. Cid Ricketts Sumner, *Tammy Tell Me True* (New York: Popular Library, 1959), 20. Further citations are included in the text.

6. Gwen Terasaki, *Bridge to the Sun* (Chapel Hill: University of North Carolina Press, 1957), 259.

7. James Michener, *Tales from the South Pacific* (New York: MacMillan, 1946), 46.

8. "What Orval Hath Wrought," *Time*, 23 September 1957, 12.

9. Michener, *Tales,* 112.

10. Gina Marchetti, *Romance and the "Yellow Peril": Race, Sex, and Discursive Strategies in Hollywood Fiction* (Berkeley: University of California Press, 1993), 125.

11. Robert Penn Warren, *Segregation* (New York: Random House, 1956), 49.

12. Miles Bennell would be reincarnated in 1993 as D-Fens, an alienated white man roaming the streets of Los Angeles, in Joel Schumacher's *Falling Down*. Here, the "monsters" haunting the main character were terrestrial "aliens": Latinos, African Americans, Korean Americans, neo-Nazis, and an ex-wife who bars him from her house.

13. Paul Wells, "The Invisible Man: Shrinking Masculinity in the 1950s Science Fiction B-Movie," in Pat Kirkham and Janet Thumin, eds., *You Tarzan: Masculinity, Movies and Men* (New York: St. Martin's, 1993), 181.

14. Richard Matheson, *The Shrinking Man*, originally published in 1956, reissued as *The Incredible Shrinking Man* (New York: Tom Doherty Associates, 1994), 10.

15. Ibid., 19.

16. Robert Penn Warren, *Band of Angels* (New York: Random House, 1955), 323–24.

17. Marchetti, *Romance and the "Yellow Peril,"* 135.

18. "The New Pictures," *Time*, 16 December 1957, 94

19. "Romance in the Orient," *Newsweek*, 9 December 1957, 96.

20. John McCarten, "Variation on the Puccini Caper," *New Yorker*, 14 December 1957, 89.

21. Robert Hatch, "Films," *Nation*, 21 December 1957, 484.

22. James Michener, *Sayonara* (New York: Random House, 1953), 148. Further citations are included in the text.

23. Quoted in Truman Capote, "The Duke in His Domain," *New Yorker*, 9 November 1957, 70.

24. Peter Manso, *Brando: The Biography* (New York: Hyperion, 1994), 421.

25. Capote, "The Duke in His Domain," 70.

26. Josh Logan, "Recovery from Fear," *Look*, 19 August 1958, 70.

27. Ibid., 72.

28. Capote, "The Duke in His Domain," 68.

29. Ibid., 70.

30. "Eastward Ho!" *Commonweal*, 13 December 1957, 287.

31. Marchetti, *Romance and the "Yellow Peril,"* 143.

Three: Natural Acts

1. Robert Penn Warren, *Segregation* (New York: Random House, 1956), 9.

2. Author interview, 18 September 1996.

3. Pete Daniel, *Lost Revolutions: The South in the 1950s* (Chapel Hill: University of North Carolina Press, 2000), 272.

4. Jack Lait and Lee Mortimer, *U.S.A. Confidential* (New York: Crown Publishers, 1952), 37.

5. Tom Englehardt, *The End of Victory Culture: Cold War America and the Disillusionment of a Generation* (New York: Basic Books, 1995), 136.

6. Quoted ibid., 134.

7. Richard Kluger, *Simple Justice: The History of "Brown v. Board of Education" and Black America's Struggle for Equality* (New York: Vintage, 1975), 443.

8. Paul Molloy, "Comic Book Censors Named—Move Speedily into Action," *Commercial Appeal*, 16 October 1954, 1.

9. David Halberstam, *The Fifties* (New York: Fawcett Columbine, 1993), 194.

10. "Adult Rings Held 'Infecting' Youth, "*New York Times*, 29 June 1954, 29.

11. "No Harm in Horror, Comics Issuer Says," *New York Times*, 22 April 1954, 34.

12. Daniel, *Lost Revolutions*, 242.

13. "The Weary Young Man," *Newsweek*, 28 September 1959, 82.

14. Peter Biskind, *Seeing Is Believing: How Hollywood Taught Us to Stop Worrying and Love the Fifties* (New York: Pantheon, 1983), 210.

15. James Gilbert, *A Cycle of Outrage: America's Reaction to the Juvenile Delinquent in the 1950s* (New York: Oxford, 1986), 194.

16. Pete Daniel notes the conjunction of southern political, social, and cultural events in mid-1954 (*Lost Revolutions*, 179).

17. Quoted in Brian Ward, *Just My Soul Responding: Rhythm and Blues, Black Consciousness and Race Relations* (London: UCL Press, 1998), 103.

18. Norman Mailer, "The White Negro," in *Advertisements for Myself* (Cambridge: Harvard University Press, 1959), 340. Further citations are included in the text.

19. Richard Slotkin, *Gunfighter Nation: The Myth of the Frontier in Twentieth-Century America* (New York: Atheneum, 1992), 16.

20. Michele Wallace, *Black Macho and the Myth of the Superwoman* (London: Verso, 1990), 45.

21. Jack Kerouac, *On the Road* (New York: Penguin, 1976), 7–8.

22. William D. Workman Jr., *The Case for the South* (New York: Devin-Adair Co., 1960), 139. Further citations are included in the text.

23. "Awakenings: 1954–1956," Episode 1, *Eyes on the Prize: America's Civil Rights Years*, Part 1, video production (Henry Hampton, executive producer, Blackside, Inc., 1988).

24. Quoted in Workman, *The Case for the South*, 276.

25. "What Hath Orval Wrought?" *Time*, 23 September 1957, 13.

26. Calvin Trillin, "State Secrets," *New Yorker*, 29 May 1995, 56.

27. Author interview, 18 March 1996.

28. Elizabeth Huckaby, *Crisis at Central High: Little Rock, 1957–58* (Baton Rouge: Louisiana State University Press, 1980), 25.

29. Margaret Anderson, *The Children of the South* (New York: Dell, 1958), 10.

30. Tom Lehrer, "It Makes a Fellow Proud to Be a Soldier," from *An Evening Wasted with Tom Lehrer*, Reprise Records, 1959.

31. Tom Lehrer, "Send the Marines," from *That Was the Year That Was: TW3 Songs and Other Songs of the Year*, Reprise Records, 1965.

32. Lehrer, "Who's Next?" from *That Was the Year That Was*.

33. Tom Lehrer, "I Wanna Go Back to Dixie," from *Tom Lehrer Revisited*, Reprise Records, 1959, TL201.

34. John Cohen, ed., *The Essential Lenny Bruce* (New York: Ballantine, 1967), 19.

35. Ibid., 97.

36. Brother Dave Gardner, *Rejoice, Dear Hearts!*, Collectors' Choice Records, 1996. Originally released in 1959.

37. Quoted in William E. Lightfoot, "Brother Dave Gardner," *Southern Quarterly* 64, no. 3 (spring 1996): 83.

38. Brother Dave Gardner, *Kick Thy Ownself*, Collectors' Choice Music, 1996. Originally released in 1960.

39. Lightfoot, "Brother Dave Gardner," 84.

40. Ibid., 91.

41. Gardner, *Rejoice, Dear Hearts!*.

42. Ibid.

43. Lightfoot, "Brother Dave Gardner," 86.

44. Larry L. King, "Whatever Happened to Brother Dave?" *Harper's* 241 (September 1970): 60.

45. Andy Griffith, "Hamlet," *Andy Griffith/American Originals*, Capitol Records, 1992 (Originally released on vinyl as *This Here Andy Griffith*, 1959, Capitol).

46. Griffith, "Opera Carmen," *Andy Griffith/American Originals* (Originally released on vinyl as *Andy and Cleopatra*, 1964, Capitol).

47. Author interview, 4 February 1997.

48. Donald Freeman, "I Think I'm Gaining on Myself," *Saturday Evening Post*, 25 June 1964, 68.

49. Ibid., 69–70.

50. Lawrence Elliott, "Andy Griffith: Yokel Boy Makes Good," *Coronet* 42 (October 1957): 108, 105, 106.

51. Gilbert Millstein, "Strange Chronicle of Andy Griffith," *New York Times Magazine*, 2 June 1957, 17.

52. James Naremore, *Acting in the Cinema* (Berkeley: University of California Press, 1988), 200.

53. Ibid., 199.

54. Elia Kazan, "Notebook for *A Streetcar Named Desire*," in Toby Cole and Helen Krich Chinoy, eds., *Directors on Directing: A Source Book of the Modern Theatre* (Indianapolis: Bobbs-Merrill, 1953), 364.

55. Naremore, *Acting in the Cinema*, 197.

56. Quoted in Millstein, "Strange Chronicle of Andy Griffith," 17.

57. Ibid.

58. Elliott, "Andy Griffith," 109.

59. Ibid.

60. Millstein, "Strange Chronicle of Andy Griffith," 17.

61. Quoted in Elliott, "Andy Griffith," 110, 107.

62. Robert Penn Warren, *All the King's Men* (New York: Modern Library, 1953), 7.

63. Budd Schulberg, "Your Arkansas Traveller," *Some Faces in the Crowd* (London: Bodley Head, 1954), 7. Further citations are included in the text.

64. William Blackburn, ed., *Love, Boy: The Letters of Mac Hyman* (Baton Rouge: Louisiana State University Press, 1969), 114.

65. Author interview, 4 February 1997.

66. Blackburn, 126.

67. J. W. Williamson, *Hillbillyland: What the Movies Did to the Mountains and What the Mountains Did to the Movies* (Chapel Hill: University of North Carolina Press, 1995), 213.

68. Barbara Ching, "Acting Naturally: Cultural Distinction and Critiques

of Pure Country," in Matt Wray and Annalee Newitz, eds., *White Trash: Race and Class in America* (New York: Routledge, 1997), 233.

69. Naremore, *Acting in the Cinema,* 202.

70. Pete Martin, "I Call on Tennessee Ernie," *Saturday Evening Post*, 28 September 1957, 35.

71. *"TV Guide" Roundup* (New York: Holt, Rinehart and Winston, 1960), 53.

72. Martin, 35.

73. Ibid.

74. "Old Pro," *Newsweek,* 3 February 1958, 65.

75. Walter (Grampa McCoy) Brennan, "What'll We Do With Grandpa?" *Today's Health* 36 (October 1958): 26, 49.

76. "Old Pro," 65.

77. Brennan, "What'll We Do With Grandpa?" 27.

78. "Old Pro," 65.

79. Richard Warren Lewis, "The Golden Hillbillies," *Saturday Evening Post*, 2 February 1963, 34.

80. Ibid.

81. "The Corn Is Green," *Newsweek*, 3 December 1962, 70.

82. Lewis, 34, 32.

Four: Reeducating the Southerner

1. Albert Goldman, *Elvis* (New York: McGraw-Hill, 1981).

2. "Hillbilly on a Pedestal," *Newsweek*, 14 May 1956, 82.

3. "A Howling Hillbilly Success," *Life*, 30 April 1956, 64.

4. Peter Guralnick, *Last Train to Memphis: The Rise of Elvis Presley* (Boston: Little, Brown and Co., 1994), 263, 293.

5. Jim Goad, *The Redneck Manifesto* (New York: Touchstone, 1997), 86.

6. Ibid., 82–83.

7. Stephen Whitfield, *A Death in the Delta: The Story of Emmett Till* (Baltimore: Johns Hopkins University Press, 1991), 46.

8. Ibid., 34, 44.

9. Quoted ibid., 146.

10. Quoted ibid., 52.

11. "Awakenings: 1954–1956," Episode 1, *Eyes on the Prize: America's Civil Rights Years*, Part 1, video production (Henry Hampton, executive producer, Blackside, Inc., 1988).

12. Whitfield, *A Death in the Delta,* 27.

13. William Bradford Huie, *Wolf Whistle and Other Stories* (New York: New American Library, 1959), 51.

14. Whitfield, *A Death in the Delta,* 54.

15. Huie, *Wolf Whistle,* 31.

16. Quoted in Whitfield, *A Death in the Delta,* 55.

17. David Halberstam, "Tallahatchie County Acquits a Peckerwood," *Reporter* 19 April 1956, 26.

18. William Bradford Huie, "What's Happened to the Emmett Till Killers?" *Look,* 22 January 1957, 68.

19. Margaret Rose Gladney, ed., *How Am I To Be Heard? Letters of Lillian Smith* (Chapel Hill: University of North Carolina Press, 1993), 318.

20. Eudora Welty, "Where Is the Voice Coming From?" in *The Collected Stories of Eurdora Welty* (New York: Harcourt, Brace, Jovanovich, 1980), 603. Further citations are included in the text.

21. Huie, *Wolf Whistle,* 21.

22. Guralnick, *Last Train to Memphis,* 449.

23. Peter Guralnick, *Careless Love: The Unmaking of Elvis Presley* (Boston: Little, Brown and Co., 1999), 74.

24. Ibid., 468, 158.

25. Film scholar Robert Ray has intriguingly observed that in his singing Elvis "reversed" the Method process. "Instead of deriving his singing performances from some pre-existing inner self . . . Elvis treated the self as an effect of performance, as the result of role-playing." From a paper presented at a symposium on Elvis Presley as actor, the University of Memphis, August 1998.

26. Guralnick, *Careless Love,* 171.

27. Eric Lott, "All the King's Men: Elvis Impersonators and White Working-Class Masculinity," in Harry Stecopoulos and Michael Uebel, eds., *Race and the Subject of Masculinities* (Durham, N.C.: Duke University Press, 1997), 207.

28. Guralnick, *Careless Love,* 157, 159.

29. Sam Kashner, "A Movie Marked Danger," *Vanity Fair,* April 2000, 431.

30. Pete Daniel, *Lost Revolutions: The South in the 1950s* (Chapel Hill: University of North Carolina Press, 2000), 94.

31. George Eells, *Robert Mitchum: A Biography* (New York: Franklin Watts, 1984), 212.

32. Daniel, *Lost Revolutions,* 95.

33. Robert Ray, *A Certain Tendency of the Hollywood Cinema, 1930–1980* (Princeton: Princeton University Press, 1985), 73.

34. Robert Warshow, *The Immediate Experience* (New York: Atheneum, 1971), 140.

35. Ibid., 141.

36. Ray, *A Certain Tendency,* 73.

37. Alan Le May, *The Unforgiven* (New York: Curtis Publishing Co., 1957), 47.

38. Brian Henderson, "*The Searchers:* An American Dilemma," in Bill Nichols, ed., *Movies and Methods* (Berkeley: University of California Press,

1985), 2:429–49; and Richard Slotkin, *Gunfighter Nation: The Myth of the Frontier in Twentieth-Century America* (New York: Atheneum, 1992).

39. Alan Le May, *The Searchers* (New York: Harper and Brothers, 1954), 203, 263–64.

40. Garry Wills, *John Wayne's America* (New York: Atheneum, 1997), 261.

41. Henderson, "*The Searchers*," 447.

42. Dan T. Carter, *The Politics of Rage: George Wallace, the Origins of the New Conservatism, and the Transformation of American Politics* (New York: Simon and Schuster, 1995), 107.

43. Dana Rubin, "The Real Education of Little Tree," *Texas Monthly* 20, no. 2 (February 1992): 94.

44. Forrest Carter, *Gone to Texas* (first published as *The Rebel Outlaw: Josey Wales*) (Albuquerque: University of New Mexico Press, 1973), 7–8. Further citations are included in the text.

45. Rubin, "The Real Education of Little Tree," 92, 81.

46. John Cohen, ed., *The Essential Lenny Bruce* (New York: Ballantine, 1967), 28–29.

47. Patrick McGilligan, ed., *Backstory 3: Interviews with Screenwriters of the 60s* (Berkeley: University of California Press, 1997), 286–87.

48. Tennessee Williams, *Orpheus Descending*, in John Gassner, ed., *Best American Plays, Fifth Series 1957–1963* (New York: Crown Publishers, 1963), 524, 519, 525.

49. In his autobiography, Brando claims to have had problems with Williams's treatment of black characters. "Like most great American writers," he writes, "he turned black people into windowpanes. In *The Fugitive Kind*, they were rendered almost invisible, as if they were props. . . . And it seemed to me a subtle form of racial discrimination." Marlon Brando, with Robert Lindsey, *Brando: Songs My Mother Taught Me* (New York: Random House, 1994), 261–62.

50. Tony Curtis and Barry Paris, *Tony Curtis: The Autobiography* (New York: William Morrow and Company, 1993), 141.

51. Michael Rogin, *Blackface, White Noise: Jewish Immigrants in the Hollywood Melting Pot* (Berkeley: University of California Press, 1996), 239.

Five: Civil Rights Films and the New Red Menace

1. Willie Morris, *The Ghosts of Mississippi: A Tale of Race, Murder, Mississippi, and Hollywood* (New York: Random House, 1998), 83. Further citations are included in the text.

2. *Los Angeles Times*, 22 February 1989, A2.

3. *Newsday*, 8 December 1988, 2:4.

4. Morris, *The Ghosts of Mississippi*, 108.

5. Footage of the attack appears in episode 6 of *Eyes on the Prize*, Part 1, video production (Henry Hampton, executive producer, Blackside, Inc., 1988).

6. Tom Lehrer, "National Brotherhood Week," from *That Was the Year That Was: TW3 Songs and Other Songs of the Year*, Reprise Records, 1965.

7. "That Was the Deb That Was," *Life*, 26 June 1964, 87.

8. Jan Jarboe Russell, quoted in Anne Morris, "Biographer's Goal: Reveal the Lady Bird No One Knows," *Austin American-Statesman*, 13 July 1999, Lifestyle section, 1.

9. Author interview, 4 February 1997.

10. Ibid.

11. Eric Sundquist, "Blues for Atticus Finch," in Larry J. Griffin and Don H. Doyle, eds., *The South as an American Problem* (Athens: University of Georgia Press, 1995), 186.

12. Harper Lee, *To Kill a Mockingbird* (New York: 1960; reprint, New York: Warner, 1982), 8. Subsequent quotations are cited within the text.

13. George Eells, *Robert Mitchum: A Biography* (New York: Franklin Watts, 1984), 29.

14. Ibid., 222.

15. Charles Beaumont, *The Intruder* (New York: G. P. Putnam's Sons, 1959), 17. Further citations are included in the text.

16. Arthur Gordon, "Intruder in the South," *Look*, 19 February 1957, 28.

17. Peter Biskind, *Easy Riders, Raging Bulls: How the Sex-Drugs-and-Rock'n' Roll Generation Saved Hollywood* (New York: Simon and Schuster, 1998), 68.

18. Reese Cleghorn, "The Segs," *Esquire*, January 1964, 133.

19. Robert Coles, *Farewell to the South* (Boston: Little, Brown and Company, 1972), 357.

20. Roy Blount Jr., *Crackers* (1980; rpt., Athens: University of Georgia Press, 1998), 51.

21. Robert E. Burns, *I Am a Fugitive from a Georgia Chain Gang!* (Athens: University of Georgia Press, 1997), 5.

22. Daniel Wolff, with S. R. Crain, Clifton White, and G. David Tenenbaum, *You Send Me: The Life and Times of Sam Cooke* (New York: William Morrow, 1995), 210.

23. Bosley Crowther, review of *Hurry Sundown* in the *New York Times*, 24 March 1967.

24. John Ball, *In the Heat of the Night* (New York: Harper and Row, 1965), 177, 183.

25. J. W. Williamson raises this issue in his discussion of the location shooting for *Deliverance* in his *Hillbillyland: What the Movies Did to the Mountains and What the Mountains Did to the Movies* (Chapel Hill: University of North Carolina Press, 1995), 163–67.

26. Sally Bedell Smith, *In All His Glory: The Life and Times of William S. Paley and the Birth of Modern Broadcasting* (New York: Touchstone, 1990), 494.

27. Blount, *Crackers*, 51.

28. Robin Wood, *Sexual Politics and Narrative Film: Hollywood and Beyond* (New York: Columbia University Press, 1998), 267.

29. Blount, *Crackers,* 122.

30. Lou Cannon, "Reagan Campaigning from County Fair to Urban League," *Washington Post,* 4 August 1980.

31. Morris, *The Ghosts of Mississippi,* 86.

32. Ibid., 232.

BIBLIOGRAPHICAL ESSAY

The critical approach I take in this book has been greatly influenced by the work of particular film, literature, and American studies scholars who have reread American history through its cultural texts. Robert Ray's *A Certain Tendency of the Hollywood Film, 1930–1980* (Princeton: Princeton University Press, 1985) is, I believe, an essential study for anyone attempting to understand recent cultural history. Ray discusses the complicated interplay of culture, industry, and politics and, moreover, demonstrates the ways in which the movies have *visually* constructed recurrent political and cultural themes. Richard Slotkin's three-volume study of the role of the frontier in shaping American political and cultural life is also indispensable, especially his last volume, *Gunfighter Nation: The Myth of the Frontier in Twentieth-Century America* (New York: Atheneum, 1992), in which he painstakingly examines a significant number of westerns. Michael Rogin's *Blackface, White Noise: Jewish Immigrants in the Hollywood Melting Pot* (Berkeley: University of California Press, 1996) looks at the complicated history of racial construction in the movies, seeing the role of Jewish immigrants as central to our popular understanding of "whiteness" and "blackness." Brian Henderson's essay, "*The Searchers:* An American Dilemma," in volume 2 of Bill Nichols's *Movies and Methods* (Berkeley: University of California Press, 1985), lucidly demonstrates the ways in which a politically problematic film can be understood as an implicit cultural "lesson" for its time (in this case, the immediate post-*Brown* years). Other important cultural studies of American film include Robin Wood's *Hollywood from Vietnam to Reagan* (New York: Columbia University Press, 1986), Peter Biskind's *Seeing Is Believing: How Hollywood*

Taught Us to Stop Worrying and Love the Fifties (New York: Pantheon, 1983), and Janet Staiger's *Interpreting Films: Studies in the Historical Reception of American Cinema* (Princeton: Princeton University Press, 1992).

Historical studies of American film that are central to an understanding of the culture of the civil rights era include Thomas Cripps's *Slow Fade to Black: The Negro in American Film, 1900–1942* (1977; rpt., New York: Oxford University Press, 1993) and *Making Movies Black: The Hollywood Message Movie from World War II to the Civil Rights Era* (New York: Oxford University Press, 1993). Cripps's later work, *Hollywood's High Noon: Moviemaking and Society Before Television* (Baltimore: Johns Hopkins University Press, 1997) refreshingly integrates race into its extensive overview of American film history. One particular history of television during this era contains an immense amount of crucial material: J. Fred MacDonald's *Blacks and White TV: African Americans in Television Since 1948* (Chicago: Nelson-Hall, 1992).

Among literary studies, Eric Sundquist's "Blues for Atticus Finch," in Larry J. Griffin's and Don H. Doyle's *The South as an American Problem* (Athens: University of Georgia Press, 1995), is a model of the kind of aesthetically and historically informed work I find inspiring. Toni Morrison's *Playing in the Dark: Whiteness and the Literary Imagination* (Cambridge: Harvard University Press, 1992) and Edward Said's *Culture and Imperialism* (New York: Alfred A, Knopf, 1993) have both played critical roles in shaping the ways in which literary (and, by extension, film) scholars pay as much attention to what is *not* said (or seen) as to what *is* said (or seen) in the art of a culture.

The demarcations between race, gender, and social class are often ambiguous, vague, and even invisible, and the most interesting work on race and representation explores these shifting frontiers. Richard Dyer's *White* (London: Routledge, 1997) places the movies' construction of racial hierarchies in the context of Western iconography and discusses the technical practices that have made this construction possible; Michael Rogin's *Blackface, White Noise,* mentioned above, dives into the complex history of Hollywood's strangely "layered" images with rigor and sophistication; Eric Lott's *Love and Theft: Blackface Minstrelsy and the American Working Class* (New York: Oxford University Press, 1993) examines the boundaries of "whiteness" and "blackness" within a performative context; Lott's essay "The Whiteness of Film Noir" (in *American Literary History* 9, no. 3 [1997]: 542–66) builds upon

the work of Toni Morrison and others to question the racial implications of the "noir" cinematic style; Harry Stecopoulos's and Michael Uebel's edited collection, *Race and the Subject of Masculinities* (Durham, N.C.: Duke University Press, 1997) contains a sizeable number of essays (including ones by Dyer and Lott) that look at the often blurred boundaries of race, gender, and class across the popular arts; and Daniel Bernardi's anthology, *The Birth of Whiteness: Race and the Emergence of U.S. Cinema* (New Brunswick: Rutgers University Press, 1995) offers a wide range of critical examinations of the first decades of American film. Gina Marchetti has extended the dialogue on race and film in her book on the representation of Asians and Asian Americans, *Romance and the "Yellow Peril": Race, Sex, and Discursive Strategies in Hollywood Fiction* (Berkeley: University of California Press, 1993).

A number of historical studies of the evolution of whiteness as a political and social category provide critical contextualization for the study of race in cultural texts. Among the most helpful are Theodore W. Allen's *The Invention of the White Race,* vol. 1, *Racial Oppression and Social Control* (London: Verso, 1994) and vol. 2, *The Origin of Racial Oppression in Anglo-America* (London: Verso, 1997), Noel Ignatiev's *How the Irish Became White* (New York: Routledge, 1995), Matthew Frye Jacobson's *Whiteness of a Different Color: European Immigrants and the Alchemy of Race* (Cambridge: Harvard University Press, 1998), Edward J. Larson's *Sex, Race, and Science: Eugenics in the Deep South* (Baltimore: Johns Hopkins University Press, 1995), and David Roediger's *The Wages of Whiteness: Race and the Making of the American Working Class* (London: Verso, 1991) and *Towards the Abolition of Whiteness* (London: Verso, 1994).

Examinations of media representations of the South during the 1950s and 1960s have, for obvious reasons, focused on the press's coverage of the civil rights movement, but a number of works have attempted to look at the perpetuation of southern stereotypes in the movies over a broader time period. Chief among them is J. W. Williamson's *Hillbillyland: What the Movies Did to the Mountains and What the Mountains Did to the Movies* (Chapel Hill: University of North Carolina Press, 1995), which provides interesting and extremely helpful information on the formation and popularization of a specific southern image in the movies. Jack Temple Kirby, in *Media-Made Dixie: The South in the American Imagination* (Athens: University of Georgia Press, rev. ed. 1986) begins his study at the turn of the last century, looking at

the influence of D. W. Griffith and a number of historians upon sub-
sequent representations of the South and ends with an informed dis-
cussion of the changing image of the South in the popular culture of
the 1970s and 1980s. As a behind-the-scenes look at the making of one
of the more recent civil rights–themed films, Willie Morris's *The Ghosts
of Mississippi: A Tale of Race, Murder, Mississippi, and Hollywood* (New
York: Random House, 1998) offers incomparable glimpses of the Holly-
woodization of the South. Warren French's edited collection, *The South
and Film* (Jackson: University Press of Mississippi, 1981), contains his-
torical and critical essays covering a wide range of topics. Peter A. Soder-
bergh's much earlier "Hollywood and the South, 1930–1960" (*Mis-
sissippi Quarterly* 19 [winter 1965–66]: 1–19) is an immensely helpful
historical overview of the reception of early sound films about the South.
Two essays, Fred Chappell's "The Image of the South in Film" (*South-
ern Humanities Review* 12 [fall 1978]: 303–11) and Edwin T. Arnold's
"What the Movies Told Us" (*Southern Quarterly* 34, no. 3 [spring 1996]:
57–65), offer more informal responses to the image of the South in film
(Arnold's autobiographical connection to the movies is entertaining as
well as perceptive).

One should not overlook documentaries when exploring media rep-
resentations of the South. Appalshop Film and Video, based in Whites-
burg, Kentucky, sells and rents several engaging films, notably *Stranger
with a Camera* (Elizabeth Barret, producer / director, 2000), a study of
the 1967 murder of Canadian filmmaker Hugh O'Connor in eastern
Kentucky by a local man resentful of media intrusion onto his prop-
erty. Herb E. Smith's *Strangers and Kin: A History of the Hillbilly Image*
(1984) makes an excellent companion to Williamson's *Hillbillyland*.

A number of works are indispensable to an understanding of south-
ern popular culture. For the most part, they focus on southern white-
ness—in particular, working-class southern whiteness—as a caricatured
and culturally degraded social category. Pete Daniel's *Lost Revolutions:
The South in the 1950s* (Chapel Hill: University of North Carolina Press,
2000) is a marvelously detailed and spirited exploration of little-studied
southern cultures (among them, stock car racing and cross-dressing).
White Trash: Race and Class in America, edited by Matt Wray and An-
nalee Newitz (New York: Routledge University Press, 1997), contains
essays on a range of historical and cultural issues; among them, Barbara
Ching's "Acting Naturally: Cultural Distinction and Critiques of Pure
Country" is essential reading for anyone studying the role of social class

in defining notions of "culture." Jim Goad's *The Redneck Manifesto: How Hillbillies, Hicks, and White Trash Became America's Scapegoats* (New York: Touchstone, 1997) is an irreverent and incisive polemic against received notions of class and taste, complementing Dorothy Allison's memoir, *Two or Three Things I Know for Sure* (New York: Plume, 1996). Although his focus is on South Boston, Michael Patrick MacDonald's autobiographical *All Souls: A Family Story from Southie* (Boston: Beacon Press, 1999) is a powerful study of the emotional and social effects of a poor, white, racist upbringing. Although all of Roy Blount Jr.'s work is wonderfully iconoclastic, his *Crackers* (1980; rpt., Athens: University of Georgia Press, 1998) may be the most hilarious and perceptive work to date on mass perceptions and *self*-perceptions of southern whites. John Shelton Reed's *Southern Folk Plain and Fancy: Native White Social Types* (Athens: University of Georgia Press, 1986) offers a concise and well-organized typography of white southerners as defined primarily through popular media. As correctives to national representations of southern debasement, four of the best studies of indigenous white culture in the South are David E. Whisnant's *All That Is Native and Fine: The Politics of Culture in an American Region* (Chapel Hill: University of North Carolina Press, 1983); Peter Guralnick's two-volume biography of Elvis Presley, *Last Train to Memphis* (Boston: Little, Brown and Co., 1994) and *Careless Love: The Unmaking of Elvis Presley* (Boston: Little, Brown and Co., 1999), a richly textured study of region, class, and artistry; and James M. Gregory's *American Exodus: The Dust Bowl Migration and Okie Culture in California* (New York: Oxford, 1989).

A number of journalists who covered the South during the Civil Rights Era have collected portions of their work in memoirs: Dan Wakefield's *Between the Lines* (New York: New American Library, 1966) and photojournalist Will Counts's *A Life Is More Than a Moment: The Desegregation of Little Rock's Central High* (Bloomington: Indiana University Press, 1999) are, for different reasons, among the most interesting and revealing. Danny Lyon, the first staff photographer for the Student Nonviolent Coordinating Committee, has reprinted many of his photographs from the era in his *Memories of the Southern Civil Rights Movement* (Chapel Hill: University of North Carolina, 1992). Both Counts and Lyon provide absorbing retrospective commentary on their experiences. The University of Mississippi has made available for sale the videotaped proceedings of its 1987 conference on press coverage of the

civil rights movement (*Covering the South: A National Symposium* and *Dateline Freedom: Civil Rights and the Press*), and the multivolume set contains fascinating discussions among a large number of broadcast and print journalists who experienced the central events of the movement firsthand.

For the sheer magnitude of resources available, the McCain Archives at the University of Southern Mississippi is the best single source I have found for contemporaneous information on the white South's reaction to *Brown v. Board of Education,* media coverage of the region, and the civil rights movement. The archives house not only the recently released papers of the Mississippi State Sovereignty Commission but also various newsletters from the 1950s and 1960s (chief among them the publication of the state's Citizens' Council). Other invaluable prosegregation material of the era can be found in Tom Brady's *Black Monday* (Jackson, Miss.: Citizens' Councils of America, 1955), James J. Kilpatrick's *The Sovereign States: Notes of a Citizen of Virginia* (Chicago: Henry Regnery Co., 1957), and William D. Workman Jr.'s *The Case for the South* (New York: Devin-Adair Co., 1960). Moderate to liberal discussions appear in Hodding Carter's *Southern Legacy* (Baton Rouge: Louisiana State University Press, 1950), Robert Coles's *Farewell to the South* (Boston: Little, Brown and Co., 1963), William Bradford Huie's *Three Lives for Mississippi* (New York: WCC Books, 1964) and *Wolf Whistle and Other Stories* (New York: New American Library, 1959), Ralph McGill's *The South and the Southerner* (1963; rpt., Athens: University of Georgia Press, 1992), James W. Silver's *Mississippi: The Closed Society* (New York: Harcourt, Brace, and World, 1963), Robert Penn Warren's *Segregation: The Inner Conflict in the South* (New York: Random House, 1956), and Pat Watters's *The South and the Nation* (New York: Pantheon, 1969).

The histories of the civil rights era which have provided me with the most helpful insights into the rhetorical climate of the time are Numan V. Bartley's *The Rise of Massive Resistance: Race and Politics in the South During the 1950s* (Baton Rouge: Louisiana State University Press, 1969), Taylor Branch's *Parting the Waters: America in the King Years, 1954–63* (New York: Simon and Schuster, 1988), Seth Cagin's and Philip Dray's *We Are Not Afraid: The Story of Goodman, Schwerner, and Chaney and the Civil Rights Campaign for Mississippi* (New York: MacMillan, 1988), Dan T. Carter's *The Politics of Rage: George Wallace, the Origins of the New Conservatism, and the Transformation of Ameri-*

can Politics (New York: Simon and Schuster, 1995), David L. Chappell's *Inside Agitators: White Southerners in the Civil Rights Movement* (Baltimore: Johns Hopkins University Press, 1994), Melissa Fay Greene's *The Temple Bombing* (Reading, Mass.: Addison-Wesley, 1996), Neil R. McMillen's *The Citizens' Councils: Organized Resistance to the Second Reconstruction, 1954–64* (Urbana: University of Illinois Press, 1994), Roy Reed's *Faubus: The Life and Times of an American Prodigal* (Fayetteville: University of Arkansas Press, 1997), Maryanne Vollers's *Ghosts of Mississippi: The Murder of Medgar Evers, the Trials of Byron De La Beckwith, and the Haunting of the New South* (Boston: Little, Brown and Co., 1995), and Stephen J. Whitfield's *A Death in the Delta: The Story of Emmett Till* (Baltimore: Johns Hopkins University Press, 1991).

Southern memoirs have proliferated in the past decade, but several older works have been especially helpful to this study: Margaret Anderson's chronicle of teaching in strife-ridden Clinton, Tennessee, *The Children of the South* (New York: Dell, 1958), Wendell Berry's eloquent testament to racism's damage to the perpetrator, *The Hidden Wound* (San Francisco: North Point Press, 1989), Elizabeth Huckaby's *Crisis at Central High: Little Rock, 1957–58* (Baton Rouge: LSU, 1980), Mary King's *Freedom Song: A Personal Story of the 1960s Civil Rights Movement* (New York: William Morrow, 1987), Florence Mars's *Witness in Philadelphia* (Baton Rouge: Louisiana State University Press, 1977), and Anne Moody's *Coming of Age in Mississippi* (New York: Dell, 1968).

Finally, some of the best historical studies of the era are on film. The entire fourteen-episode *Eyes on the Prize* series (Boston: Blackside, Inc., 1988–90) is breathtaking in its use of contemporaneous footage; a number of episodes dramatically demonstrate the complicated role of the media in the coverage of civil rights struggles from 1954 through the late 1980s. Connie Field's and Marilyn Mulford's *Freedom on My Mind* (distributed by California Newsreel, 1996) is a gripping study of the experiences of black and white activists during Freedom Summer, 1964.

INDEX

Bold numerals indicate figures.

217